When Janey Comes Marching Home

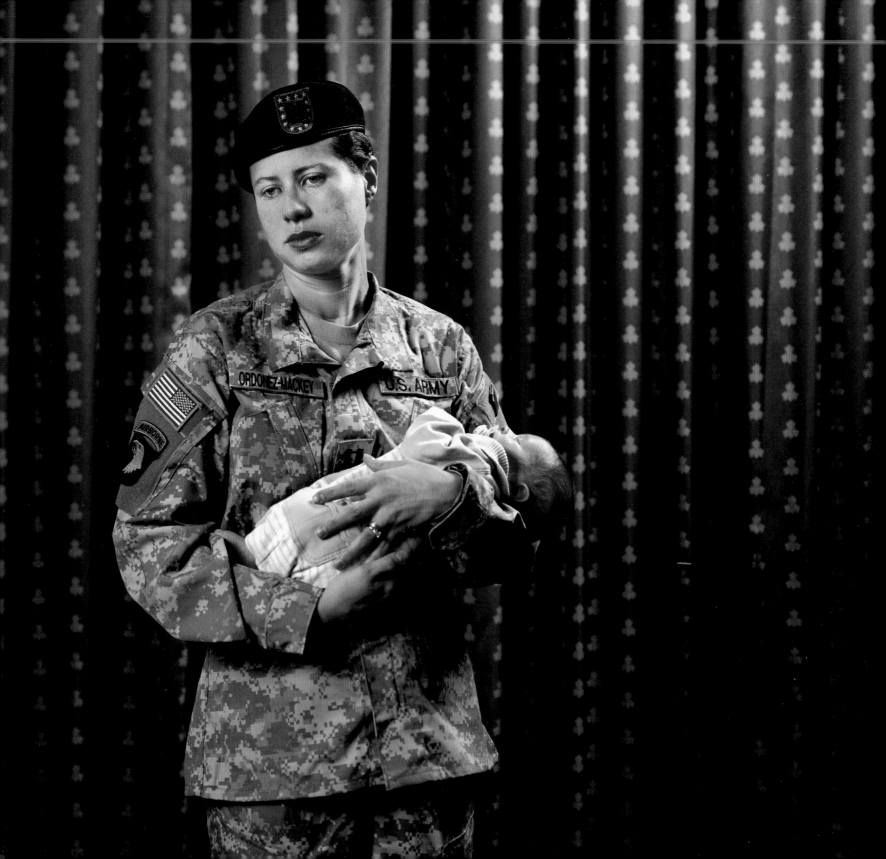

PORTRAITS OF WOMEN COMBAT VETERANS

When Janey
Comes Marching Home

LAURA BROWDER

Photographs by SASCHA PFLAEGING

THE UNIVERSITY OF NORTH CAROLINA PRESS Chapel Hill

© 2010 THE UNIVERSITY OF NORTH CAROLINA PRESS

All rights reserved

Designed and set by Kimberly Bryant in Miller and Gotham types.

Manufactured in Singapore

The paper in this book meets the guidelines for permanence and durability of the Committee on Production Guidelines for Book Longevity of the Council on Library Resources. The University of North Carolina Press has been a member of the Green Press Initiative since 2003.

Library of Congress Cataloging-in-Publication Data

When Janey comes marching home : portraits of women combat veterans / [collected by] Laura Browder ; photographs by Sascha Pflaeging.

 p. cm.

Includes bibliographical references and index.

ISBN 978-0-8078-3380-3 (cloth : alk. paper)

1. Women veterans—United States—Biography. 2. Women veterans—United States—Pictorial works. 3. United States—Armed Forces—Women—Biography. 4. United States—Armed Forces—Women—Pictorial works. 5. Iraq War, 2003—Women—United States—Biography. 6. Afghan War, 2001—Women—United States—Biography. 7. Iraq War, 2003—Personal narratives, American. 8. Afghan War, 2003—Personal narratives, American. 9. Women and war—United States. I. Browder, Laura, 1963– II. Pflaeging, Sascha.

U52.W475 2010

956.7044′34092273—dc22 2009039271

Portions of this book originally appeared in the *Virginia Quarterly Review*.

14 13 12 11 10 5 4 3 2 1

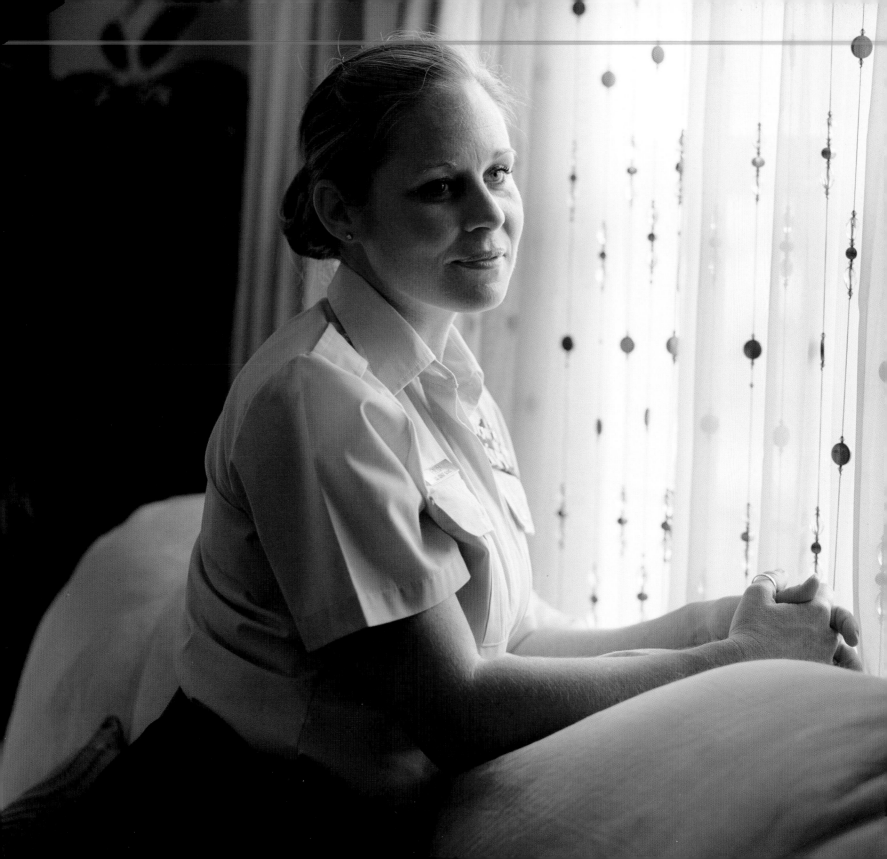

Contents

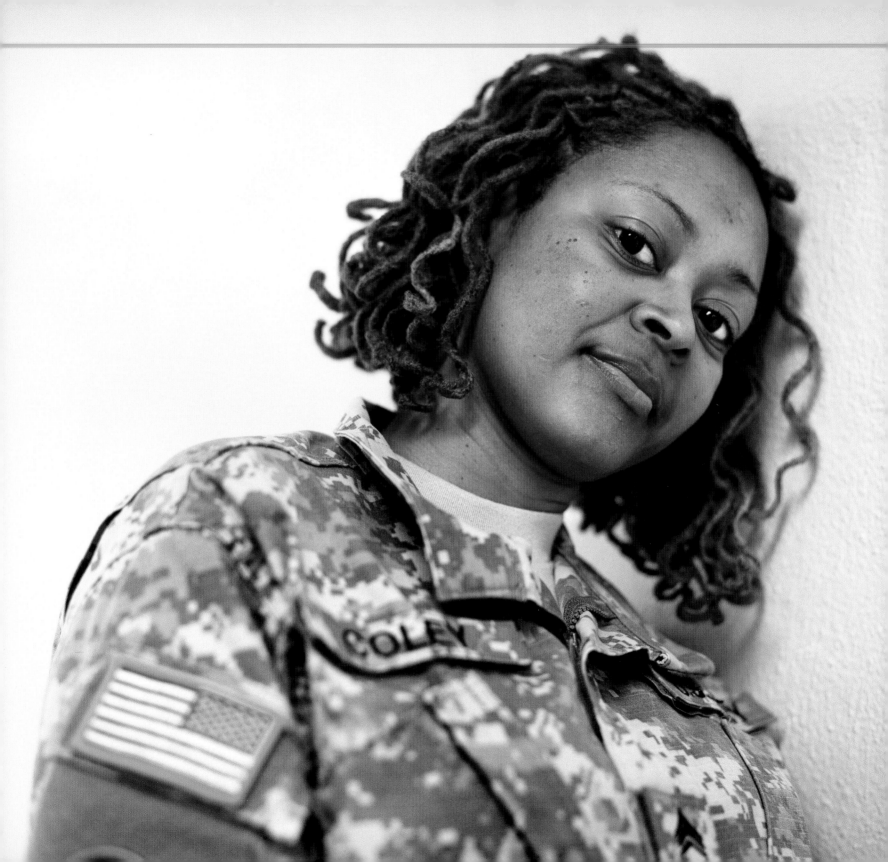

When Janey Comes Marching Home

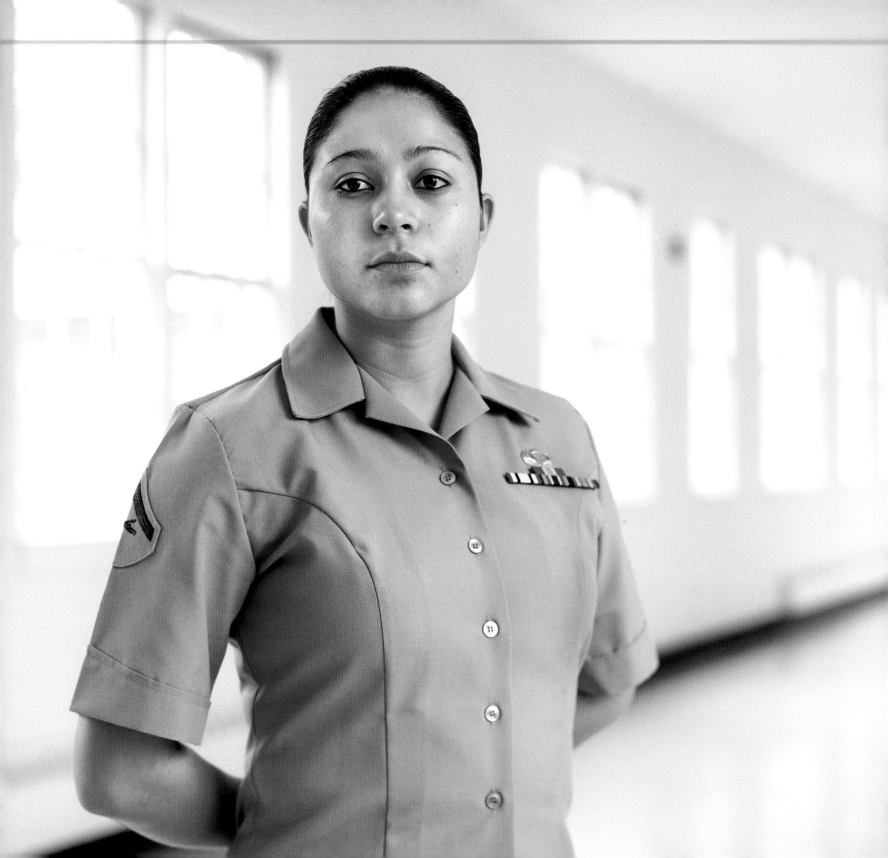

Introduction

The first time I heard a woman describe her deployment in glowing terms, I was taken aback. Marine Colonel Jenny Holbert told me that being in charge of public affairs for the second battle of Fallujah was "probably one of the biggest events of my life, other than birthing two children." I thought, cynically, that this enthusiasm was all part of her role as a public affairs officer. It took me a while to understand how compelling the experience of being in a combat zone could be for the women I talked with.

Colonel Holbert's enthusiasm for deployment was only one of many surprises I encountered over the course of the fifty-two interviews I did with women soldiers, sailors, coasties, airmen, and marines across the eastern seaboard. Originally, photographer Sascha Pflaeging and I had conceived of our collaboration as a way of hearing the stories and showing the faces of some of the first large cohort of women—over 221,000 as of this writing[1]—who had served in the American military in Iraq, Afghanistan, and surrounding regions.

This is a far greater number than have served in any previous war in which the American military was deployed. Although a handful of women served in the Revolutionary and Civil Wars, they had to cross-dress to do so. The 35,000 women deployed in War World I worked mainly as telephone operators and in other positions far from the front lines. Although almost 400,000 served in World War II, mostly in the Army and Navy Auxiliary Corps (WAC and WAVES), these women were barred from wielding weapons. The 7,500 women who were deployed in the Vietnam War served primarily as nurses.

However, the changes in the American military over the last several decades, including the end of the draft in 1973 and the beginning of the all-volunteer force, have dramatically in-

creased both the number of women assigned to combat zones and their roles there. The Coast Guard Academy enrolled its first cohort of women in 1975, and the other service academies followed suit the following year. In 1993, Secretary of Defense Les Aspin directed the armed services to open up combat aviation jobs for women, and directed the navy to draft legislation repealing the combat ship exclusion. The following year, the Department of Defense Risk Rule, which closed many combat support positions to women, was rescinded, and 32,700 army positions and 48,000 Marine Corps positions were subsequently opened to women.[2]

The current wars are providing a vastly larger number of women than ever before with the opportunity and the obligation to serve in combat zones. Before 1973, women made up less than 2 percent of the U.S. military. According to the U.S. Census, the U.S. military is now 14 percent female.[3] There are 1.8 million women veterans of the armed services,[4] and over 200,000 active duty service members, with an additional 150,000 in the reserves and National Guard.[5] The percentage of women varies by service branch: while women constitute 19.6 percent of the air force and 14.9 percent of the navy, the marines are only 6 percent female.[6] Yet in the reserves, the numbers are much higher: overall, women make up 24.1 percent of the reserves and 31.3 percent of the army reserves. Reservists have been deployed in large numbers, and as of this writing, 121 women have died serving in Iraq and Afghanistan.[7]

This project first took the form of a gallery exhibition. Ashley Kistler, the curator of our show at the Visual Arts Center of Richmond, encouraged us to think expansively about our work. We planned on creating forty large-scale color photographic prints, each paired with a narrative panel in the portrait subject's own words. Sascha's photographs, we thought, would be a means of exploring a new genre of war photography. Although soldiers have long been the subjects of documentary photographs, it is rare that the public has seen images of women who have experienced combat. War photography has traditionally focused on men as heroes and aggressors and on women and children as victims. Photographs of wounded soldiers who are mothers could have the power to unsettle our fixed ideas about Americans at war, and their narratives could add dimension to the often flawed or fragmentary representations of women soldiers in popular culture: they too often appear as novelties, not as real soldiers.

From a civilian perspective, the Iraq War would seem to be a horrific experience, with its improvised explosive devices (IEDs), long deployments, and resulting high incidence of post-traumatic stress disorder (PTSD). (Bill Nash, a marine psychiatrist I spoke with, said that the military was anticipating higher rates of PTSD than came out of the Vietnam War.)

The experience of being taken away from loved ones for up to fifteen months at a time must have been nearly unendurable for many who served. And surely there were some members of the military who did not believe that this was a war we should have been fighting. How then could they return to Iraq or Afghanistan for deployment after deployment? For women soldiers, we might imagine such deployments as particularly difficult, especially given the recent studies citing the high incidence of rape and sexual harassment in the military. These were our thoughts and expectations going into the project. We did not yet know how the women we interviewed would see their own experience.

There were a few common themes that emerged in all of the interviews I did, though predictably, the soldiers' responses were as varied as the women themselves. One issue that came up repeatedly was motherhood. Police Captain Odetta Johnson, an army reservist, still regretted that she had had to cut her deployment a month or two short in order to return to her young son, who was facing surgery. She described her family's pressure on her to come back and her disappointment at letting down the members of her unit. As Marine Sergeant Jocelyn Proano said, "You want to be a marine, and you can't be a mom all the time." Sergeant Proano, who joined the military after being expelled from high school, talked about getting her deployment orders when her daughter had just turned one: "That was the worst ever— to leave my kid and everything." Yet she found her feelings for her daughter were in conflict with her military training: "The mommy mentality left me as soon as we got on that bus and started flying to Cherry Point." Proano ended up extending her six-month deployment so that she would not have to leave her unit. Single mother Lieutenant Colonel Willa Townes, U.S. Army Reserve, now retired, was deployed when her son was four. She had the choice of not going, because she had no family member who could take the child. But she was determined to serve in Iraq and finally got her son's daycare provider to board him for the year, to her great relief.

Our societal expectation that motherhood should be the overwhelming force in every woman's life was not shared by every woman I interviewed. While we have learned (perhaps through watching countless war movies) that the bonds forged between male comrades during war are stronger than those of family, it may be a surprise to learn that this is true for many women as well.

Not all women I talked to celebrated this shift in importance from family to unit. Many women were disturbed by the way their deployments had attenuated the bonds they had with their children. Army Staff Sergeant Connica McFadden was deployed with her husband when her baby, whom she was breast-feeding, was six months old. She returned a year later

to find that her daughter did not recognize her or her husband and cried when left alone with them. It took two months before their little girl would come home with them. Yet even as military life made motherhood difficult, motherhood was the reason many women gave for joining the armed services. Several women I interviewed had children with serious health problems. For them, joining the military was a way of getting good health insurance.

The issue of motherhood for deployed women was more complex than even these stories suggest, however, for women's bodies offer them a way out of deployment that men lack: pregnancy. During the first Gulf War, conservative commentators pointed disapprovingly to women soldiers who became pregnant while deployed as evidence that women should not be serving in the military.[8] Army Sergeant Erica Crawley told me that when she was doing pre-deployment processing of soldiers on their way to Iraq, many simply did not show up—and many women became pregnant to get out of deploying. And Dr. Lori Sweeney, a retired major in the army, said that when she was serving in Iraq, she saw women get pregnant in order to cut their deployments short. Since the military prevents doctors from prescribing birth control (a rule Dr. Sweeney ignored), it is likely that not all of these pregnancies were deliberate. As Sweeney said, "When soldiers [became] pregnant and it occurred during deployment, [it was] actually punishable—a military punishable infraction, if you will, because there was no sex in theater when I was deployed—no alcohol and no sex. I gave oral contraception. I had no moral issue with doing that. I knew that sex was going to occur in theater, and I had condoms in a basket in the clinic. I just set them out and didn't ask any questions. They were right by the door. You could grab them as you were walking out."

Pregnancy and the larger issue of women's sexuality have for centuries been linked to the debate over women's suitability for combat; and women's inability to engage in combat has been tied to their unsuitability for full citizenship. Historian Linda Kerber has traced the trajectory of this debate from the Spartan ideal of the warrior-citizen through the work of Machiavelli. As she points out, American revolutionaries of the eighteenth century admired the political theories of the English writer James Burgh, who described the "possession of arms [as] the distinction between a freeman and a slave." Kerber writes that in the early American republic the "connection between the republic and male patriots—who could enlist—was immediate. The connection between the republic and women—however patriotic they might feel themselves to be—was not."[9] Women were considered physically and mentally unsuited for combat and thus for the obligations and rights of full citizenship. Military service was at the heart of arguments for women's disenfranchisement, for during times of war men's valor and strength and their service to the nation were given special importance.

Both feminists and antifeminists in the years leading up to the Civil War saw military

service as the ultimate outcome of the women's rights movement—and as the ultimate test of women's patriotism. Women's rights advocates of the 1840s pointed to Revolutionary War soldiers such as Deborah Samson as proof that women were capable of martial valor and thus should gain access to the full privileges of citizenship. Both sides recognized the female soldier as one of the most charged symbols in a republican ideology that stressed male valor as the basis for citizenship.

Even before the Revolutionary Era, images of female soldiers suggested a sexual ambiguity and aggressiveness that seems incompatible with traditional gender roles. At the turn of the seventeenth century, ballads featuring female warriors first appeared in Britain, where—distributed in the form of broadsides—they became wildly popular. American editions of the broadsides soon appeared. Many of these soldier heroines cross-dressed and ran off to war to join their lovers; their imposture was detected when they became pregnant. A spate of American narratives published in the first half of the nineteenth century laid much more emphasis on thrilling situations than on patriotic sentiment. Like the "breeches roles" popular on the nineteenth-century stage, in which women cross-dressed to play male roles, fictional representations of the female soldier in the first half of the nineteenth century seemed designed to titillate audiences even as they purported to teach moral lessons.[10] The creation of male authors, these ostensibly autobiographical accounts of female soldiers highlighted the romantic and sexual aspects of their impostures. The focus of these narratives was often the delight their heroines took in the act of cross-dressing; one would be hard pressed to find much patriotic sentiment evinced by these protagonists.

Actual female soldiers had to fight against these fantasies to gain acceptance. The women who cross-dressed as soldiers in the Civil War and then published memoirs about their experiences had to portray themselves as almost ludicrously respectable and committed to upholding traditional gender roles if they were to succeed in reaching a wide audience.

Belle Boyd, the most famous female Confederate spy, described her first killing of a Yankee soldier as a way of protecting the honor of southern women. She recounts her first assault on a Yankee soldier who attempts to bring a federal flag into her home and who responds to her mother's protests with insults: "I could stand it no longer; my indignation was roused beyond control; my blood was literally boiling in my veins; I drew out my pistol and shot him. He was carried away mortally wounded, and soon after expired."[11] Boyd's ladylike self-depiction ensured the success of her 1865 memoir, which later formed the basis for her dramatic monologue "Perils of a Spy." Although Boyd attracted a great deal of negative as well as positive publicity, she was able to continue her theater tour, presenting "Memories of the War" until her death fourteen years later.[12]

Sarah Edmonds, author of a best-selling memoir about her service in the Union army, not only omitted mention of her years of cross-dressing before the onset of the war, but also barely alluded to her soldierly disguise, burying those references beneath a welter of patriotic and Christian language.[13]

Boyd's and Edmonds's books sold well. But when Loreta Velazquez, the Confederate author of *The Woman in Battle*, described the pleasure it gave her to cross-dress and to out-fight, out-love, and out-swagger the male soldiers with whom she fought, commentators denounced her, charging that she had besmirched southern womanhood. Her memoir, which purported to tell the story of her years fighting as a Confederate soldier and spy, appeared in 1876 to critical obloquy. Velazquez found her work reviled for its critique of American manhood. Perhaps this was because of the many passages in which she describes how much more successful she was than her comrades in arms—both in battle and in romance. The woman in battle whom Velazquez describes was a reproach to male soldiers for their lack of presumably masculine qualities like courage and ambition. Velazquez takes no trouble to present herself as either virtuous or victimized: she coolly describes the way she successfully plotted to steal a schoolmate's lover and avoid a marriage her parents had arranged for her. Moreover, her love of warfare only grows as she gains experience on the battlefield: "The skirmishes in which I had thus far been engaged only seemed to whet my appetite for fighting."[14]

The caricature of the female soldier as a sex-crazed thrill-seeker continued to afflict twentieth-century women soldiers. In the forties, it appeared in the form of a cartoon of a World War II WAC inside a tank, training its gun on her male comrade in order to get him to go out on a date. Soft-core porn posters and videos that feature busty women in skimpy camo bikinis and wielding assault weapons have been hot sellers since the 1980s. During the closing weeks of his 2006 campaign, U.S. Senate candidate James Webb of Virginia was dogged by his 1979 charge that a Naval Academy dorm was "a horny woman's dream." Of course, these sexy images are predicated on the notion that women are not real soldiers, since they are barred from combat (more specifically, from assignments to units below the brigade level whose primary mission is direct ground combat).[15]

Today, American women in the military still have to struggle against stereotypes that they are either masculine or sexually out of control when they join the armed forces. As former army sergeant Kayla Williams wrote in her recent Iraq combat memoir, women soldiers get to choose between being seen as either "sluts" or "bitches." She framed her own memoir as an attempt to educate the American public about the reality of the woman soldier because "no one has ever written that book—about what life is like for the 15 percent." Williams admonishes the reader, "Don't count Jessica Lynch. Her story meant nothing to us. The same goes

for Lynndie England. I'm not either of them, and neither are any of the real women I know in the service."[16]

Jessica Lynch, who was injured and captured by Iraqi forces in 2003, became famous when she was liberated by U.S. special operations forces in a highly publicized incident. Her staged rescue was described by Iraqi doctors as "like a Hollywood film. [The U.S. forces] cried 'go, go, go,' with guns and blanks without bullets, blanks and the sound of explosions. . . . They made a show for the American attack on the hospital—[like] action movies [starring] Sylvester Stallone or Jackie Chan."[17] Lynch herself denounced the U.S. government for making her a symbol after news reports revealed that her injuries resulted from an auto accident rather than from torture. She and her Iraqi doctors angrily rejected the allegation of her official biographer, Rick Bragg, that she had been the victim of anal rape. But the government's portrayal of Lynch as a victim of sexual assault seemed to reinforce old stereotypes that women soldiers could not competently serve because their physical and sexual weakness made them especially vulnerable. As Bragg, the author of *I Am a Soldier, Too: The Jessica Lynch Story*, wrote, "Everyone knew what Saddam's soldiers did to women captives."[18]

By contrast, the images of U.S. soldier Lynndie England—grinning as she holds a leashed Iraqi prisoner, playfully pointing her fingers like guns at the genitals of naked Iraqi soldiers— suggest another stereotype. England, who also had herself photographed having sex with a member of her unit, embodies a nightmare version of the female soldier: violent, sexually out of control, and amoral. The shocking images of her with a leashed prisoner at Abu Ghraib prison have continued to reverberate in the United States and internationally. In Iraq, as *Washington Post* reporter Jackie Spinner noted in her recent memoir, many people see England as the embodiment of degenerate American womanhood.[19]

Today, American women in the military still have to struggle against stereotypes that they are either masculine or sexually out of control when they join the armed forces. Although Kayla Williams tried to move beyond these stereotypes, her book, in which she presents herself as a competent soldier but does not downplay the sexism she faced from her male comrades, drew the ire of conservative critics. Commentator Kathleen Parker, for instance, saw Williams's memoir as evidence of why women should be barred from combat roles. Parker suggested "her truth-telling about the relationships between men and women . . . may be the best argument yet for keeping men and women apart as much as possible." Ultimately, "equal corruptibility and incompetence are weak arguments to advance Williams' view that our nation is well served by mixing men and women in combat where the imminent possibility of death apparently brings out the basest instincts in both."[20]

These stereotypes of sexually loose female troops sometimes come in the form of urban

legends. After one of my first interviews, a veteran of the first Gulf War, who is now a civilian employee of the army, described the adultery in her unit in Iraq: "Of course, it's not like what goes on today with all those women soldiers prostituting themselves over there." In previous wars, like the one in Vietnam, she said, there was a great deal of prostitution by local women; she claimed that in Iraq, female soldiers and marines were augmenting their meager paychecks by taking over this business. Several women I talked to said that they had heard rumors that this was true, but as one interviewee, Sergeant Proano, finally said, "Yeah, when I was over there, I heard rumors about some lieutenant with a sea bag full of cash from making booty calls. But you know, I think it's just another way to trash women in the military."

The kind of trashing that Sergeant Proano talked about took many forms. Women talked about rape and sexual harassment, but often in a roundabout way. Army National Guard Sergeant Shyra Jones complained about the curfews at Camp Virginia, where she was stationed in Kuwait, but acknowledged the reason for them: the threat of rape on her base. Army Staff Sergeant Chanda Jackson debated whether the threat of rape was greater from the Afghans and third-country nationals on her base or from her fellow GIs. Once in a while a woman would tell me, halfway through her interview, that she had stayed up late the night before, debating whether or not to tell the truth before deciding to share her story of harassment. When I asked Army Staff Sergeant Shawntel Lotson to describe one good leadership experience and one that was not so good, she told of a CO who made a woman apologize to a superior officer for having lodged a complaint that he had inappropriately touched her. On the other hand, she told me about another EEO officer for whom she had great respect, someone who punished abusers—and who was burned alive when the vehicle he was traveling in was mortared.

Clearly, many women faced extreme difficulties during their deployments. And some did not believe that they should have been deployed in the first place—not to this particular war. In the end, though, the bonds they felt with members of their units seemed to trump ideology. Ensign Colleen Fagan had left the navy when I interviewed her. However, even though she did not believe in the war, she wanted to reenlist and deploy again: "I wouldn't be going back there for politicians who are running the war, the taxpayers who are funding the war, the people who control the White House and all of its everyday functions with the war; I would honestly be going back there for the troops. They need the support, and I would be going there to help them." Fagan, who left after several years in the navy as an enlisted sailor, recently completed officer candidate school in Newport, Rhode Island.

In fact, the issue of "supporting the troops" turned out to be an important piece of code. Since criticizing the commander in chief violates the military code of conduct, publicly ques-

tioning the mission was way off limits. So it was interesting to me how many times, at the end of an interview, a woman would spontaneously say, "It's impossible to support the troops without supporting the war" or "You know, you can support the troops even if you don't believe in the war."

Because I was interviewing active-duty military personnel, there were other issues I could not raise. Although more than once a woman's girlfriend was present during the interview or joined us for lunch afterward, I could not bring up any "don't ask, don't tell" questions. It would have been fascinating to ask how life had changed over the years for a lesbian who had been in the military for more than two decades, but those were questions that could jeopardize a woman's career.

There are clear advantages and disadvantages to interviewing active-duty military personnel. According to the regulations, a public affairs officer is supposed to sit in on the interview. This happened at only one base. Most of the time I was able to interview women alone, and even at Fort Lee, Jamie Carson, the PAO who initially escorted me around, was sympathetic to my desire to get a range of responses. She explained that commissioned officers are trained not to say anything interesting to any representative of the media. When I interviewed a woman who was not only a commissioned officer but also a JAG lawyer, I was finally provoked to ask her what she thought about Abu Ghraib; she gave a predictably bland response. Jamie told me afterward that she was surprised I hadn't goaded her more. I finally asked another young public affairs officer there if she might sit farther back from the table where I was conducting the interview, as it was distracting the soldier. "Oh, I know what I am not supposed to talk about," the soldier said cheerfully. Although I got many great interviews at Fort Lee, a number of them ended with a stock recitation of how wonderful it was to be fighting for freedom.

On the other hand, a public affairs officer at another base had herself faced harassment from her CO and had been busted down in rank during her deployment. She set up a series of remarkable interviews for me with women who had very tough stories to tell.

When we began working on this project, I envisioned interviewing both pro-war and antiwar combat vets. When the Virginia Foundation for the Humanities gave us the first of three grants, they insisted on reassurance that this would be a project that took no position on the war—that it was not just an antiwar project. Interestingly, nobody who was actually in the military thought that this was an antiwar project—quite the contrary. One public affairs officer suggested that our exhibition would be a great place for recruiters to bring prospects—an idea that took me aback. I used letters of introduction to approach leaders and members of antiwar veterans groups, handed out my card at rallies, and got nowhere. After doing fifty-

two interviews, I have come to believe that "pro-war" and "antiwar" are not always relevant categories.

It was clear when we went to interview Army Sergeant First Class Kim Dionne in Maine that she was, at best, ambivalent about the war. When we drove up in our SUV, the only vehicle left at the rental agency following a much-delayed flight, she cracked, "So that's why we're fighting this war." Yet she spent a year flying from one forward operating base (FOB) to another in Iraq and Afghanistan, signing up soldiers for additional tours of duty. How could she be a reenlistment recruiter for a war that she did not seem to believe in?

The answer, it seemed, lay in compartmentalization. Colleen Fagan told me that she thought the reason many soldiers, sailors, and marines did not vote was because thinking about politics made it harder to focus on the mission. Retired army major Dr. Lori Sweeney maintained that her opinions about the war would shift from one extreme to the other during any given day of her deployment, but that she, like so many other women I spoke with, was bolstered by her relationships with other members of her unit. Even Sergeant First Class Gwendolyn-Lorene Lawrence, who had endured not only abuse at the hands of a superior officer, but also a grueling two-year battle to reverse the disciplinary action she faced, found her strength in army values—the ones that are printed on posters you can see on any base: loyalty, duty, respect, selfless service, honor, integrity, and personal courage. As Sergeant Lawrence reminded me, these were the values she had before joining the army—and the values that sustained her in her long fight to win back her rank and benefits.

In the end, what seems most impressive about the women I interviewed was their capacity for survival: the means they had for balancing their family lives and their military lives and the complex ways they found to keep on going after seeing and experiencing horrific things. A psychologist friend of mine who works with veterans describes going through war as an all-encompassing experience—one that is transformative, life-defining, difficult to leave behind, and almost impossible to understand for someone who is not part of the same cohort. In today's all-volunteer military, the kinship felt among those who have deployed is magnified by the ways in which the military, as a culture, really is very separate from the rest of the United States. Sascha and I hope that by coming face to face with women who have deployed, those of us who are outside that culture can begin to get a real sense of how women soldiers are experiencing this long war and how their stories may ripple out and affect the experience of all American women.

Why I Joined

In 2006, at a point when more than 70 percent of the troops due to be deployed in Iraq the next year were returning for their third time, a study commissioned by the Pentagon found that the U.S. military was "stretched to the breaking point."[1] Perhaps in response to this, the Marine Corps embarked on a highly publicized campaign in early 2008 to recruit women. As the *New York Times* noted, "Faced with the difficulty of recruiting during a long and unpopular war, the United States Marine Corps has started marketing itself to women in a concerted way for the first time."[2] And Judith Matteson, director of the U.S. Army Women's Museum at Fort Lee once told me, the military never changes its attitude toward women because it wants to—only because it has to. When there is a need, she said, women are accepted.

Women join the military for many reasons, including the desire for adventure and a strong sense of patriotism. This is especially true of those who joined after 9/11, knowing that they would probably be deployed to a war zone sooner or later. Many women I talked to enlisted for very pragmatic reasons, be it because the military presented the best alternative to flipping burgers or, for the reservists and guardsmen especially, because it offered a way to get college money. For mothers, especially single mothers and those whose kids had major health problems, the military offered health insurance and security.

Master Sergeant Odetta Johnson, U.S. Army

I joined the military in 1987. I graduated from high school in 1986 and we were talking in a government class—do we ever believe that they were going to reinitiate the draft? It was an interesting, heated conversation, and for some reason it became gender-split and the males said, "Well, don't worry, we'll take care of the country. That will be our part to do." And I said, "It is open for everyone." And I decided that this would be my piece.

Sergeant Katharine Broome, Virginia Army National Guard

I grew up in a single-parent household. I have a twin sister and an older brother, and my mother is not a college graduate. She had to work very hard to make sure that we had food on the table and that we had clothes to wear to school, and so when we graduated from high school it became blaringly obvious that if we wanted to go to college we were going to have to come up with a way to do it ourselves. I ended up dropping out of that first semester of college. There were too many parties to go to and class was just not important to me, so I ended up dropping out. There was a recruiting office in the strip mall where I was working and I figured out that I didn't want to end up working in the strip mall for the rest of my life. The recruiters told me about the GI Bill and I figured this is going to be how I'm going to be able to pay for my college education. It was the Clinton administration; it was a peace-time army. I joined not ever thinking that anything would ever happen to the United States, and I joined, as horrible as it sounds, for the college money.

First Sergeant Shirley Wright, U.S. Army

I grew up in a poor family, and we moved around quite a bit. We ended up in a small town in Colorado, where I graduated high school. I basically just wanted to do more for myself: getting married and living in a small town wasn't exactly my cup of tea. I think I was a little more open-minded in wanting to see more of the world and experience more things, so I decided that for me to grow on my own and become more independent, the military would be something that I would like to try. A lot of women, they come up thinking that they have to have a man to take care of everything, but I just had a different attitude.

Staff Sergeant Phyllis Magee-Lindsey, U.S. Army

I got a master's at Jackson State in History. And then, when I was in my first year of my master's, I found out about an archive, museum, and editing program at Duquesne University of Pittsburgh, so I went there and did that program, and I came out and my first job was at the National Archives. I did archival work for about two-and-a-half years. I left there, and I was

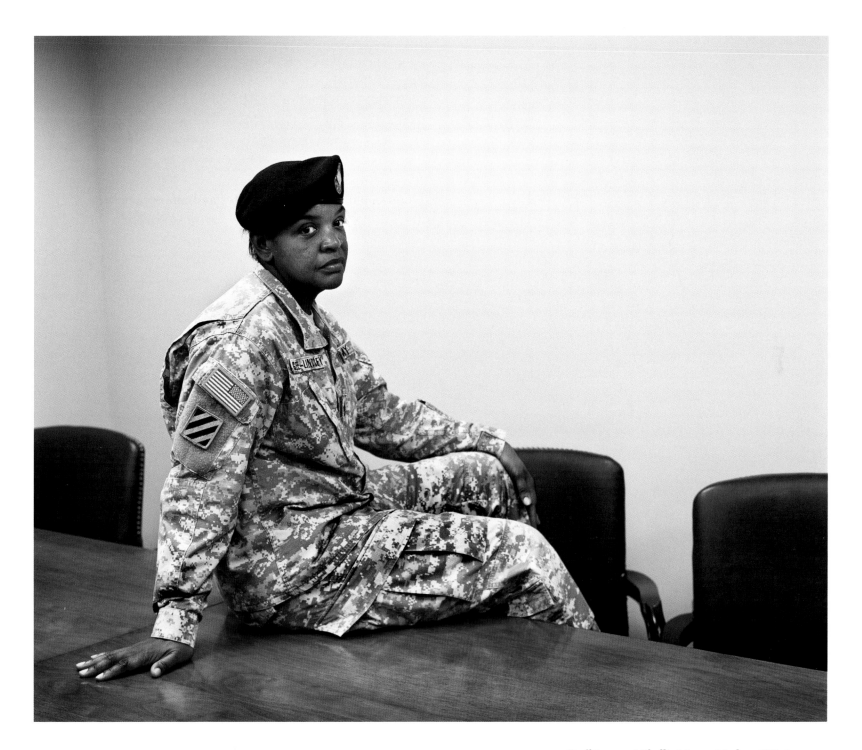

Staff Sergeant Phyllis Magee-Lindsey, U.S. Army

a records manager for the South Carolina Department of Archival History. I got married, and moved back to New Orleans, and I worked part-time at a university for about a year, and during that year I had gotten pregnant with my second son. I said, "Hey I've got to find another job," because my baby was born pigeon-toed. I was paying $300 for insurance and on a part-time job, I just couldn't afford, so I said, "You know, there's gotta be something else that I can do." So, I went down and talked to a recruiter, and he was like, "Yeah, we can get you in," and he was like, "What do you want to do?" I had worked on the inside all of my life, doggone eight years of college, and it was like, "Oh, I just want to do something different." He said, "Okay." I said, "As long as it doesn't involve driving, 'cause I'm a terrible driver." He told me about petroleum supply specialist, and I was like, "Will I have to drive?" He said, "Oh no, it's not going to entail too much driving." That recruiter—I wish I could find him today.

So I came in basic training a week before I turned thirty-five. On my thirty-fifth birthday, I did my one push-up, so that I could move on to actually be trained at Fort Jackson, South Carolina. The whole time I was there, I was older than everybody in the whole company— maybe in the whole army at that time, at least it felt that way to me because they would call me "Grandma Lindsey." And through all the training that we did, I was so afraid that I would have to do it again that I would do it right the first time. Just being away from my kids I wanted to quit, but I just couldn't quit. Almost twelve years and still here—trying not to quit.

Captain Carla Campbell, U.S. Army

I'm from a small island in the Caribbean called Grenada. I have six brothers, two sisters—I'm the baby. I grew up in a pretty Catholic home, a pretty traditional family. Back in '83, they had an invasion in Grenada and that was when I was about six years old. I came in contact with soldiers—I saw them jumping in. And then I got to ride in a helicopter. Ever since I was six years old, I always told my mom that I was going to join the army. Of course, she wanted me to be a doctor or a lawyer, something like that. But when I turned eighteen, I was like, "Okay, I'm going in the army now."

I'm the only one that actually joined. My mom was in the military in Grenada, the PRA [People's Revolutionary Army]. And my family was a little bit involved in politics while in Grenada, so it wasn't something I was totally not familiar with, but I am the only one that has actually donned the American uniform.

Airman Victoria Hager, U.S. Coast Guard

My whole life, my mom has been on me—not in a bad way, in a good way. I graduated from high school. I went and did a little bit of college, and it's not so much that things didn't work out, it was just a hard time in my life. My mom sat me down, and at first I didn't even know the Coast Guard was a branch in the military. I was like, "No it's not. It's not anything." She just knew that there was a lot of opportunities with the Coast Guard, more so than any other service, and I wouldn't have to go into the heart of the war. So I went and talked to the recruiter for Coast Guard, and he pretty much sold it to me. I love working. I love doing things. I don't like sitting in the office. I was like, "I can do this, get paid for it and help people—well, that's perfect." I enlisted, and it was hard for me at first.

Master Sergeant Lisa Whipple, U.S. Air Force

I was a tomboy from a very young age, trying to keep up with the boys. I was always into adventure, got into lots of trouble growing up. When I was a junior in high school, Desert Storm was going on. I remember listening to the radio at night in my room and thinking how brave those people were over there. It sounded so cool to me. I realized that those were the people that were making our country great at that time, and I wanted to be able to do that. That's what eventually led me to join the military.

Sergeant Mikeishia Kennedy, Virginia Army National Guard

My father was in the army for twenty-three years, so I was a military brat and used to that lifestyle, and I wanted to be like my dad. He's one of my role models. I joined the military after 9/11.

Sergeant Major Andrea Farmer, U.S. Army

I grew up in New Jersey, in the inner city. It was poverty stricken, but I came from a family that had strong morals and strong family values, a very religious family. My god brother was in the military. He was in the Vietnam era. And he would always come home in his uniform and I was quite fascinated. He was always coming home telling army stories, army jokes and how good his life in the military was. So that was my first inspiration. I decided in 1982 to enlist because I didn't want to go to college, so the future probably would have been working in the minimum wage job for a very long time with no room for growth. So my parents were very excited for me and they encouraged me to try to make a career in the military.

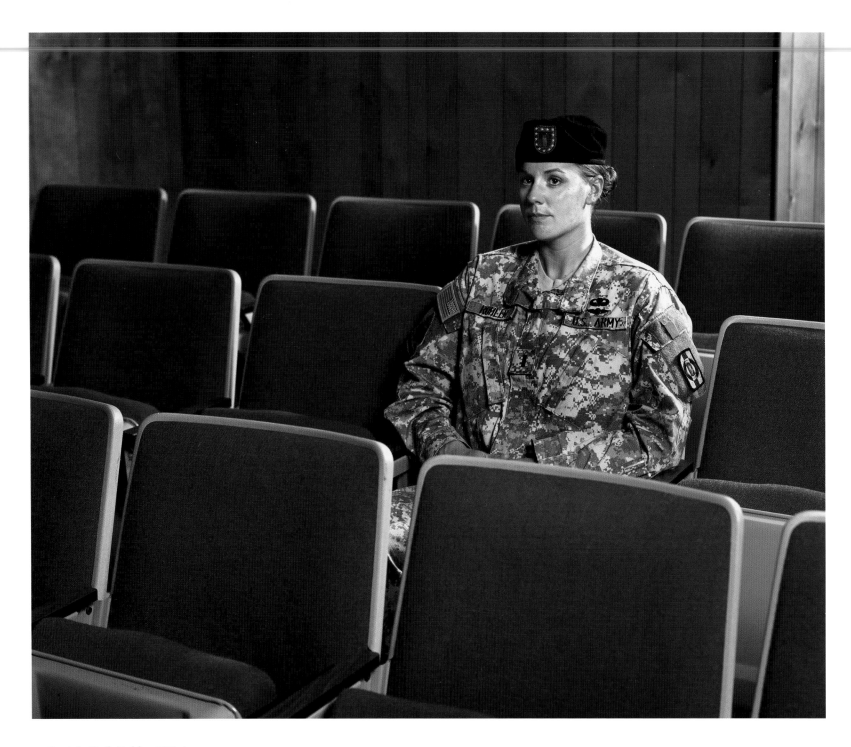

Captain Beth Rohler, U.S. Army

When I started college I wanted to do corporate fitness. In my freshman year I took this scholarship with ROTC and it kind of blew everything else out the window: this was going to be my career now.

That first quarter we got to fire M16s and go to the range and would crawl through the woods once a week, and I got college credit for it. It was just so much fun. I was a tomboy growing up always, and it was just a lot of fun. I'd always been in clubs and things like that when I was in high school and so I'm used to being in front of people and being a leader. President of this club, treasurer of that club. It was just something that I was comfortable with and used to.

I was a platoon leader when I went over there so I had fifty-two soldiers who I was truly responsible for. I'm just coming out of school, out of a great home life my entire life, great parents, great upbringing. So, I think for me it was a lot different than it was for someone who was a little more seasoned. Because I hadn't been past the reality of how people grow up. I didn't know that people lived the way that some of my soldiers had lived prior to being in Iraq. I can choose my friends at home, but these are my soldiers now.

There's a lot of stories that I would hear that normally I would just close my ears and walk on by. It's strange to me; it's upsetting to me. It makes me uncomfortable a lot of times. It's not something that I grew up around, not something I'm used to.

It's a struggle to this day, but no matter what, I've got to keep my head in the right place and not judge people. You know, I was that girl in high school who had the clique and who judged her and her and that's the geek table, but I can't be like that in the world that I'm in. So I have to step outside of that spoiled child that I always was and have compassion for the soldiers that I'm in charge of. You know, they're my responsibility and I have to make sure they are taken care of no matter whether I agree with their situation or not. I also have to say that you have to still be hard on soldiers; you have to still make the hard right. I don't necessarily want to put somebody out of the army who's having family trouble; but if they can't perform, if they can't deploy, if they can't go to Iraq, you still have to look out for the needs of the army. So, it's a very fine line to walk where you have to have compassion for a soldier but you also have to take care of the mission, take care of the army as well.

First Sergeant Jennifer Love, U.S. Army

I decided I wanted to join the military when I was in second grade. Some of my cousins and then my brother joined the military, but mostly it was from watching the commercials—the "Be All You Can Be" commercials. I wanted to really focus on making something of myself, and so I did.

Sergeant First Class Keisha Williams, U.S. Army

I grew up in Bennettsville, South Carolina. I'm the oldest of three kids. My mom was a single parent. I got caught up with the wrong crowd, and I ended up getting pregnant at fifteen, so I had my son. My mom was determined that I was going to graduate from high school the normal way. So I graduated on time in 1995, and my mom pretty much gave me a year to decide what I was going to do with myself. I finally decided that I would give the army a try. Originally, I thought I was only going to be in the army for my first enlistment. But as those three years approached, I decided that I would try to continue. So now I've been in the army for eleven years and hope to retire.

Sergeant Jocelyn Proano, U.S. Marine Corps

I grew up in New Jersey, in the ghetto. I was always getting in trouble, getting into fights. And so I got expelled from school.

My brother was the one who actually inspired me to join the military. He joined the army. His recruiter said they had a youth challenge program and you could get your GED, so I did army boot camp. And I loved it so much, living in a squad bay, going out PT-ing. It was just awesome, marching and all that. The army was pretty cool, and then I started hearing about the marines. All the movies—they're the most hardcore. I see that recruiter in dress blues, he looks good, so I chased the recruiter down. Once I turned seventeen, I called that office and said, "Hey—sign me up, what do I gotta do? Let's get going." And, my mom wasn't all right with it, but she supported me, at least I'm not out on the streets getting in trouble. I just wanted to get out, get some adventure, travel, go out to war, do the whole nine.

Earlier Wars

Although the current wars in Iraq and Afghanistan have involved the deployment of many more women than any previous war, American women have been serving in combat zones for decades. I did not interview any of the 7,500 Vietnam-era female veterans, most of whom served as nurses, but I did talk to women who had participated in the invasions of Panama and Honduras, women who were among the 41,000 women deployed during the first Gulf War, and women who had seen duty in Bosnia. All of the women I spoke with had entered the military in the post-Vietnam era, some in the first few years after women were admitted to the service academies.[1] Many of them had been deployed to several wars. Even in those earlier wars, the women who deployed to combat zones were not necessarily anomalies: Army Sergeant First Class Deidre Coley, who processed POWs during the first Gulf War, estimated her unit was 70 percent women.

Oh, God, when I joined boot camp, women were just being allowed to use rifles. We were still just running a mile and a half, and the guys were running three miles. I would talk to women who joined the Marine Corps the year prior, and they were still doing this little etiquette thing with their gloves out in town. There were a number of times early on when commanders were like, "I'm not taking you—you're a woman, and I have nothing but male marines. I don't even have facilities for you." I can remember going to Honduras—2,200 marines, and I was the only female. Everybody wanted to tiptoe around me. "You don't need to tiptoe around me," I'd say. "I can use a bush just like you can use a bush, and if you're not gonna shower, I don't need to shower either."

Captain Katherine Stryck, U.S. Army, Retired

I was a platoon leader in the first Gulf War, and our company was responsible for setting up a network communication—a tactical communication infrastructure. It was a very austere environment back then. They didn't have the PX and everything that they have down there today, or showers and bathroom facilities, so it was like the movies.

After five months of that, we finally went back into Kuwait just before we were gonna come back, and I saw a porcelain toilet. I was so happy because I hadn't seen one for five months. I thought, "This is not for me. This is just not the life that I want to live."

Thirty days prior to going over the border, we had to pop these pills every day. Well, I never took them because I knew that I wanted to have a baby, and I had no idea what this was going to do. The army is notorious for giving you things that haven't been tested appropriately. My commander said, "Make sure that everybody does this. You will line them up and watch them put these in their mouth." How am I supposed to do that if I'm not willing to take the pills myself? When someone said, "I don't want to take this," I said, "Well, then throw it over your shoulder. I don't care." Again, I disobeyed a direct order, but it was one of those things. I just thought it was really wrong and yes, okay, you're supposed to be government issue. That's what GI is, right: government issue. You no longer have control over yourself or your body.

I remember our division band was playing on the ridge when we were going over, and I thought, "What is this? This is so bizarre." Here we're gonna go and die, and there's this band playing up on the berm. I just remember that like yesterday. And then you can't hear the band anymore, and you're seeing the burning tanks to the right and to the left. That was pretty intense; you knew people were in there. You'd see buses in flames, and people literally hanging onto the steering wheels that had burned. You can see them screaming with their

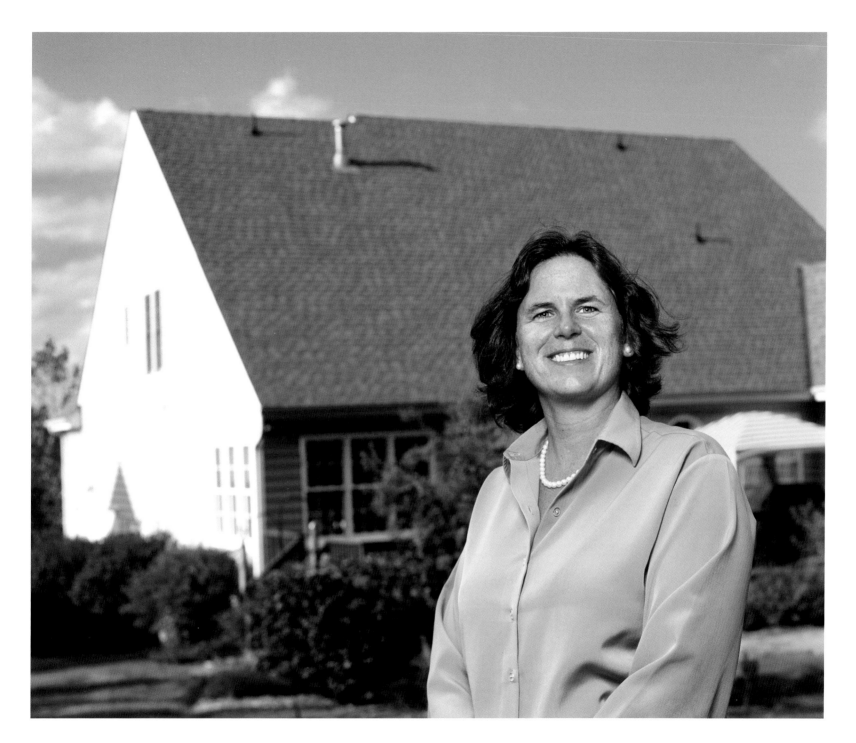

Captain Katherine Stryck, U.S. Army, Retired

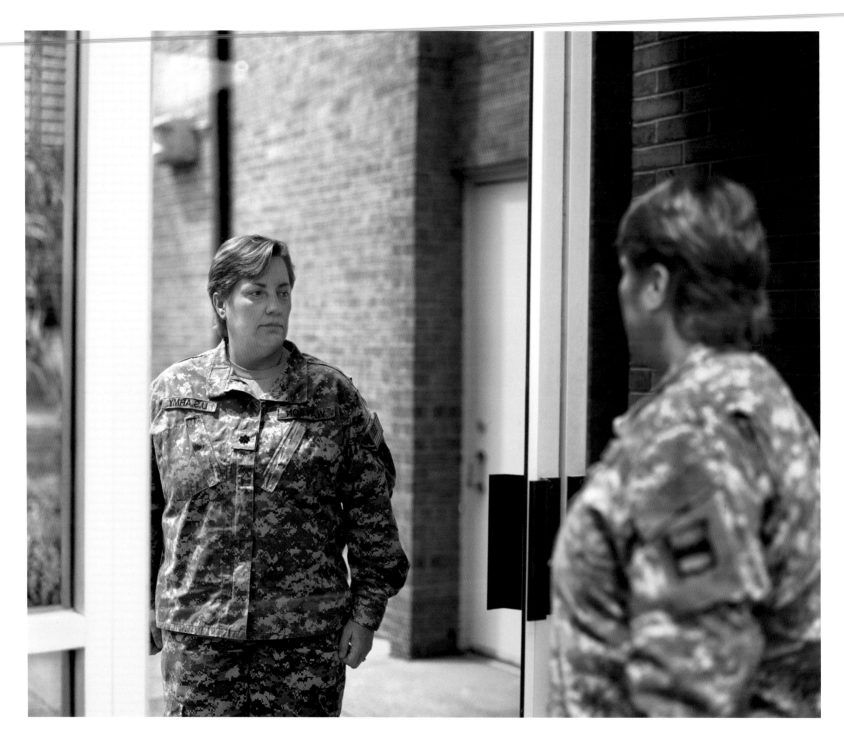

Lieutenant Colonel Colleen Watson, U.S. Army Reserve

mouths open, but they're dead. That was pretty traumatic. I understand that that's a reality, but it's not a place where I want to be for the rest of my life. I can't imagine the people who are down there right now.

Lieutenant Colonel Colleen Watson, U.S. Army Reserve

During the invasion of Panama, I was a platoon leader. We were attached to an infantry brigade, and our job was to secure check points and keep the roads open. It was scary and tough. We had prepared for this type of operation but never thought we'd actually implement it. It began at midnight, and my machine gunner was killed pretty quickly because we came under this barrage of fire from two sides. That really hurt morale because he was nineteen years old, a great soldier, and everybody loved him, but also just the fact that, wow, this can happen.

I remember being in awe of the damage that the American forces had done, trying to get to Noriega. My platoon had to do a lot of house-to-house searches, which was very scary because, okay, you find Noriega, but he's probably not going to be alone. The Panamanian MP station that I'd visited to count prisoners on prior duty was leveled. It's hard to put into words because it's a very beautiful area, and then just to see all the devastation . . . but that's what it took to capture Noriega.

Back then it was a big controversy: it's one thing to have women in the military, but now we have them in combat, and how is that going to be viewed by the American public? I always joked that I felt like a rock star when I got back because I was a female platoon leader and got a lot of attention. Reporters were literally fighting over who gets to me first; I really didn't like that. I understand they wanted to report, and I think it was important, but I had lost a soldier and was just so glad to be home. I didn't want to talk about it; I just wanted to see my family and get back on track. It really got to be overwhelming.

That was in January of 1990; then in September of that year, we went to Saudi Arabia in support of Desert Shield/Desert Storm. If you recall, there was actually a female who was taken hostage but later released. It again elevated the idea that women are in combat. Is the American public ready for this? Are we ready for women to come home in body bags? It's a mindset we're not used to, though I think we've come a long way since then. More women have died in Iraq, but a soldier's a soldier, and it's certainly not any more tragic when it's a woman.

I was in the Guard when I was deployed to the Gulf. My job over there was processing POWs. It wasn't so bad because of the fact that the POWs were giving themselves up very, very easily back then. And so it made processing them a lot easier. They were probably more afraid of us than we were of them. It was evident that it wasn't anything that they were prepared for. They really didn't give us any indication that they wanted to be where they were.

The baby in the group was seventeen when we deployed and, while we were over there, she turned eighteen. We really tried to stay on the positive side with everything that was going on, being away from family and kind of just leaning on each other. She was an inspiration. When I first met her, she was this out-of-control youngster; but once we deployed, I guess the environment made her calm down and grow up a little quicker. She was a very good person. Shortly after we fellowshipped over there, she gave her life to Christ, and a week later she was killed. We were all with her.

Our camp had run out of supplies, and so we loaded up a truck. We had a male driver who hadn't been in the country long enough to learn any of the language or be able to communicate. There were two-lane highways and no speed limits. Because the war was officially over, other soldiers were coming from Kuwait, traveling in the opposite direction. Another driver, who was carrying a tank, apparently fell asleep behind the wheel and came over into our lane. The tank almost took off the side of our truck and injured a lot of soldiers in the back. They were hollering and screaming, and it was very difficult to hear because of how loud the vehicles were on the road.

We pulled over, and the Saudi men who were standing there would not communicate with us because they don't communicate with women; and our driver didn't know the language well enough to tell them we needed a hospital. Everything just happened so fast; we couldn't react in enough time.

We did find a hospital, but because of internal injuries she didn't survive. So that took a toll; that was a real turning point for us. I guess, not really having family, we had to lean on each other. She was the youngest over there, and she lost her life. She's one of those stars in the sky that can never be forgotten. Her name was Pamela Gay, and she was from Essex County, Virginia.

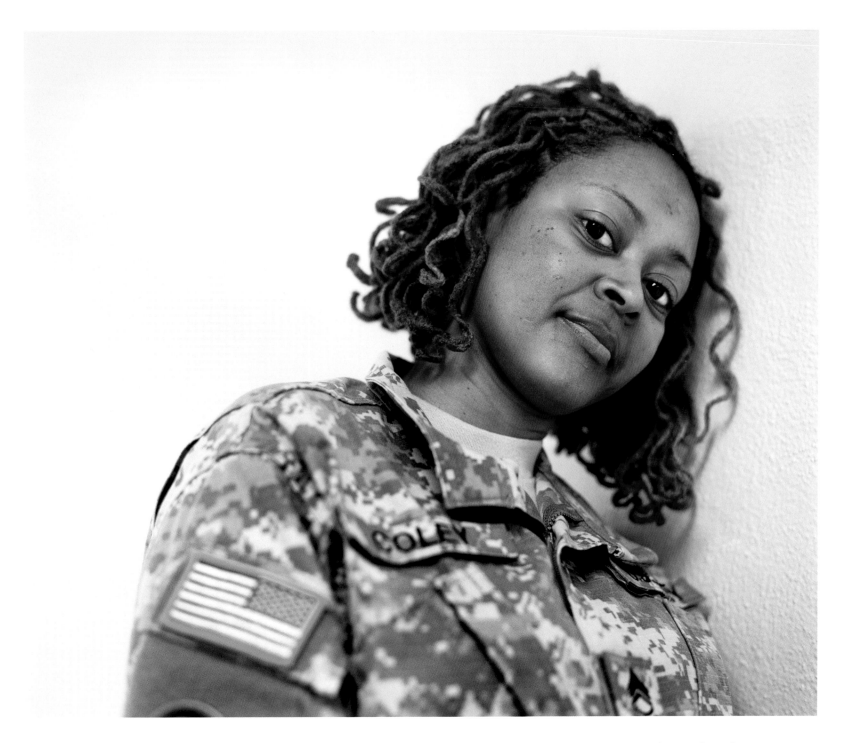

Sergeant First Class Deidre Coley, U.S. Army

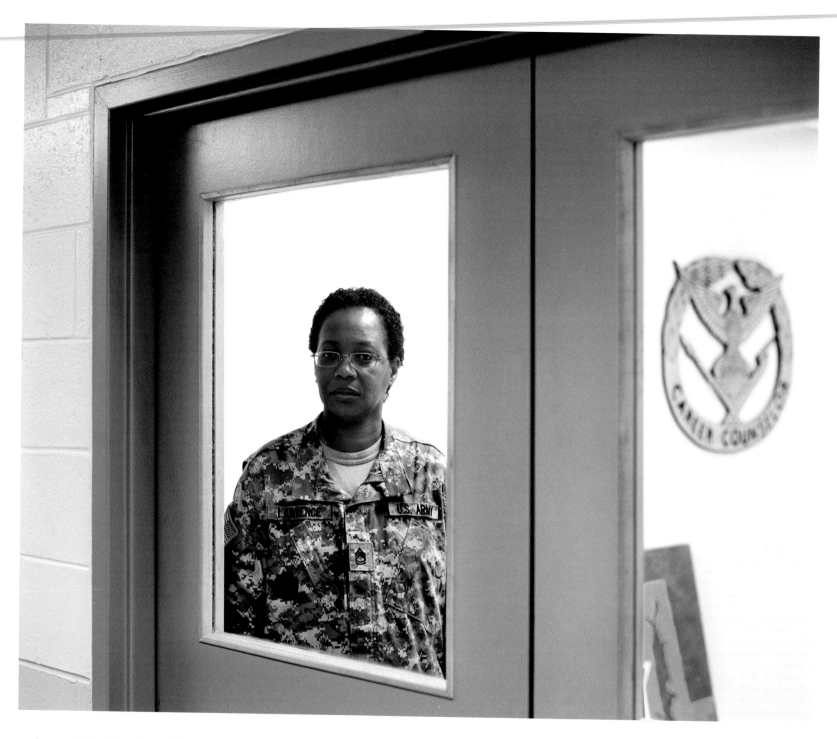

Sergeant First Class Gwendolyn-Lorene Lawrence, U.S. Army

In 1996, we went to Bosnia with a replacement unit. We had to piece this unit back to life—it was broker than broke. We had a new commander who didn't know or really care about the unit. I had a brand-new baby and a brand-new husband, and it was rough. Most of the unit members were young; some of them were new mothers and fathers, but mostly they were students.

We were convoy commanders and lived in tents. That means you could have four seasons in one day. You had your weapon with you 24/7 because anything could happen at any time. We were that close to the perimeter. Sometimes our bus got shot at. I kind of understand what my dad went through when he went to Vietnam. I saw kids coming out of trash cans, kids with guns strapped to them.

Sometimes when you think you can't do something, they say, "Dig within yourself; find the strength in your faith." You're like, "I done spent." It's almost like a bank: you keep withdrawing, and there ain't nothing going in.

When I got back to home base and went before the very same ones who recommended me for the unit, I had to fight to keep food on the table. As I was fighting for that, I saw my unit come home in pieces. I saw broken spirits, soldiers who didn't want to put on a uniform anymore. We had some suicide attempts and families broken up.

I had an administrative action for insubordination and dereliction of duty. I quit. I was ordered back into uniform, and it was the hardest thirty days. My supervisor walked away with top-of-the-line awards. When the unit was ordered to come back and receive their awards, there was a mutiny. No, I'm not coming back.

I fought for two years. I would like to believe that I did something to make it worth it because when the word went out that I had won my case, they were like, "Ain't no way in the world, especially against that command." And I was like, "Why do we, as females, got to keep re-proving and re-proving ourselves?"

Within the armed forces, we still got that same sexism. So we see our females and hear, "Hey, another one made it." Yes! We jump for joy because we're saying that those who went before—your prayers ain't in vain. It's slow, but it ain't in vain.

Deployment

Deployments vary greatly in length from one branch of the service to the next, and even from one military occupational specialty (MOS) to another within the same branch. Although army deployments have stretched to fifteen months and even longer at different points in the war, marine and navy deployments are generally seven months long while airmen are deployed for four months.

What is notable about this war is not just the length of deployments, which have stretched to eighteen months for some soldiers, but also their frequency. For instance, Army Staff Sergeant Laweeda Blash has deployed three times to Iraq, and Army Staff Sergeant Shawntel Lotson was back for only seven months before deploying again.

Some women volunteer for deployments, and some do so frequently. After her first deployment to Iraq, Religious Program Specialist Second Class Rachel Doran, U.S. Navy Reserve, spent only two weeks back in the United States before heading to Djibouti, and then spent less than a month at home after her return from Africa before she went back to Iraq—a decision that did not sit well with her family.

As these stories make clear, there is nothing like a uniform deployment experi-

ence. Army Staff Sergeant Phyllis Magee-Lindsey, who arrived in Kuwait in the days shortly after the invasion, lived in an abandoned warehouse where she had to burn feces, eat MREs three times a day, and was unable to take a shower. Staff Sergeant Magee-Lindsey's experience was very different from that of Army Sergeant Major Andrea Farmer, who was at Life Support Area Anaconda for her second deployment, where she had a twenty-four-hour PX, a movie theater with three daily screenings, a high-tech optometry clinic, a health clinic, five dining facilities, and indoor and outdoor swimming pools. Yet both women recalled the early days of the war, before IEDs became a common danger and many FOBs began to be mortared on a nightly basis, as being easier.

An MP who is outside the wire twelve hours a day will have had a very different experience from a machinist who never leaves her FOB. Soldiers who stayed in Kuwait for their entire deployments talked much more about discord within their units, and much less about the incredible camaraderie that developed. Yet taken together, these stories tell us a great deal about women troops' daily lives in a war zone.

Lance Corporal Layla Martinez, U.S. Marine Corps

We landed in Kuwait. It was dark when we landed, we're in giant buses and we have curtains covering the windows. I don't even think it's one feeling that you actually feel. You're upset because you left your family. You're excited. You're mad. You're happy. You're everything all at once and you're just waiting.

Sergeant Jocelyn Proano, U.S. Marine Corps

As soon as we landed, they gave us our ammo and we have to take a bus and cover all the windows so the insurgents won't see us and they have to drive with the lights off and everything. That was kind of scary, so I'm thinking, "Oh my God, what's gonna happen? What if we get hit? What if we have to run outside and start shooting and protecting ourselves? I really don't want to go out this way—not even getting to my place of duty. God, please don't let anything happen." I was scared but at the time, I'm like, if this happens, I'm gonna shoot. I'm gonna start throwing grenades. I'm gonna to do what I was trained to do. I was G.I. Jane as soon as we landed in Kuwait.

The first night we got to Al Asad, what woke us up in the morning, we got hit—the fuel farm blew up. I think a mortar hit a fuel farm and it exploded. Smoke everywhere. And I wasn't even scared—I was pretty excited. I was like, "Holy crap—we're at war. This is gonna be good."

Sergeant Kimberly Baptist, U.S. Army Reserve, Active Guard Reserve

We landed in Kuwait in the middle of the day. It was so hot because this was the end of August. The wind was blowing and it didn't even feel like wind. It felt like a huge, hot hairdryer.

Master Gunnery Sergeant Constance Heinz, U.S. Marine Corps

The flight from Kuwait to Al Asad was on a c-130—piece of cake. The flight from Al Asad to Fallujah was on a forty-six, and halfway through the flight, I smell smoke, and I look over to the crew chief, and it just bursts into flames behind him. I'm sitting there in this helicopter with a half a dozen other people and we're all realizing, "Damn, our bird's on fire, I'll be damned, I'm never even going to make it to Fallujah. I'm going to crash out here in the middle of the desert and never experience anything. This is it." And then just as quickly as it started, the crew chief had everything under control and we just kept on going. Needless to say, when we landed in Fallujah, we were ready to get off that helicopter.

Sergeant Katharine Broome, Virginia Army National Guard

We were in Kuwait for about twelve hours and then we got onto a c-130 and flew straight into Al Asad. The c-130 did a combat landing. They want to stay out of range of the anti-aircraft missiles, so they stay as high as they can for as long as you can and then fire roll down at a rapid rate, corkscrewing down onto the landing pad. When we woke up the next morning, we were in the middle of a sandstorm, so the world was orange. One of our executive officers came up to us and was like, "Welcome to Mars." Just stepping outside, you would become covered in sand. The water smelled. You couldn't open your eyes or your mouth when you took a shower. Yeah, it was Mars.

Staff Sergeant Phyllis Magee-Lindsey, U.S. Army

When we first arrived in Kuwait, I didn't believe it, because it was fricking raining. It was so cold. I really felt like I was in the wrong place. And I was still thinking maybe they didn't really take us to Iraq or Kuwait. Maybe they took us to someplace else. I just hoped it was a bad dream and I was gonna wake up and I'd be back in [Fort] Stewart and in my own bed, but it didn't happen. Before we crossed over into Iraq, they told us that we needed to lock our weapons. I remember praying, "Oh Lord, just keep me safe, I gotta get back to raise my boys." When we finally got there, it was about 6:00 A.M. I looked out the window, and I saw all of these tanks. And I saw American soldiers, and they were drinking soda. I felt safe because I knew that those guys had gone through there and they had cleared the way for us to come. It was okay then.

Sergeant Paigh Bumgarner, Virginia Army National Guard, Retired

When we pulled into Iraq, it was at night. Everyone was getting off the plane and there was a company waiting to get on the plane and they were like, "Next stop, USA," and I was like, "God! This is going to be a long year." I remember being really shocked that they had street lights and paved roads—because we were on Balad, which is huge—and huge buildings. We get to these little wooden huts where we'd be staying that leaked on us all night, because it was during the rainy season, which wasn't any fun. And then we had our first mortar attack. When we heard the first mortars hit and we could hear the sirens on post, that's when it really sunk in for me.

Airman Victoria Hager, U.S. Coast Guard

Especially with us being in the Coast Guard, a lot of people don't know that we're over there. Prior to going out there, it looked like a vacation spot. Really, that's how they advertised it to us. Where we're going to live, what our work was going to be like. We were going to go out there, be on a boat—a little cruise—and then we're going to come back to a suite and never be bothered. You're going to have these long in-ports, you're going to have everything there. And I was like, "Yes! I'm going on a boat. I'm getting more money." It was just great. I was in my own little world. I got there—bam.

After a fourteen to seventeen hour flight, we got to Bahrain and we walked off the plane into the airport, and it's kind of weird. You're looking for the one or two people that are supposed to be picking you up. You don't know where to go. You don't know anything. Everything just hits you all at once. You just kind of look at each other like, "Wow. We're here." At the time, we flew commercial. We all came over at different times in little groups of people per boat and we slowly filtered in/filtered out.

Coast Guard–wise, we're so small over there that I think we want to be unnoticed, but it's kind of hard to hide Americans in a totally different place. We weren't allowed to be in uniform, except for on the boat or on base. We couldn't have anything that said "United States," any teams for the United States, like the Texas Longhorns—couldn't wear any of that while I was there. Just had to come in regular clothes. Low profile.

Corporal Maria Holman Weeg, U.S. Marine Corps

I was begging to go, actually. I was like, "Yeah, I'm gonna go get some," you know? Me and a bunch of friends—that's all we'd do is pretty much train for deployment, and I was working a drug dog for the first year, when I was on the island. And drug dogs on the island, they don't deploy. You stay stuck on Okinawa. So, I was really pretty bummed out about that. I was doing a lot of custom missions. I got to see a lot of things, but I definitely just wanted to get out and really understand what the whole Marine Corps was about. So, when I got my explosives dog, I was super excited. I was like, "Yes, I'm going to Iraq." I guess there was a little bit of nervousness, but I was definitely overwhelmed with excitement.

My first impression: it was nighttime, and the stars were immaculate. As soon as you got out of the aircraft, the land is completely flat in Iraq, and so you can see all 180 degrees, and the whole entire sky was filled with stars—I mean, the brightest I've ever seen. I grew up in the country, so I thought the stars were pretty there, but then when I got there, I was like, "And this is a hostile place? This is wonderful. This is beautiful." We were on the flight line, so

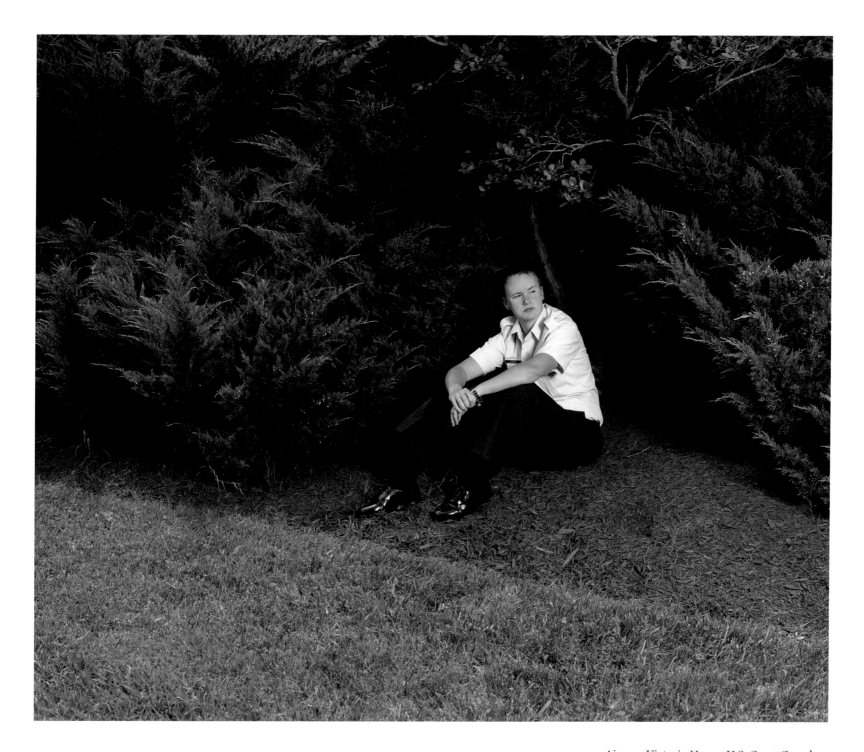

Airman Victoria Hager, U.S. Coast Guard

it was all concrete, and you didn't see any sand, and it was dark, and I was like, "I thought this was supposed to be the desert." But I waited till the morning and then I figured out, "Yeah. I'm in Iraq."

Being There

Captain Beth Rohler, U.S. Army

Deployment for me was an amazing experience. It was a privilege to be over there, to be doing what I was doing, especially supporting the war fighters. Taking care of them, boosting their morale. It was peaceful.

I mean you don't want to think of Iraq as a peaceful place. We get so wrapped up in a lot of the little things here, but you're there to do your mission, and that's what you do. You do your mission; you make sure it's taken care of. There were quite a few scares. Being on the road, your heart just pounds the whole time you're out there. But it's an adrenaline pounding, and I looked forward to convoy days to get out and actually stretch my legs, get off the FOB, and just get in there. So I really enjoyed my deployment experience.

I honestly believe—and I've talked to a lot of people who feel this way—if it weren't for families back home and things like that, shoot, I would be deployed my entire army career if I could, because it really gives you a sense of meaning. It's like any job: you get in a rut, and every day I do the same thing, and I go to meeting after meeting after meeting. What am I really here for, what's my real mission? Over there, you know. You're there to do one thing, and that's what you do. And it's really great, having a purpose.

For a year in Iraq, you know what you're gonna wear. There's no choices in wardrobe: you either wear this, or you wear a set of physical training uniforms. And no civilian clothes. You go to the D-Fac to eat, and you might have three main dishes to choose from. You eat what's there; it's good food. So when I came home, making decisions was hard.

Specialist Elizabeth Sartain, U.S. Army, Retired

When I was able to pick anything I wanted within the medical field because of my high score, I asked the recruiter, "What's mortuary affairs?" He said, "You're only the second person in ten years to ever pick that MOS." I was pretty curious about it, so I decided without any further education that that's what I was going to do.

I just think about our poor fallen soldiers. My heart goes out to those families. The devas-

tation we saw was so incredible. When we went to AIT, there was only small-arms fire. There were no IEDs, so we weren't really prepared to see what our fallen comrades looked like when they came to us.

When we work on the remains, we go through their personal property. We see letters from their family, pictures, a baby sonogram, and we have to double check to make sure if they have a wedding ring on. I just felt guilty for doing that.

We had some high-profile cases. Back when I was deployed, there were seven soldiers who had disappeared, and it was all on the news. We only received three out of the seven. You could see how they were tortured alive. And then to see their families on the TV not wanting to believe that this was their child. They still wanted to believe that their child is out there, you know, alive. So that was very, very hard.

Airman Victoria Hager, U.S. Coast Guard

I'd never been on that big of a boat ever—to live on. I was supposed to live with twenty-one people on this 110-foot boat. We went through the kitchen area, which is called the galley, and it was so little. And all of us were supposed to eat in there. I had no idea how that was supposed to work. The most traumatizing part was we went into my bedroom, and she showed me my rack. It looked like a shelf—a cabinet. I was like, "I'm supposed to sleep up there?" It took a while for me to get accustomed to it all.

We guarded the two oil platforms over there that were Iraqi. We'd get tasked with the boardings—we'd go on tankers, or we'd go on dhows. We'd go alongside and take them food, water, everything. We'd go on there just to show them that we're friendly: we're not there to hurt them, we're not there to hinder what they're doing.

My boat was a go-to boat, so we were always out working. We had very short in-ports. You have watch twenty-four hours any time, but they put you on probably two watches a day, sometimes one if you had a good rotation. You would have your meals when you could get 'em, eat whatever you can really fast. Say I'd have watch from midwatch to four in the morning, then I'd sleep for as long as I can without other people that are going on and off watch waking me up. If I could grab something to eat I would, then it's almost time for watch again, and that's if they don't need you for a boarding. So, you go on a boarding at maybe 3:30 P.M., maybe until 7:00 P.M. at night. And if there's another boarding, you may go from that boarding to the next boarding and board till 11:00 P.M. at night. Then, if they can, they find someone to take your watch. Then you may be standing watch again. It's nonstop. I've never been so tired in my life.

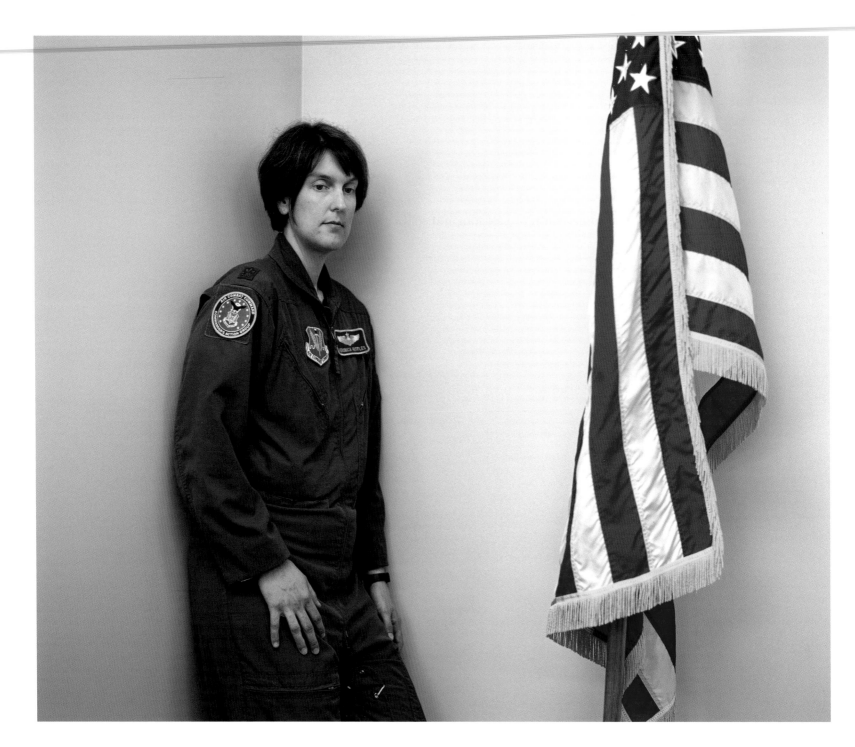

Major Veronica Hutfles, U.S. Air Force

I was stationed up in North Dakota and spent four years there flying B-52s. I was upgrading to an aircraft commander when 9/11 happened. I finished that training and three months after that I deployed for Enduring Freedom. We were flying so much that the crews we had there were limited by how many hours you could fly in certain periods of time. They were running themselves out of hours, so they brought over extra crews. We were glad to go and happy to get the chance to go over there and to fly and support it.

Being a large bomber we need a lot of space to land and so we are always stationed out of the country. We flew out of an island called Diego Garcia, which is about seven degrees south of the equator, in the Indian Ocean, so it's south of Pakistan and south of Afghanistan and India. The British own it, there are some permanent facilities there like dorms and a gym and a chow hall, a library. For a place to be deployed to, it's a pretty good location, because you're essentially on a tropical island. They had sailboats you could rent and bicycles, and there was always some type of island event going on. There were movie nights, there was a 5K every week or there was a picnic or they had bike races and they had swims. It's a totally different experience than somebody who is in Kabul or even the fighter guys who go to Saudi Arabia or Qatar.

I flew my first sortie within twenty-four hours of getting on the island. We dropped a full load of M117s, which is a 750-pound third-class weapon. We were trying to block a pass in the mountains to contain the enemies that were there or support the Army guys on the ground. Generally we were out there to be on call with weapons on the way if someone needed help, so as a matter of fact, the only sortie we actually dropped any weapons on was that very first one.

You'd have a refueling on the way up to Afghanistan. It would take us about five hours just to get to where you were in country. And then we'd do about three-hour orbits of just holding there waiting to see if anyone would need assistance. You would refuel once while you were there, and then coming back home, same thing. If you were airborne for fifteen hours, you were also briefed beforehand, plus the debrief at the end with the intel folks. You're getting close to a twenty-four-hour day by the time that you're done.

With the B-52, if we carry 500-pound weapons, we can carry forty-five of them. Afghanistan didn't have a lot of infrastructure in the first place, so there wasn't really a need to destroy large swaths of anything. When my squadron went back in September through December, we flew almost 100 sorties as a unit, and we only had one crew deploy weapons. Some TACPs on the ground got in a firefight and got pinned down, so they called in a crew and they dropped some JDAMs for 'em. We were able to free up the guys that were pinned down

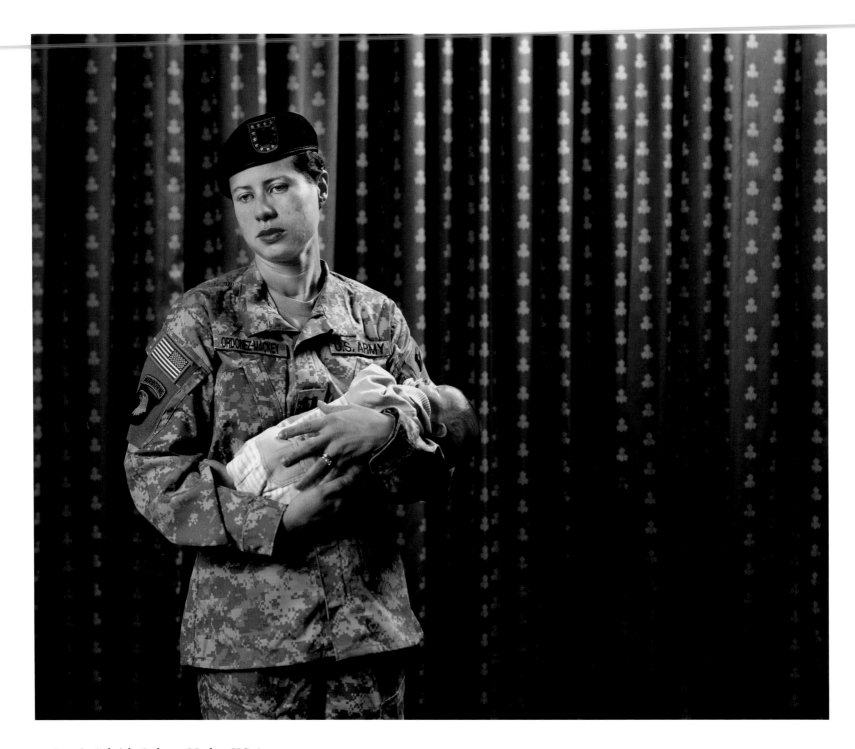

Captain Gabriela Ordonez-Mackey, U.S. Army

and allow them to get out of a situation that they were stuck in. Amazingly enough, we made contact with those guys that were on the ground and actually got to see some of the footage one of the guys had taken from the ground of the bombs that they deployed. It's good to have that personal interaction with the guys that you're actually helping out.

A challenge was to feel like you were still contributing in some way. A big part of what bombers do is deterrence. That's why the insurgents are so hard to find. They're hiding in caves, because they know as soon as they come out in the open, that we're just waiting for them. But that's not a very glamorous way to do it and it's hard to feel like that makes any difference one way or the other. The weapons we dropped, whether it hit anyone or did anything, I honestly couldn't tell you. I just know that we put them where we were asked to put them, and hopefully it was helpful, you know?

Captain Gabriela Ordonez-Mackey, U.S. Army

9/11 is actually what sparked my interest in joining the military. I was at home, studying to pass the Utah bar, and my husband was at law school. He called and asked me if I had been watching TV, and said he'd be right home. So I watched and couldn't believe what I was seeing. When he came back, I said to my husband, who was in school but still active duty, "If they're going to send you away, I'm going with you." And that came to be a couple of years later once I joined the military. I did other things, like the Red Cross training program for mass-casualty relief. We had a big flagpole in front of our house, and I put up the flag. But it was just this feeling that if we go to war against whoever did this, I want to be part of that.

Adjusting to everything that was new and to that feeling of just being confined was pretty dramatic for me. It's almost feeling like you're a caged animal, that you know you can't leave because outside that gate are people who hate you and hate what you stand for.

I did operational law, which involves training the soldiers on the rules of engagement, the Geneva Conventions, just getting them up to speed on what those rules are and how to follow them. We also did a lot of different things with detaining operations, including a legal review to see if there was enough evidence for a person to continue to be detained.

I also did get to meet some of the Iraqi army soldiers. We actually had a conference with several of their legal advisors and talked about the rules of engagement, the Geneva Conventions. We also talked about detainee operations. An Iraqi raised his hand and said he didn't understand why somebody who had just harmed one of their people should be treated with dignity and respect, when that person hadn't given the same dignity and respect to the person he had killed. You're dealing with a different culture and trying to explain to someone why that's the right thing to do when they're thirty or forty years old. That was difficult.

Sergeant Kimberly Baptist, U.S. Army Reserve, Active Guard Reserve

I would literally sit there at work and be like, "Okay, I'm working. I'm working. I hope a mortar doesn't fall on my head and kill me." I would look up at the ceiling and be like, "Oh gosh, I don't know. Maybe I should sit over there today."

I was very depressed and felt like I was helpless, and I couldn't do anything about it. It was really hard for a while. I got past it, though. And then, when the attacks started coming more and more frequent, I was like, "You know what? I'm only twenty-five years old. I haven't had kids. I've never been married. I haven't had a life yet. If I die here and don't make it home, I'm gonna be so pissed."

And that's the whole mentality I had for a little while, and I was really upset. I couldn't even fathom the fact of going over there. Then, when I was over there, I couldn't even fathom the fact of—oh, my God—I'm actually going home. It was really like I was going to be stuck in that hellhole forever. When we were about to leave, it didn't seem real to me; just like it didn't seem real to me when I got there. I mean I was happy, but I was also heartbroken. I felt like my life was just all over the place. I didn't have a place to live when I got home, and I had to stay with my mom. I was happy to get back home, but it was kind of a bittersweet homecoming.

And the one thing that I always have feelings about: I feel so guilty that I'm back home, and people are still over there dying. Like all the soldiers. I just wish everybody could come home and be happy.

Sergeant Katharine Broome, Virginia Army National Guard

There is television over there: you watch the news channels and Paris Hilton or Anna Nicole Smith is bombarding the news twenty-four hours a day. Then on the ticker that scrolls by they'll mention how many soldiers have died in a recent attack. We get paranoid that Americans have forgotten about us.

Sergeant First Class Kim Dionne, U.S. Army Reserve

I became a recruiter for the reserves. I started getting a lot of recruits—more than I thought would be possible. I was honored as the first woman recruiter of the year.

In 2004, the war had just broken out. I volunteered to go and didn't tell anyone in my family or anybody else. I thought that I'd be better at my job here in the States: how could I possibly empathize with soldiers if I didn't understand their experience of not wanting to be redeployed or reenlist because of the hardship for their families?

I went to Fort Bliss, Texas, the mobilization site where a lot of the soldiers are processed for

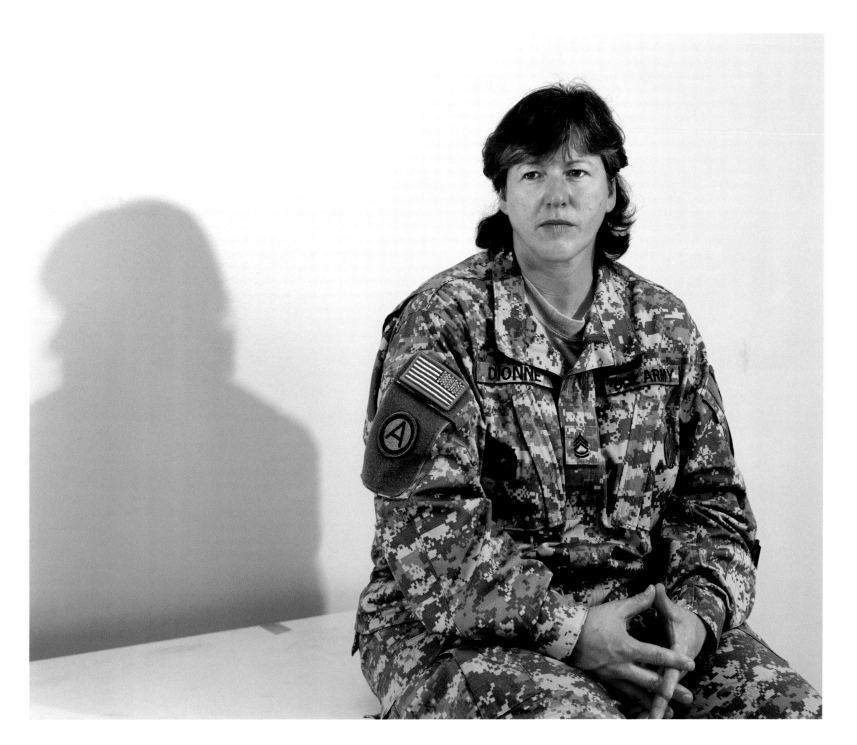

Sergeant First Class Kim Dionne, U.S. Army Reserve

deployment. This one girl had been deployed before, and I guess she had come under attack. In the middle of the night, she'd wake up screaming with nightmares, and it scared me.

I was in Afghanistan for three months. I'd fly out there to reenlist soldiers, asking them to stay for three or six more years, or indefinitely if they were older. It was difficult. They were like, "Hell, no." It was boring down in Kandahar, so I volunteered to go up north to Iraq.

We'd get a lot of walk-ins, people who would come find us, determined to reenlist. As soon as they got into theater, they received a tax-free bonus. Yeah, it was nonstop. We'd go out to the units and start stirring the pot and shaking them up to see who wanted to reenlist. We had a real live mission every day.

We took a lot of mortars, mostly at night. My friend showed me how to grab my Kevlar and roll out of the bed and under the bunk. I'm IM-ing my friends back at college: "Okay, we're getting incoming." Mortar attacks meant you slept with your ears open.

We had every kind of pie. Cheesecake, every type of cheesecake. Everything. I mean we were so taken care of. It's just no one dared to go to the mess hall to eat because you'd get mortared.

You wonder if you're really helping. You join the army to make things better and give your-self to a greater cause, and you just feel like: did it really make a difference? It's not like World War II. The bonds are stronger with the few friends that I've kept. I don't keep up with some of them because they really just want to know about Iraq. I'm reluctant to talk. I've got PTSD, and that's all you need to know.

Lance Corporal LeAnne Neal, U.S. Marine Corps

My uncle's in the Marine Corps, and I have another aunt and uncle who are also in the Ma-rine Corps. They seem to like it, and my grandmother always told me I needed a backbone. So why not?

When I got there, there was not much to see at all. It's nothing but sand, no trees or grass. I think it rained one time while we were there.

I shouldn't have been like hey, today's gonna be just like it was yesterday. That mindset's not really the best to have, but my days were pretty much the same. You woke up every day and went to work. You stayed there until about six o'clock, and then you'd go eat, and then you might have time to watch a movie or go to the gym. It made going to the gym a lot easier. At times you didn't want to be there; you just wanted to be left alone.

You see yourself in cammies everyday, and you just really couldn't wait to put that hair up someway and put clothes on. So I was looking forward to that. You come to appreciate things a lot more after you've been deployed, just the little things.

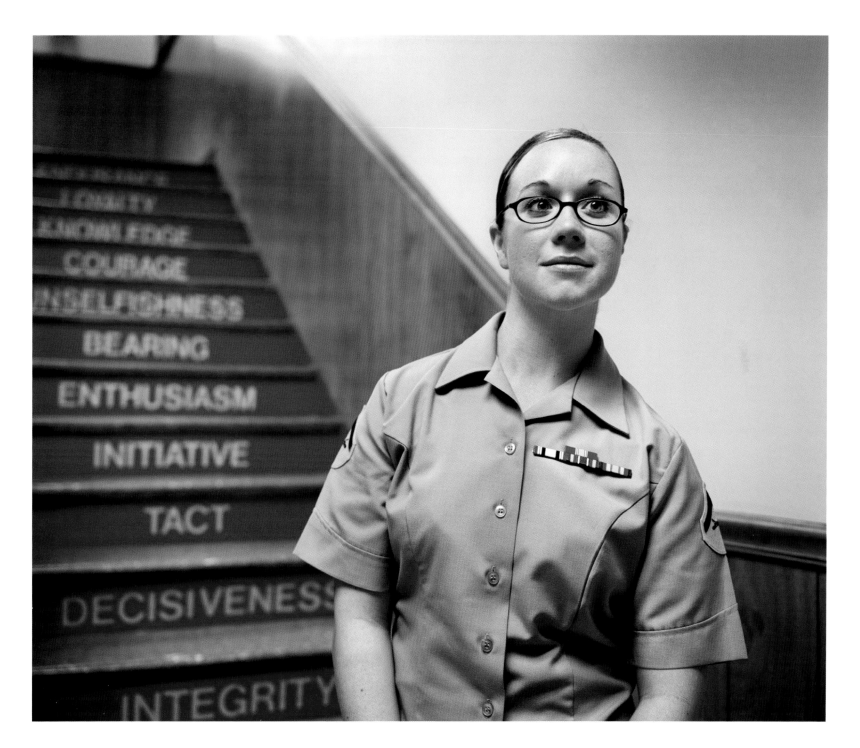

Lance Corporal LeAnne Neal, U.S. Marine Corps

I do think it's a good experience, to actually get to go over there. The deployment wasn't as bad as I would have ever thought it to be. I got to learn my job and, if I had to do it again, of course I'd go again. It was not anything bad for me, but that was just me.

I got used to the planes coming and going throughout the night, all day. It's just something you got used to. The heat. Everything. It was something you did everyday. That's what it was for me.

Sergeant Mikeishia Kennedy, Virginia Army National Guard

I got a letter stating it's possible that we'll get deployed, and I was put on stop-loss in the middle of the semester here at vcu. I was stressed. A lot of emotions were running through my mind because I was a full-time student. I had to talk to my professors and let them know that I had to leave in the middle of the semester; some were helpful, and some really weren't trying to work with me. So it was very stressful, trying to get my finances together and everything like a full-time soldier. A lot of people in the National Guard or the reserve are full-time students; so it's a big transition for us to go from part time to full time, even the soldiers who are active duty.

I worked the night shift at Camp Virginia, a twelve-hour shift. I was personnel, so I did id cards and tags. We did basically all the paperwork there, so the night shift was really laid back.

I would talk on the phone and write letters and go to a place called mwr, where they had games, a pool hall, and a basketball court; they would do fun things like bingo night. Then they had salsa night, old-school night, rap and hip-hop nights, so I would try to get out instead of being by myself. That can be depressing.

My commander was not as good a commander as she should have been during the deployment. She did have some soldier care, but not 100 percent soldier care. We were on curfew the entire time, even though you're old enough to get shipped to Kuwait and end your life. I have no idea why—maybe partly because we were mostly females. Some soldiers didn't say too much, but others were outspoken about it: we're living like criminals.

We came home for two weeks on our leave, so I was very happy during that period. But when it was time to go back, I was sad, depressed: "Oh, I have to go back for another six months." So I went back, and then it was time for us to come home in January of 2006. I came back on a Friday and started school on Monday.

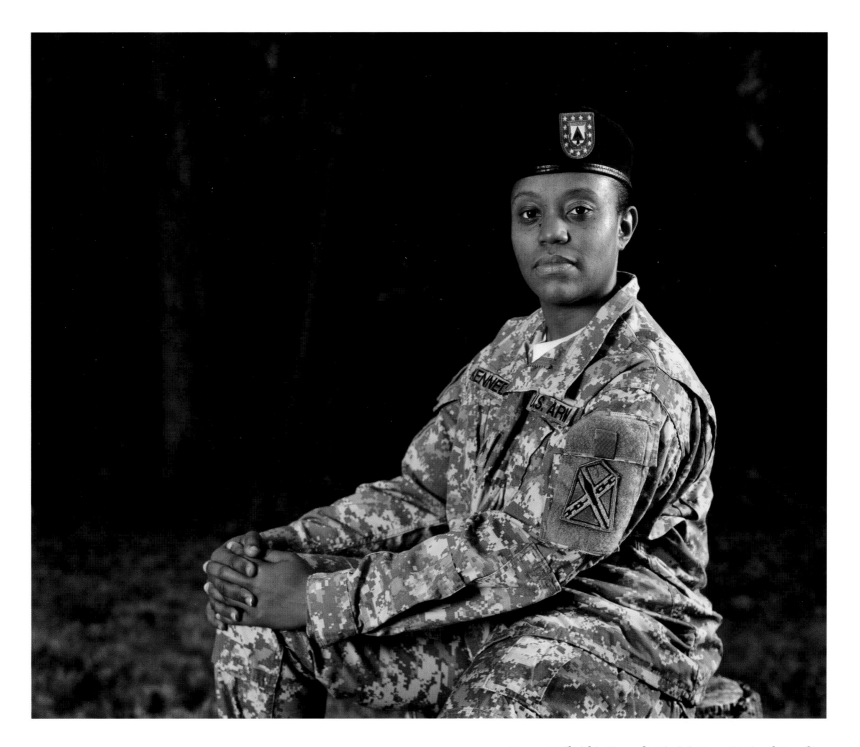

Sergeant Mikeishia Kennedy, Virginia Army National Guard

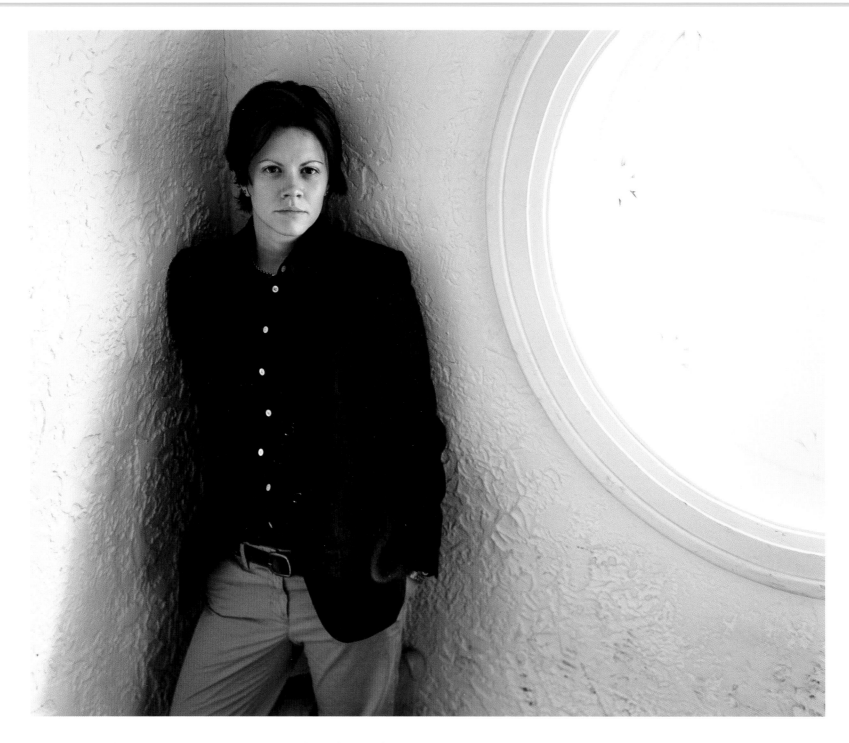

Sergeant Paigh Bumgarner, Virginia Army National Guard, Retired

Sergeant Paigh Bumgarner, Virginia Army National Guard, Retired

We went by this one base called Ashraf, and it wasn't as busy as it should have been. When there's not a lot of hustle and bustle of everyday life, you know something's up. The first gun truck reported a dead dog on the side, which had an IED in it. It blew up right behind the truck, part of a daisy chain of three other IEDs that went off. Then we started taking fire from the left all the way down, but we had to keep on going because we can't break up a convoy. So we just kept going through this fire.

They had RPGs and were shooting for the tires and the gunners. A lot of vehicles got hit with RPGs, directly into the windows. Once we got through, they tried to hit us with a VBED, but I ordered, "No one gets close to this convoy," so it was taken out, a confirmed kill. We found an amazing cache of weapons, and there were actually nine more IEDs. So it was bad, but it could have been really bad.

I get in touch with Mulcahy, who was the commander, and he was like, "Um, Bum, I need you back here." And I was like, "Why?" He goes, "I need the body bag." And I was like, "For who?" And he said, "Ski." My driver froze, and I was like, "Come on, just turn around." I literally had to talk him through it because that was his friend, too. I went back there and saw Mulcahy and Ghent, who had shrapnel damage. I got two medics to help bandage them up and just be there for 'em. I was like, "Where's Ski?" I looked in the back, and there was my buddy, completely in pieces. So I got the body bag, and put him in there. Then this guy came over, and he just looked at me, and I was like, "Go get some gloves." And so we did that and cleaned up the truck. I wouldn't let anyone near it because no one else needed to see that.

We were also escorting a first sergeant and a captain. I remember during the craziness of everything, the first sergeant came up and tried to take over, and I was like, "I'm in control of this convoy." He said, "Okay, what do you want me to do?" And that's how it was and, you know, it sucked because it took that for me to get my respect. After that, all the guys were like, "I'll go anywhere with you. I'll follow you anywhere."

Master Sergeant Bonnie McKusick, U.S. Air Force

I was a last minute choice, so I only had a week to prepare for my deployment to Afghanistan. I got shipped to Fort Riley, Kansas, where we did our combat-skills training, and that was the first eye-opening experience. As a medic, we're taught always we're protected by Geneva Conventions. If we pick up a gun, we're a combatant. Having to get in a different mindset was amazing. What we were, it was called ILO back then—"in lieu of." Basically because the army, they didn't have enough people, so they were reaching out to air force, navy people to be support for them while they're over there in Afghanistan and Iraq. I had to qualify on the

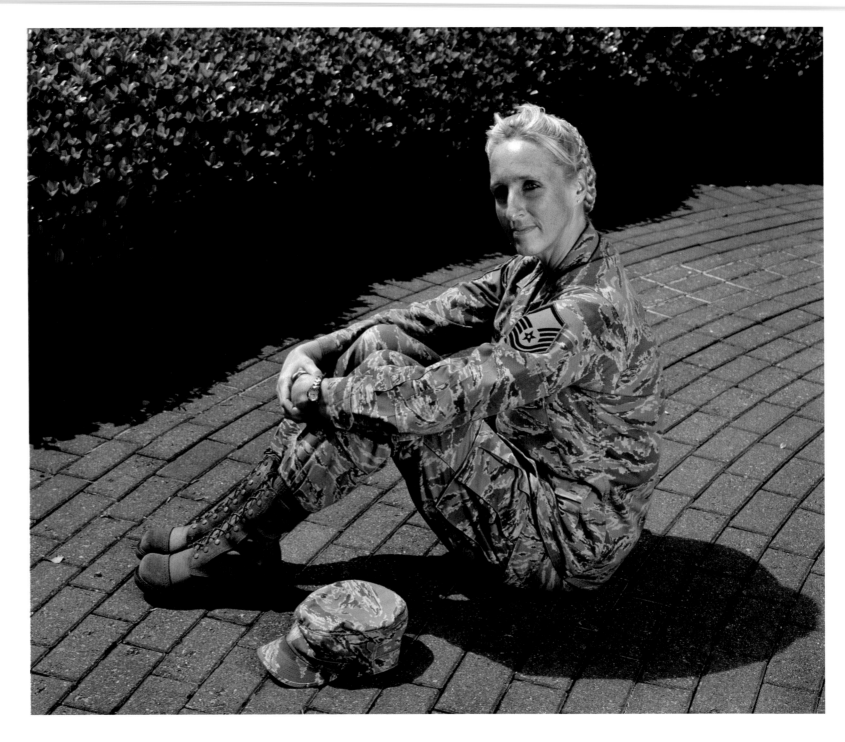

Master Sergeant Bonnie McKusick, U.S. Air Force

four and the nine, just in case we were on one of these convoys and we had to take over. We had to get trained on all these weapons, so it was long days at the range, and then we had to do night firing, and then we had to drive the Humvees. We got our Humvee license to be drivers over there, and we learned how to be tank commanders just in case you're over there on a convoy and something happens.

Fourteen of us went on to Camp Spann, which is in northern Afghanistan, fourteen air force on a base of 500. I was the NCOIC of the troop medical clinic. There was only four of us, and we were 24/7 operations over there. We locked and loaded as soon as we got on that base.

The air force isn't allowed to go on combat operations over there, so I went on a couple humanitarian missions. One of the sergeant majors took me to a school opening, which ended up getting bombed before I left over there. It's frustrating because we're trying to help over there, then some people over there just don't like what we're doing. We went to a refugee camp. We were the support for the Afghan National Army, because they were delivering goods to all these people, trying to get them to say, "The army is here for you. The Afghan National Army is here for you—for their own people," so they're handing out blankets, handing out food, things like that. And the Americans took three tanks to go with them to provide combat support, just in case anything happened. I was a combat medic on that—nothing happened, thank goodness. We did some good humanitarian work out there. They don't get a lot of medical care at all over there, so just getting immunizations that they've never gotten before is just a huge thing for them. So, yeah, we got chances to do plenty over there.

Sergeant Erica Crawley, U.S. Army

I volunteered for special duty in St. Louis, helping people who were supposed to go overseas get to where they were going. We had a lot of people who went AWOL, who were trying to get out of going over there. There were many different excuses, and I heard them all.

It was exciting and serious—going to a new place. We were in Kuwait, which is a peaceful place, so I really wasn't scared. I had heard people who went over there say that the place was nice where we were going, so that was fine.

I was the outcast of the unit. I asked them all the time if they were going by the book. I challenged them to do stuff, and they didn't like that. I didn't get along with a lot of the chain of command. I think some of them changed when they got over there; they had a lot more power than they had in the States. I just prayed for them. I prayed every day that I would try to do the best that I can, even though I got in trouble sometimes. It's just like some of them

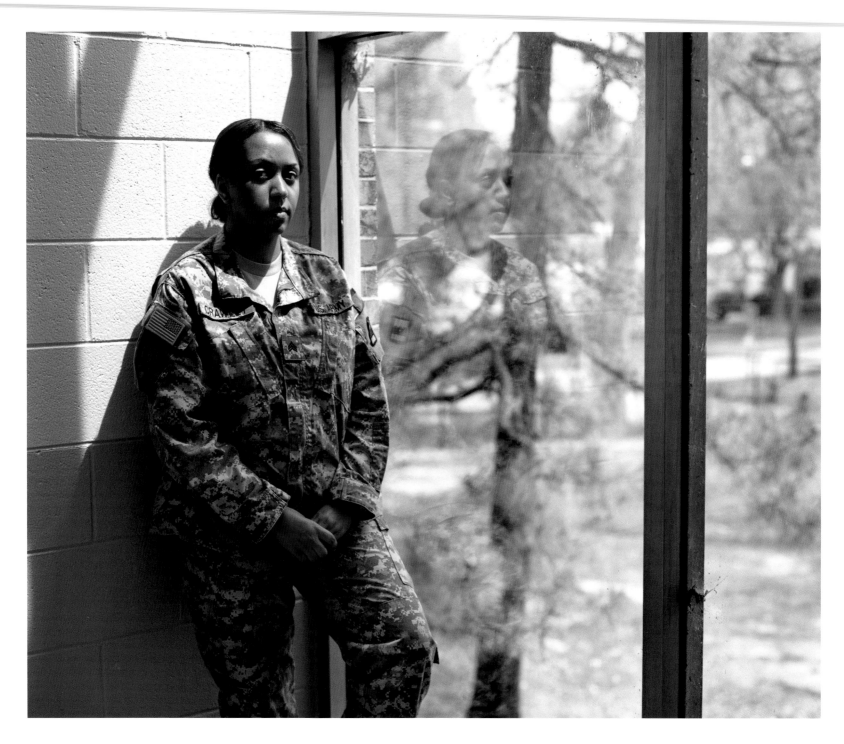

Sergeant Erica Crawley, U.S. Army

let their power get to them. They downed the soldiers who were trying to lift us up over there, when we're already in a situation overseas that we don't want to be in.

They sent me to Iraq. It was supposed to be an all-male mission, but I was having a little problem in Kuwait, so they asked me, "Did I want to go?" Iraq was okay, but scary because there was more violence over there. I was at the airport and guarded Iraqis at first. All I would do is sit down and watch them do what they had to do, which was build buildings. But then they didn't like females doing that because the Iraqi people would try to talk to you, and try to buy you, and they would always pick on the females. The army didn't like that, so they moved me to postal.

I stick with what I believe. If somebody does something wrong to another person, I'm not gonna let them do it. I'm gonna stick up for that person, and that's how I was with the soldiers who were lower than me. It wasn't so bad because some of the older, higher-ranking NCOs I dealt with, like the one who I worked for, I loved her to death. She watched out for me the whole time I was over there.

Senior Master Sergeant Pamela Hadsell, U.S. Air Force

A first sergeant is in charge of health, morale, welfare, and discipline of a squadron. I often joke about "just call me Mom" because if you have a problem, just come to Mom, and Mom fixes it. If you get in a little bit of trouble, well, Mom might have to put you back on that right path. If you're having difficulty with a personal issue, financial issue, you can come to Mom, and we'll try to fix it for you. The joke I make is my little size seven can go a long way, so please don't mistake my kindness for weakness. I will take care of you and I'll give you that hug if you need it. But I'll also give you the kick in the butt when you need it. Love and discipline go hand in hand. I have that Mom Mentality. I have been doing this for almost six years now, and every day it's a new adventure. And I mean that in a good way.

My first deployment to Qatar, I was the first sergeant for an aerial port squadron that dealt with all of the cargo coming in and out of that area of responsibility and all of the passengers going in and out of Iraq, Afghanistan. They taught me how to load cargo on a C-17, they let me drive the forklift, they taught me how to book passengers, they showed me what they do, because part of my job is understanding what my airmen do, so I can better help them do their job.

I got notification of my deployment to Iraq while my husband was in Iraq. He came home from Iraq while I was at my combat-skills training. My current husband is not the father of my two children. Their father, who is active-duty army, happened to be stationed in Iraq the same time that I was stationed in Iraq, and we actually bumped into one another in Balad.

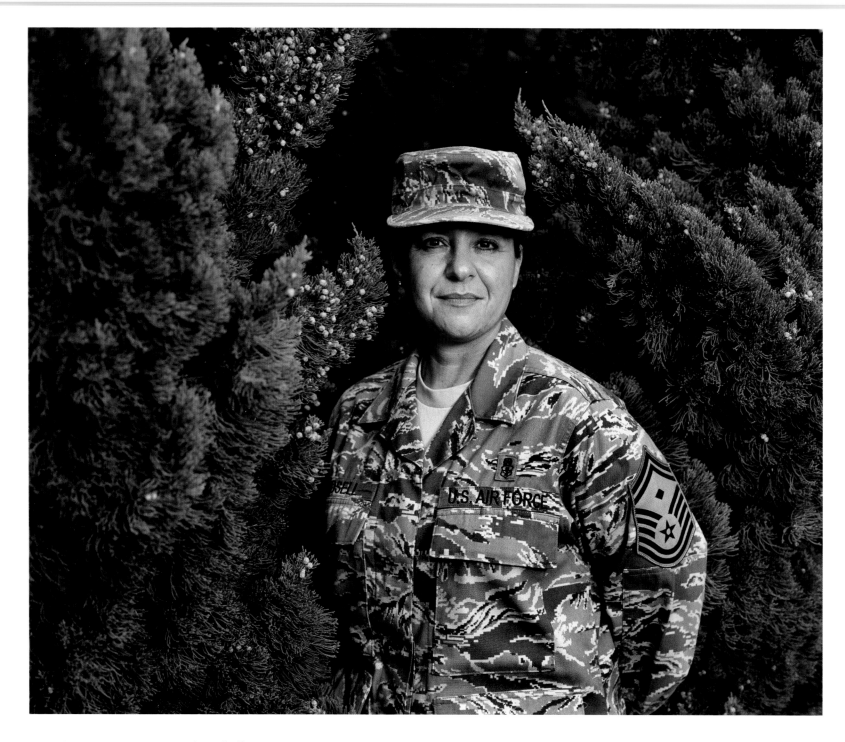

Senior Master Sergeant Pamela Hadsell, U.S. Air Force

My children have grown up in a military family—both on their mother's side, and their real father's side and their step-father's side, so they've been through a lot of deployments and a lot of away-from-parent time.

I was on the road constantly, the whole six months I was there. I got there my first day, the very next day, I'm catching a chopper to Fallujah, seeing some of my airmen. I was the first sergeant for an expeditionary engineer squadron, so we went and built things. I got to pour concrete at an Iraqi police academy. All of my airmen that were deployed over in Iraq were what's called in-lieu-of taskings, so they were working for the army. And in some cases, they embedded with the marines. The army worked alongside the air force that worked alongside the navy that worked alongside the marines. They just all merged together to kick butt, to win the global war on terror.

I had one airman that did not want to go outside the wire anymore. Had been outside the wire, didn't want to go outside anymore, and was having a—I don't want to say a mental breakdown. I went to the helicopter pad, I said, "I need to be on the next flight out." I ended up going to Baghdad. I got ahold of my airman in Baghdad, and we put him in a combat stress clinic down in Baghdad. I picked up my airman, I brought him over there, and he spent seventy-two hours there. And when he came out, he was okay.

Sergeant Shyra Jones, Virginia Army National Guard

There was this place called the Dusty Room on our camp; it was like the morale-booster mini-club, where we could play music. They had all different types of music that you could hear each night of the week, and I spent the majority of my free time just working at the desk because it was something that really lifted my spirits every time I went there. So we did everything we could to make sure that the people who were coming through Kuwait felt good, had a place where they could relax and just remove all the stress from the day.

Yeah, we all have t-shirts that say "Dusty Room." We had talent shows and hip-hop night, country night, Latin salsa night, rock night. It was so much fun because I learned so many different line dances. I used to work on country night and sell drinks. They had the near beer, which was not beer but it's served in beer bottles; we just sold sodas and listened to music.

It was just after getting off work, and you really didn't want to have to think about anything else. You couldn't be home, and you'd already spent time calling your family. You just wanted someplace to go relax because, even in Kuwait, it was stressful. We hated the fact that we had curfews, but it was for our safety. One of our oldest people in our unit was a fifty-year-old. How do you tell a fifty-year-old that they have a ten o'clock curfew? So no one appreciated that—we all felt that it was wrong. But really when you think about it, it was for our

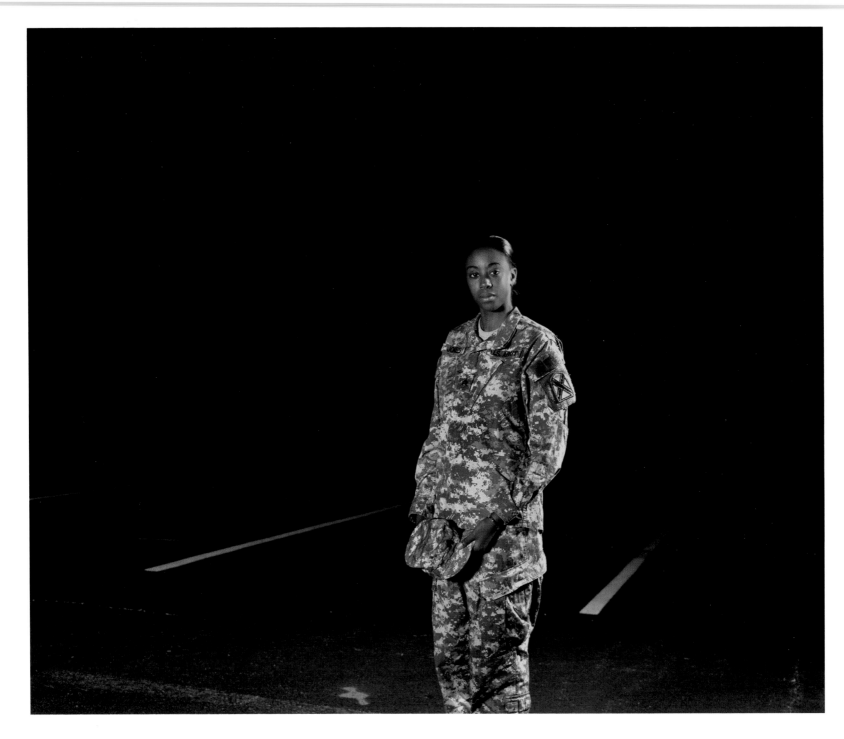

Sergeant Shyra Jones, Virginia Army National Guard

safety. Lots of stuff happened. There were attempted rapes. A marine tried to rape someone from the army. Some of the nationals hadn't been around black women, so black women were really fascinating to some of the different cultures over there. The Georgians would always crowd around you asking questions and stuff. That's one of the reasons why we had the curfew. And it got to the point where we all had to have a battle buddy, too.

Well, the American contractors, they had this way of getting stuff from home, and we always loved that. They were the most resourceful people ever. In some ways, we liked the contractors, but then we didn't like them because they were doing the same things that we were doing, but they got paid a lot more for it; and they didn't have to go through the strict curfews and the security measures that we had to go through. Like they were free to roam around the cities and stuff like that, where with us, it was a long process to get to leave camp. So I liked the contractors. They would barbeque out on the pads, which was where our tents were. They were nice people. I'd go to the barbeques, but nothing wild. The Dusty Room was wilder than anything else.

Sergeant Major Andrea Farmer, U.S. Army

We arrived in Kuwait, and it was really a bit scary because the war started about two weeks after we got there. We knew that the enemy was not far. We knew we were in a foreign country and that people were dying every day. And so we just didn't know if we were gonna be next, if we were gonna get hit by a rocket-propelled grenade or what. So all we could do is just drive on, continue to train our soldiers, and just do the best that we could, and hope and pray that we would make it through each time.

We were back for about sixteen months and received notification that we were gonna go again, the latter part of 2004. My family was concerned. They were afraid that I may not make it the second time.

It was more dangerous the second time. We were getting mortared every day. But as far as the facilities, they had twenty-four-hour PX shopping, a movie theater that showed three movies a day, and they erected the hospital. They had a high-tech optometry clinic, about five dining facilities, indoor and outdoor swimming pools. Of course we did our mission, but the quality of life was excellent.

A lot of us have chosen the military as a career, and we are serious about what we do, and that we really care, and that we have to obey orders despite how we personally may feel. I did get a lot of different opinions from civilians and even my family, but I think that they need to be more understanding of who we are and what our responsibilities are, and our obligation

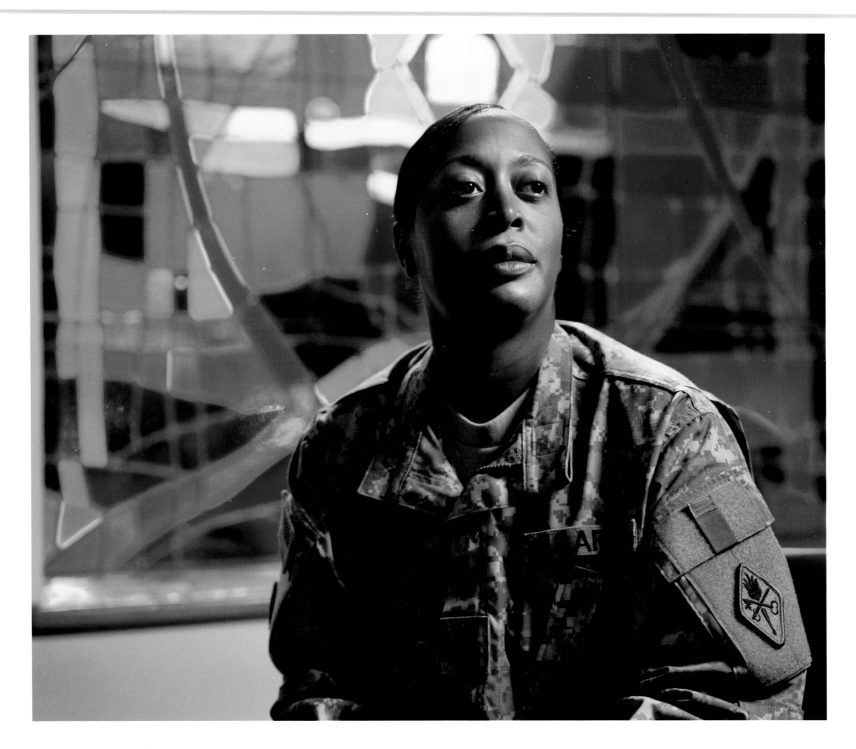

Sergeant Major Andrea Farmer, U.S. Army

to our country and our chain of command. I just try to explain to them our position and that it's not necessarily our opinion. We took an oath when we joined, and we're gonna obey the orders of those appointed over us.

Corporal Maria Holman Weeg, U.S. Marine Corps

We would search houses. We would go in the houses, and it was actually kind of a bad thing, we would tell the family to get out—and we were searching it. I mean, yeah, as far as our safety, but how would you like it if you were at home and somebody came into your house and said, "Get out, we're searching your house"? So, we would clear them out of their houses, and I would run my dog through the house, and she would sniff out to see if there was any ammunition or any kind of weapons, any kind of IED-making devices or any kind of explosive devices that a dog can sniff out. We would search any kind of vehicle if we were doing a traffic-control point, because IEDs are a huge thing out there, and vehicle IEDs is a big thing of what people are taking a toll of out there—the death rate. December of 2006 was actually the deadliest month of that year, and so we were really working on vehicles to make sure that they were all clear before they were coming into Fallujah.

We started getting indirect fire, and we were like, "Oh God!" I was with the National Guard out there, and it was their first time out there, too, and so they were definitely excited. They were a little scared because we were searching up and down the river and then we hear this bullet come back, and we see dirt fly up. It was my first time to get fire. When you go hunting back home, when you hear somebody shoot something, you're like, "Ooh. I wonder what they killed." You know, a deer or a squirrel or whatever they were shooting at. So, I'm thinking, "Wow. I wonder who's killed something," you know? I didn't realize that they were shooting at me, and they're like, "Take cover! Take cover!" And I'm like, "Why? They're just shooting something." And they're like, "They're shooting at you!" And I'm like, "Oh." I know that's horrible to say. I probably should've been a nervous wreck, but I was just like, "Oh. Okay." And so I jumped down in the irrigation ditch, and we're taking cover and we're trying to figure out who was shooting at us. It was actually pretty depressing though, because they were shooting at us, and then they started sending mortars our way. And they actually hit the Humvee that we were in, but we were outside in the irrigation ditch, so we were blessed that we weren't traveling at the time. And we couldn't return fire, because the rules of engagement right now—if you don't see the muzzle flash, you can't shoot 'em. And that's just not my way of thinking. My way of thinking is if somebody's shooting at me, I'm going to shoot back at 'em. I don't care if I can't see 'em or not. And I was like, "What the hell? Why can't I do that?" So,

we were doing fire-team rushes back to the Humvees trying to take cover, but it was definitely exciting and everything that we had found that day, we couldn't even get it. We had to wait, so we got back in the Humvees and we got our machine guns, and we got to return the fire, but we couldn't come back until the next day to get all the things that we had found, and most of it was gone, so it was definitely kind of a bummer.

They knew our rules of engagement, and that was the worst thing because they knew we could not fire unless we saw them. I think that's why the war isn't over, because we sit back and play defense. When I was out there, I believed that we should have been a lot more pro-active. I know that we're there in support of the war, or to finish it, but at the same time, you can't win the war just playing defense. You have to have some kind of offensive strategy.

Relationships with Iraqis and Afghans

The wars in Iraq and Afghanistan are ones in which there is often a great deal of interaction between the country's citizens and the U.S. troops there. But here, too, experiences ranged from those of women soldiers and marines who could not feel comfortable with the Iraqis they met—as Kate Broome said, the Iraqis who were doing her laundry were also the ones who were mortaring her base at night—and others who built strong bonds with their interpreters or Iraqi co-workers, bonds that were sometimes interrupted when a village was destroyed or when an Iraqi disappeared without warning. Army Master Sergeant Odetta Johnson remembered how difficult it was, "talking with my interpreters, building friendships because you can't let them get but so close, but it's difficult when you work with someone every day and they taught you about their family and one day they come back and tell you that their whole village is gone or everyone's dead, but they're coming to work every

day. You know, or to talk with an interpreter and then find out that they've been killed."

In these difficult relationships—sometimes warm, sometimes close, but always tempered by a sense of their impermanence and often suffused with mistrust—women's memories of Iraqi children stood out. The visits to schools to give children notebooks and plush toys afforded a human connection untainted by doubts; but the sight of shoeless Iraqi children, sometimes hawking alcohol and pornography to U.S. troops, haunted many women, and made them acutely aware of the suffering of the Iraqi people. To date, the most conservative estimates of Iraqi civilian casualties since the war started in 2003 range from 92,000 to 100,000 dead.[1]

Sergeant First Class Kim Dionne, U.S. Army Reserve

I got to go to volunteer for humanitarian missions. And we had a friend in the Guard here and he would send me these little stuffed animals and candy and potato chips—things that were unique to the States—and also backpacks and paper for the kids. And we just handed them out to the orphanage. It was great, but sad, you know. Sad to see the little-boy soldiers that were five, six, seven, eight years old. A lot of them have scabies and sores all over their hands, they don't have the right vitamins, and a lot of them didn't have shoes. We'd send them balls from America and kites and paper planes and really you don't want to be doing that because there's minefields and they're out there playing.

Sergeant Jocelyn Proano, U.S. Marine Corps

On base they had a stadium—we called it the Hajjimart—and all these national people from Jordan—from Afghanistan—they lived out in town or lived in the stadium. I don't know how they got there in the mornings, but we'd go there and they'd sell cheap DVDs, cheap cigarettes, cheap everything and at night, they'd have parties, and they were so cool. As soon as I'd get there, the marines that we were replacing, they said, "Oh yeah, come to the stadium—the Hajjimart—these guys are awesome—they make you tea and they party all night." I first got there, and I'm like, "I don't know if we should trust these guys." Of course, I'm brainwashed by all the security briefs, but when we get there they were really cool. They'd make a fire and start dancing around the fire. They'd make you chai and they'd crush them themselves—was so good. Partying with those guys—they were a lot of fun. They kind of remind you of back home. But then again, you still couldn't trust them, plus you're partying with your M16, you have to carry it everywhere, so you're just trying to watch everybody at first, but they were awesome. But then I heard later on one of the guys was arrested, because he was behind some insurgent plotting. And I'm thinking, "The old guy? He was so cool!" And that just kind of teaches you, you can't trust everybody out there. And it hit you right in the stomach. Hanging out with those guys—they were a lot of fun.

Staff Sergeant Shawntel Lotson, U.S. Army

You have to go through correctional training about a week long. You have to learn how to handcuff the detainees, how to search them, tell them what to do, how to touch them, how not to touch them. Then once I got out there, it was twelve hours on, twelve hours off, which was actually about fourteen hours because you have to make sure that the soldiers are up and ready, so you're up for fourteen to sixteen hours total. I was also the evidence NCO, so I saw a lot of different terrorists that came through there from different countries. If they're with

their family members, they also bring in the minors. The mother instinct kinda comes out, but at the same time, hey look, these people are trying to blow you up, too. But that mother instinct comes in because you have the child crying, "I want to be with my father." But, you can't.

The minors were between twelve and fourteen; you'd have the crying all night. Oh my God, I'll never forget Omar. He was one of the detainees. He came in as a minor and left as an adult because he came through three times. You had a lot of them. They get sent up to Abu to be interviewed and interrogated or whatnot. But if they don't have enough evidence on them, then they release them.

I mean, you have detainees who come through who are so scared because they don't know what's going to happen to them. You know what? We're here to do our job. You were brought here because you were trying to do your job, too. So that was an experience.

If you see a soldier yell at a detainee or kind of nudge 'em along, you kind of have to say, "Hey, look, I don't want to be the next person on CNN, so don't touch that detainee." You know, you have those soldiers who are just so angry and so upset and so passionate about the terrorists who are trying to blow us up that they want to fight. Yes, we know they're our enemy, but at the same time, we have to treat them humane, so that we don't get ourselves in trouble. So it was kind of hard. There were times when I wanted to choke a few of them, but you know, you can't.

Captain Carla Campbell, U.S. Army

I got to talk to a few Iraqis. And you realize that for most of them, they are just like you. They want to do the same things. They just have a different culture, but underneath it all they are just like you. Put to death a couple of myths.

I met a bunch of Iraqi females, including Selma who I became really good friends with. They were all translators and helped out doing contracts and stuff like that. I started eating lunch with them, and they would tell me stories. I got to ask questions about their day-to-day lives.

Selma was wearing a burqa, and I just looked at her and said, "Aren't you hot?" I always wanted to ask that question. It was the middle of summer, and I was hot looking at her. And she just started to laugh. That's the way we started talking at first because I had to ask. I knew where she worked, so I would make an effort to go over and sit down and chat because it was interesting.

It's a lot more liberal than we actually think it is. You know, I didn't expect them to have so

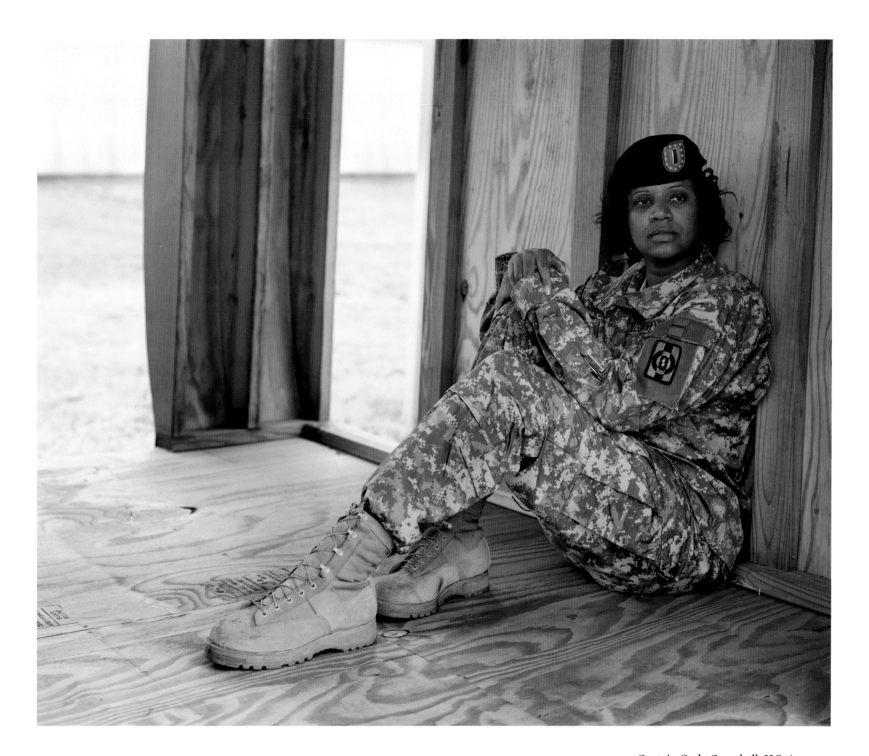

Captain Carla Campbell, U.S. Army

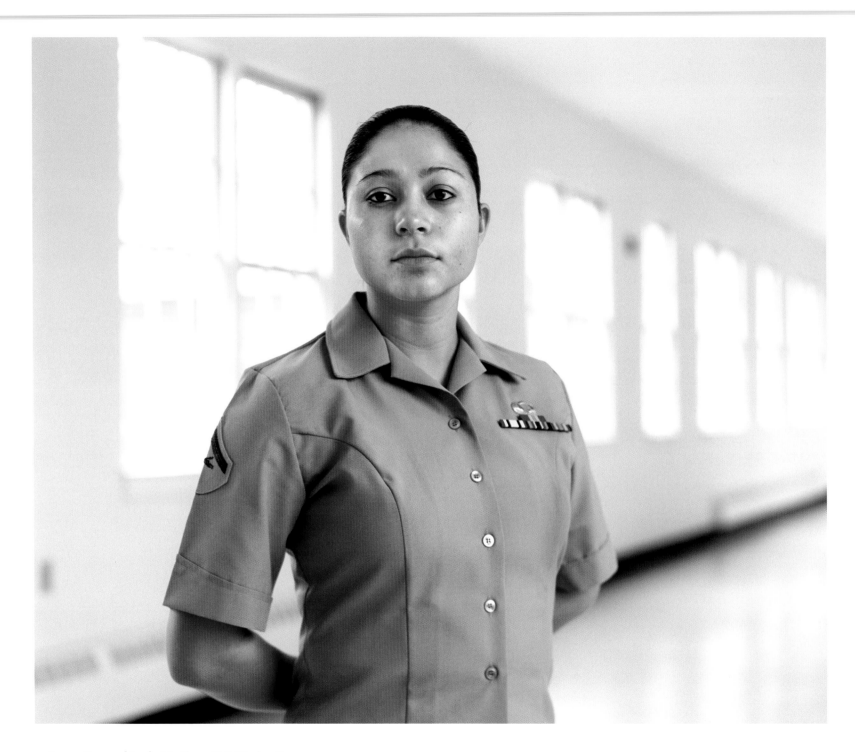

Lance Corporal Layla Martinez, U.S. Marine Corps

much freedom. That was kind of shocking. But they do have a lot more choices than I thought they would have, so that was pretty cool.

There were only two things that made me upset—really upset—when I was over there. The first one was a friend from ROTC who died in a roadside bomb. That was upsetting because I found out about it through the newspaper.

And the other one was Selma. She disappeared. She was actually teaching me how to belly dance. Over there, you're supposed to only do it for your husband or the man you're marrying. And I promised her that I was going to learn it for my future husband.

She went home, and we never saw her again. It was a little more than that. Like I said, you ask questions but sometimes you don't get answers.

Sergeant Katharine Broome, Virginia Army National Guard

You get mortared so much, and then you find out that it's the guys just down the street who are selling you rugs to mail home to your family, or the guys in the kitchen who are washing the dishes. My roommate was really upset when I first came home because I was throwing around the H-word: Hajji did this, and Hajji did that. I didn't used to be a racist; I was a liberal. I was open-minded. When I came home for the first few months, I kept a switchblade in my purse that I called my Hajji sticker. My roommate and a best friend both talked to me one night, and they were like, you didn't used to be this way. The fact that the government has instilled a hatred inside of you towards an entire percentage of the population is really disturbing. After they talked to me about it, I didn't say the H-word anymore. I try to not have bad thoughts about people and to not judge them on their outward appearances.

Lance Corporal Layla Martinez, U.S. Marine Corps

A lot of the Iraqis are really friendly, like the ones who work on base and in the stadium. They're always offering you their fresh produce—tomatoes, cucumbers, lettuce. The ones we knew worked in the shops, and those shops sold DVDs, so everybody loved it. We got to see all of the movies that came out while we were deployed, before people back in the States. We had our hookahs out there, and we'd all get together and smoke. So, it was just good times, really good times.

I got sick. I got medevac'd out to Balad for a week, just going through tests. I was one of the able bodies—able to walk—so I was out there taking any injured marines off the helo, bringing them into the ER. Marines, soldiers, everybody, you know, because a lot of people got injured. One thing that really stands out from my trip in Balad was four soldiers who were DOA; it was me and another marine and two soldiers who got to drape the flag over

their bodies and take them out. We were walking them out to go into the truck so they could go home to Germany, sending them back to their families. Everybody saluted. Very, very, very touching. Just the honor that people show. It's something I'll never forget, nor will I forget anything that happened.

A lot of people see the war side of it, but you don't see people being injured, missing body parts. Even Iraqi children, babies were going in there. Stuff happens. We all have a job to do, and sometimes people get hurt, civilians, but there's nothing you can do about that. It happens here in America all the time. You're just doing your job, and people get hurt in the line of duty. Other people get hurt just being a by-stander. So it's nothing that anybody can prevent.

Going back, I thought about everything a little different. My view towards Iraqis had changed—friendly feelings just gone, in a snap. I just saw all these people who were dead or injured or missing because of them.

I'm pregnant. I think I'll go back out again, probably next year. I'll volunteer again. If the military wanted you to have a kid, they would have issued it. So you still have a job to do, and that's what you've gotta do.

Major Lori Sweeney, U.S. Army, Retired

Okay, so the press hit about Abu Ghraib and, as a result, about 1,000 to 1,500 prisoners were brought to Camp Bucca.

I had the really interesting experience of working with this doctor who had been the personal surgeon to Saddam at one point. He was not a die-hard Saddam loyalist. He was a prisoner, but they allowed him to do surgery because the need was so great while we were there. The wonderful thing was that he got me quickly trained on simple suturing and small surgical procedures that I was not real prepared to do because I had been an internal medicine doc.

He was a terrific guy, and before I left Bucca, he had actually been freed. As a kind of gift to him for all of his service, they allowed him to live in the aid tent, so he was not part of the general population. But bless his heart, he probably did 600 small surgeries while I was there and helped to train me and my medics. Iraq used to have state-of-the-art medicine and then, because of all the turbulence, the country really fell behind, so that it was ten years behind the power curve. So he wanted me to teach him all the new medicines and strategies that had emerged for treating heart failure and diabetes. We had this neat give-and-take.

He talked about Iraq ten to fifteen years ago. Ironically, fifteen years ago the major medical problem in Iraq was type II diabetes because the culture lived so well. He had seen this

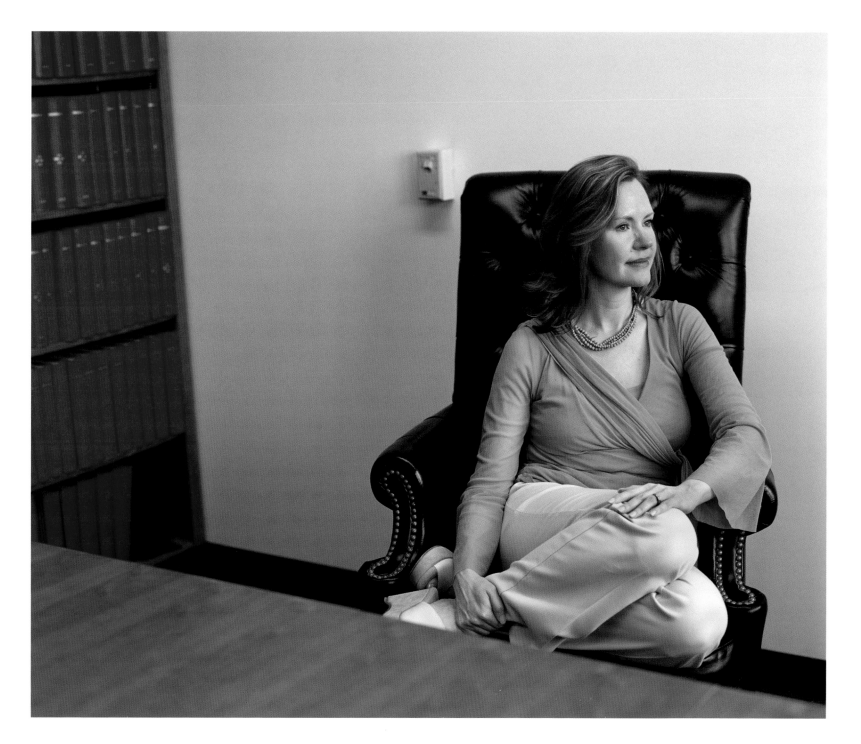

Major Lori Sweeney, U.S. Army, Retired

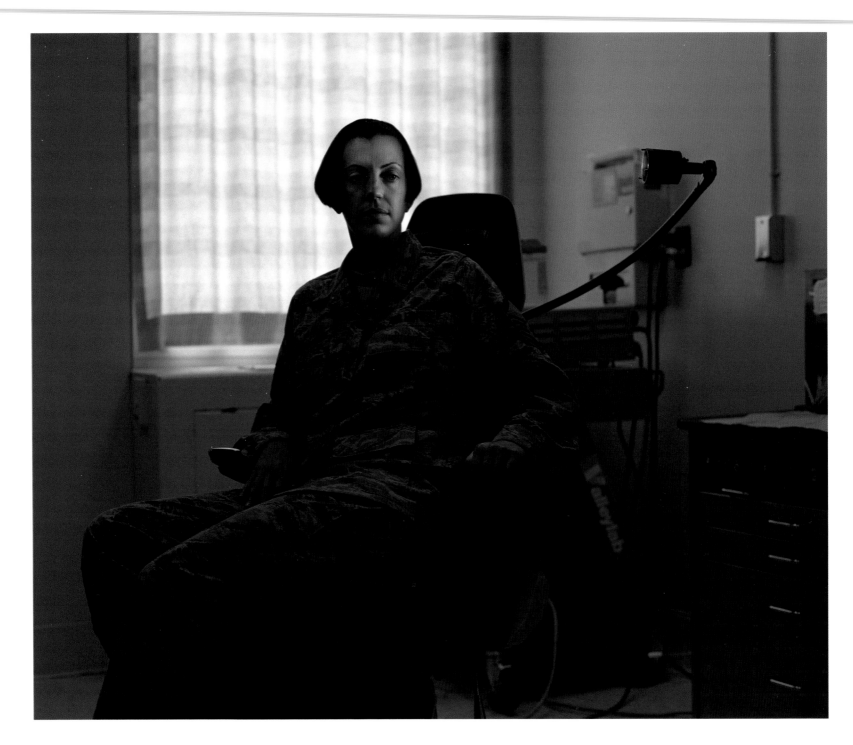

Master Sergeant Lisa Whipple, U.S. Air Force

phenomenal change and talked about the romantic Iraq of many years ago, and what it was like to come up through training. But mostly he wanted to talk about medicine. You could tell he was one of those guys who probably had a dozen medical journals, who read all the time. It was like he was starved for information, so a lot of what we talked about was what was new and exciting in medicine. We were colleagues.

Master Sergeant Lisa Whipple, U.S. Air Force

I'm a specialty surgical tech—head and neck. There's only fifty-five of us in the entire air force. I was in charge of the surgical suite in Salerno—we only had five surgical technicians. When you have eighteen patients come in and there's only five of you and two doctors, there were some long days sometimes. We were the first ones that the soldiers and coalition forces saw from the battlefield. So we were kind of first line there, which was very exciting, very high-paced. Salerno, since it was on the Pakistan border, it got a lot of attention from insurgents. At least a couple times a week, we were getting rocket attacks and mortar. At first, that was really scary, but after a few weeks, you hear the explosions—is it incoming or outgoing?—and just go on with what you're doing.

The day that I arrived in Salerno, we had a mass-casualty event. When the insurgents would try to attack us, a lot of times it would affect the villages around us. This particular day, we had tons of children that came to us, and we ended up losing a lot of them. You have to go out and find the parents of these kids, because when they are hurt, we just pretty much would snatch them up and try to provide them care and later try to find the family member. Before you're there, you don't understand. These are real people and they value their families just like we do. When you get insurgents in and you have to help them, knowing what they're doing to us, you realize that these are human lives. Hopefully by providing help for them, their thoughts towards us might improve. I had never seen death like that and especially the children—that was the tough part, knowing that I have two little boys back home. When you get there, you have negative feelings sometimes towards the other culture, but when you actually see them interacting with each other and you know that this is as important to them as it is to us, that changed a lot.

I have a greater understanding of other cultures and what's going on in the world. Sometimes all we hear back here is the negative, but when you experience it, you realize that those cultures are just like us. They have their beliefs. They're fighting for what they believe in, even though we don't agree with it at all. They're just fighting for their beliefs the same as we're going over there fighting for what we believe in.

For people who have never left America, it's easy to just get focused on what's going on here and how anything that doesn't fit into what America believes or stands for is bad, and that's not the case. You have to get out there and open your mind a little bit.

We had Afghan doctors that would come and work with us, even surgeons. Over there, if you have an eighth-grade education, you can say, okay, I'm going to be a doctor. To bring them in and be able to work with them and expand their knowledge was pretty cool. It was fascinating because they're very eager to learn and a lot of them don't have the resources in their country to get the experience and education that they need, so to be able to provide some of that was very cool.

Specialist Elizabeth Sartain, U.S. Army, Retired

I had met some people, some third-country nationals that worked on our post, and it made me realize not to stereotype, because not every Muslim is the same. So, I met friends while I was over there. We would talk for hours about how they lived in Bangladesh or India and how they came to be here, and it made me appreciate how diverse this country really is and not to stereotype. There are some good people out there.

Sergeant Kimberly Baptist, U.S. Army Reserve, Active Guard Reserve

I'm not a mother myself, but everybody I worked with was a mother in my section. I was like, "Wow. I don't know how you guys do it. I don't know how you guys stay away from your children like that." But they're like, "Oh, whatever. My husband has them." I guess it was a break for them. I did work with one woman and she wore her heart on her sleeve. I remember we had this little girl who was a four-year-old Iraqi civilian who had an open head injury and I think it was because she got shot in the head by one of her family members. Yeah, it was crazy.

We were in charge of calling up medevac birds to go out and pick up these people, but the hospital that was in charge of the head and neck only had a certain number of ICU beds and we tried to keep them open for U.S. soldiers. If it got over a certain number we had to call the hospital and get a doctor's acceptance for other patients, Iraqi civilians, Iraqi police, Iraqi army, detainees even. I remember calling and they were like, can you send her somewhere else. And that was kind of cold.

I was like, "You know what, Sergeant. This is war. You know, we've got to keep these beds open for U.S. soldiers." She just wasn't having it. She has a four-year-old little daughter. I felt kind of bad saying that. But that's how you gotta be when you work in that situation because we can't save everybody. And the doctors at these hospitals, they would accept anybody under

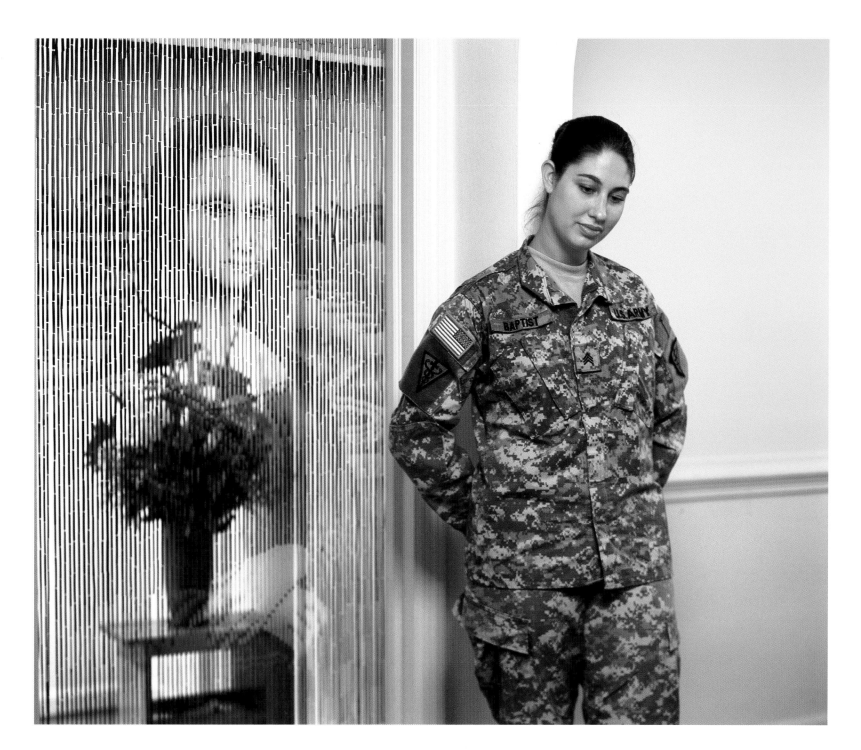

Sergeant Kimberly Baptist, U.S. Army Reserve, Active Guard Reserve

the sun. It was our job to regulate. And it's a hard job. You gotta say no to go pick up a four-year-old girl with a head injury. I think we ended up making it happen and I don't think the girl lived. There was a lot of death over there. Iraqi civilians were the people who died the most.

First Sergeant Shirley Wright, U.S. Army

You see the children out on the side of the road in their rags and barefooted and they haven't had a bath in God only knows how long. They're out there putting their hands in their mouth wanting food or selling liquor or alcohol and pornography, and these are little kids. But their concept is they're trying to make money, and they're being told that this is what Americans like. Whether it's against their religion or not, they're trying to survive.

My commander told me that it was inappropriate for us to interact with the Iraqis, especially with me being a female: it didn't look good. And I said, "Me being a female? They learned from me that they can greet me with affection as another person. They have never once been derogatory towards me. I probably have more respect from those Iraqi men than I've ever had from these men in the military. They understand and they respect me, I have made friends, and this will be in their minds for the rest of their life. Just because I'm an American woman, I'm showing skin, doesn't mean that I'm for sale. They learned from an American woman herself how it really is. I won't be that way with the guys in the unit; I will not be that way with anyone else. But I do believe it's important that we interact and we learn about each other to make things better around here, because you're saying we have to keep a certain distance from them, and I don't believe in that." We used to play games with them, we used to have water fights, just to show them it's okay for you to be happy. It's okay to feel good about being alive. I told him, "If you think that that's wrong, well, I'm sorry. It's not gonna change—not for me."

Sergeant Major Andrea Farmer, U.S. Army

I have fond memories because this was an opportunity to meet a lot of different people including the foreigners. We met some great people that were foreign nationals that work for the contractor and we even met some people from Iraq. And they were great people. The ones that we met were nonthreatening and you could tell that they were trying to do their part. You know, they came on post. They were vendors selling jewelry and things of that nature. They were great people who just really wanted to see a peaceful resolution from my understanding.

Now, in the camps, we had locals that came on, and they had a little bazaar and sold their local stuff, like rugs or whatever the case may be. Movies—that's a huge thing over there—movies. And we had girls that cut hair, too. I went there often to get my hair cut. They had a barber shop and then they had a beauty salon. It was nice to go in and it was a female atmosphere. It was all girls. You could put your hair down, instead of having it in a bun all the time, get it washed. I got it done over. It was just something to escape for a while. Get away from everything. And it was nice to interact, and the girls were always dressed nice and always very complimentary: "You have such beautiful . . ." and I don't know if it was BS, but it felt good that day. That was a good escape.

Ensign Colleen Fagan, U.S. Navy

Deployment teaches you a lot about survival and teaches you a lot about cultural awareness. It also teaches you about what other women around the world are going through. I have met women in burqas; I have met women who were following behind men; I sat outside a mosque at a café table one day and just watched people go by, and it really makes you aware. I learned a little bit of Arabic while I was over there; it really teaches you that it's one world. It's not the U.S. and the rest of the world. It's one world, and it really kind of crashes down those ethnocentric attitudes that we have. There is a lot of arrogance within the military and in the civilian community, and I think that by forcing yourself into situations like the military or deployment, it breaks all of those barriers. You really find out "Wow, that person over there is just trying to feed their family, just like me."

I think it changed me in that aspect. I've always been very liberal-minded. But it really hits home when you talk to people, and I talked to everybody over there. I mean everybody. I would talk to women, men. It's amazing—they just want to talk to you. They just want you to know that they are not looking for battle. They're not looking for war. In my generation, I think that there's a real lack of leadership and a real lack of responsibility, and I think that going through the deployment and the military thing, it really heightened my sense of awareness that I need to be just as much of a leader as the people in my dad's generation.

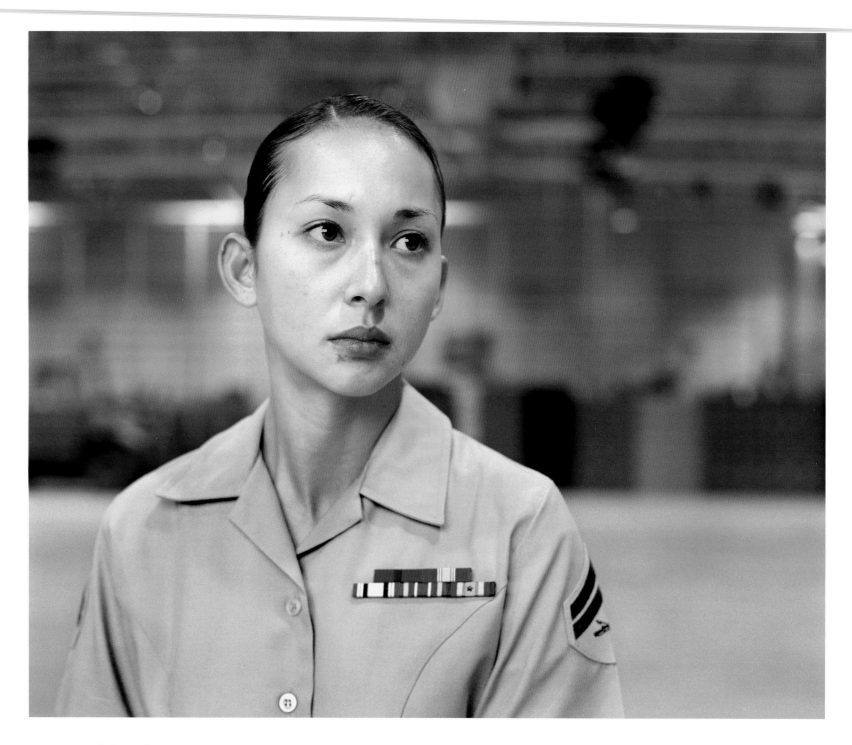

Sergeant Chalina Seligson, U.S. Marine Corps

I was born and raised in Seoul, South Korea. I lived there for eighteen years and then, after I graduated from high school, I came to the States.

I was in a Lioness program. It's a program where female marines go and search other females. I hadn't gotten to go outside the wire on my first deployment, and I really wanted to on my second. I finally was able to go for about a month, and it was pretty exciting and interesting.

I was part of a team of marines who worked with Iraqi officials managing their port. They had cargo trucks coming in and, because we were on the border, we were checking passports and making sure the Iraqi officials were doing their job. Just trying to maintain good relations, basically. That part was extremely fun. I got to have a lot of Iraqi food and chai, and there were a lot of meetings.

I'm actually getting out pretty soon. I'm going to go to school for international relations. This deployment really sparked that. I just want to be a part of that somehow. I haven't really fine-tuned the direction yet, but I know it's somewhere in international relations.

Just seeing how different the cultures are, even within the Iraqi culture itself, is really interesting. The Iraqi Kurdish and their cultures were completely different; their language was also very distinctly different. What they think because of what they were taught when they were little is quite different from what we were taught when we were little. How it's all imbedded in their culture and way of life is really quite interesting to me.

Contractors

Throughout the Iraq and Afghanistan wars, the U.S. government has relied to an unusual degree on outside contractors to provide not only services like laundry and waste disposal, but also cooking, recovery teams after IED explosions, and security details. Generally, there have been as many contractors as there have been U.S. troops serving in these war zones, and contractors often outnumber troops; in December 2008, there were 142,000 U.S. troops in Iraq, and 148,050 defense-contractor personnel working in Iraq, 39,262 of them U.S. citizens.[1] This reliance on contractors has proved controversial—as a recent article in the *Army Times* noted, "More than 500 other major fraud cases . . . involving millions of dollars at home and overseas, have kept a team of Army Criminal Investigation Command special agents so busy that their commanders are asking for more money for more agents to combat a seemingly rampant problem."[2] (In fact, the new Army Contracting Command, officially activated in March 2008, has over 4,000 personnel, including 400 military and 1,100 civilian personnel specializing in contracting.) Such attention to contractors is necessary; by the end of 2008, the United States had spent $100 bil-

lion on contractors in Iraq since the invasion in 2003, and as a report in the *New York Times* noted, "One out of every five dollars spent on the war in Iraq has gone to contractors for the United States military and other government agencies, in a war zone where employees of private contractors now outnumber American troops."[3]

Contractors like Kellogg, Brown & Root provide what more than one soldier fondly remembered as "those weekly KBR lobster tails and T-bone steaks." But contractors also make significantly more money than troops doing similar jobs, which has often made for uneasy relationships between the two groups.[4]

Sergeant Katharine Broome, Virginia Army National Guard

We had some civilian aviation mechanics working with us. I'm sure they were all nice people. We just avoided them. It was hard to not be resentful of the fact that they were coming over, never had to put themselves in harm's way and yet were able to clean house financially. When somebody is making that much more than everyone else in our battalion to include our commander. . . . You would see written on the inside of porta-potties, KBR and then underneath someone would say, "Keep Bush rich."

Sergeant First Class Kim Dionne, U.S. Army Reserve

We had KBR. We used to call them kin, brothers, and relatives because of all their buddies hooking each other up, making a fortune. A lot of the soldiers wouldn't reenlist. They'd say, "F-you, buddy. Why would I want to reenlist when I can go back home, get out of the reserves and go work for KBR and make $100,000?"

Sergeant Kimberly Baptist, U.S. Army Reserve, Active Guard Reserve

We did see a lot of American contractors in our hospitals. I talked to a few on base. They were contractors who had contractor parties. Because alcohol was forbidden over there, but they had the hook ups, so you would hear people like, "Yeah, I'm going to a contractor party." "Okay. Have fun." They were really cool. They worked long hours just like we did and they had to abide by the same rules. In a war zone, quite a few Americans gathered together. They're young, they're gonna try and have their fun. They were involved in fire fights, but they don't carry a weapon so it's just crazy. They're walking around without a weapon. I just think that contractors over there should be able to carry a weapon. Just maybe even a sidearm.

Staff Sergeant Jamie Rogers, U.S. Army

The contractors, like Brown and Root, we worked side by side with those guys because they were our recovery team. And any time anything got blown up and any time there was an accident we had to call them out and escort them out there, and they had this $300,000 rig that they recovered things with. And they were older men, probably between forty-five and fifty-five on average. A lot of people liked them, but I never really got into their whole persona. They used to always talk to us and some of them had been in the military. They didn't like the part that they couldn't carry a weapon. You understand that, because if they would kill somebody, there's really no jurisdiction for them to be tried, because what law did they follow? Yeah, it's a very fine line. But of course you don't get into the politics with them. You're just like, "Yeah, yeah, whatever. We'll take care of ya."

Spirituality

Many women, whether they were praying for strength to withstand the daily mortar fire or to hold up under the unjust treatment of a commanding officer, talked about their experiences attending church in the desert, singing in the choir, and sometimes having profound spiritual awakenings. For some women, their faith provided them with a rationale when nothing seemed to make sense. As Staff Sergeant Laweeda Blash told her oldest son when he said, "'Mommy, I'm tired of you going.' I said, 'I know but, you know, Jesus got a plan. He's allowed me to go for many reasons, and plus that's part of my job.' So he took it with a grain of salt and just did his best." She said, "It was heart-wrenching knowing that you had to leave your family, not knowing what to expect, praying to God that everything's just gonna stay afloat till you come back. And you pray that you come back. You pray that this hurt is over."

First Sergeant Jennifer Love, U.S. Army

Once we did get into Al Asad Air Base, it was almost destroyed. It became home after seven months. We had a lot of convoys going out all the time, especially our supply and transportation unit, which was always on the road, taking fuel, water, and food to places like Haditha—the other little places in Iraq. And almost each time we had fatalities, IEDs. It was mostly RPGs. When we were sending a lot of our soldiers back to the States on R&R, the Chinook got hit by a RPG that killed all of those soldiers on that aircraft. That was the saddest day in Iraq for us. We lost, I think, thirty-six soldiers, and they all were E-5 and below.

When convoys'd go out, I'd pray that they'd come back safely. That was my source in dealing with everything, just prayer and trust in God that he would bring them back.

I believe that the Lord allowed me to go there so that I could be a strong pillar for the rest of them. And I believe that many of them leaned on me a lot, whether it was prayer or just to talk. It caused me to really see that my purpose there was to minister and encourage, motivate and inspire. We established the first gospel church services on Al Asad, and a lot of soldiers attended. It didn't matter what race or gender, they came. And even some of the Iraqi nationals came to the services. We had Bible studies and prayer.

I have a heart of compassion, so I'm a firm but fair drill sergeant. I'm gonna listen to you and hear what's going on. When you don't do what I've told you to do, then yes, that's when the yelling and screaming come into play. But, for the most part, it is enforcing standards and teaching them how to be soldiers and leading by example, as well. I want them to be proud of who they are. I'm proud of who I am and the things I've accomplished in my eighteen years of military service.

Major Lori Sweeney, U.S. Army, Retired

During that time that we were in Camp Virginia, I started to look at the medics that I thought were going to be assigned to me, 'cause you know, we traveled with forty, and I was going to get twelve or fifteen, and I thought, "Oh my God." There's a cuss word every two minutes, and I think some of them had been forced to join the military rather than go to jail. And I think that I was a little freaked out by them, and I think they were a little freaked out by me, because they just saw me as this sort of nerdy female who was reading medical textbooks all the time, and didn't talk a lot, and read the Bible a fair amount. 'Cause I certainly reaffirmed my spirituality about two weeks into my deployment into Iraq. I've always had a personal relationship with God, but really felt that I needed a stronger sense of purpose while I was there. As soon as I got to Camp Virginia, I started attending the little church sessions that were held by the chaplain, and started reading the Bible and really praying a lot. And so, there was just

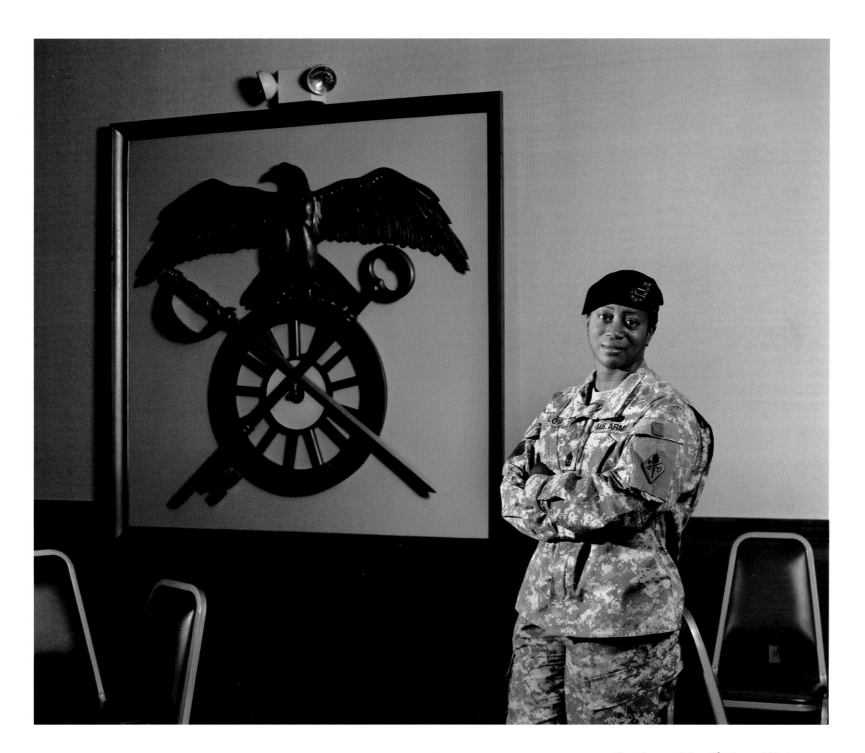

First Sergeant Jennifer Love, U.S. Army

this sense of "how am I going to teach these guys who are so different from anybody else I know? How's this going to work?"

By the end of a year, the relationship that I had formed with them was probably one of the most significant, intense types of relationships that I've had with any humans. And the ones that I thought were the coarsest, had the worst attitude problems, that were not motivated—were. And I think of them now as my children and still correspond with them by email. So, there was this wonderful thing that happened over the course of a year—very moving, wonderful thing that happened.

Staff Sergeant Debra Fulk, U.S. Army

I have a whole different outlook on life. When I first came back from Iraq I said I went over there with what I felt was more and things were taken away from me. I lost my sister and my rank. But then I came to the conclusion, it was spiritual, that no, I came back with much more than I ever knew because it gave me more sense of self. Gave me another outlook on life. I did wonder when they first asked me to go, why me? But I know I was sent over there for a reason, even to go through all of that madness. It had to be a reason because that's the only thing that makes sense to me and had I not had that experience, I don't think that I would be the person I am now.

I had to dig down deep. I just remember what my grandmother told me years ago: "You are what you are and what you have is what God has blessed you with. He's blessed you with so much. Don't ever give up. We don't have that spirit in our family. We're not quitters. Don't ever give up." So her voice would often ring in my head, "Don't ever give up."

The Mission

U.S. troops are sworn to uphold the orders of their commander in chief, and to carry out their assigned missions. Some believed in the mission, some didn't, and many women talked about how they had to believe their actions made a positive difference. Each woman found her own way to bring meaning to the mission whether she talked about the importance of bringing democracy to Iraq, or saw her job as helping to provide a better life for Iraqi children, or redefined the mission in her own terms to be about supporting her fellow troops.

Sometimes, this conflict got to be too much. One retired army officer, who ultimately asked that her photograph not be included in the exhibit or the book, told me that she spent the months leading up to her deployment searching the internet for positive information about Bush and the war effort because she needed to believe and couldn't. In an Iraq supply unit, she was in agony over having to send her troops out on convoys knowing that she had to plan for a ten percent attrition rate. Ultimately, she came home and resigned her commission.

Yet there were many women I interviewed who did not share these qualms, who joined the armed services in the wake of 9/11 out of a strong desire to defend their country—and knowing that they would almost certainly be deployed to a combat zone.

Staff Sergeant Chanda Jackson, U.S. Army

During my first deployment in Afghanistan, I spent most of it being so unsure—unsure of why we were really there, trying to really understand it. What are we really fighting for was the biggest question. I spent a lot of time keeping up with what was going on in the news, and watching what was going on with other units when they had the ambush of Jessica Lynch's unit and all of that.

Why were we sending soldiers straight out of basic training onto the battlefield? I know they say that it should be fresh in your mind right after basic, but to be taken from a crawling stage to running I thought was crazy. I want to say that's something I've seen progress on from then to now; they're not sending as many people straight out of basic.

I deployed the second time with a lot of soldiers who had never deployed before, and I still couldn't truly answer why we were really there. I mean I can give you an answer. Is that answer acceptable in my mind? No. But we're here to do a job, and I signed up for it. I'm going to do what I'm called to do.

Senior Master Sergeant Pamela Hadsell, U.S. Air Force

My dad spent several years in the Marine Corps many years ago. When I called him and said, "Hey, I'm deploying," he said, "Pam, you can retire. Just retire now. You move down here, you can come work for me, and I don't want you to go over there." He was getting really angry at me. And I said, "Dad, I love ya. But you just need to support me. You just need to support my decision."

He hates the war. Hated it from day one. But I had to tell him, "Don't get mad at me. It's my job. It's what I do. I am out there helping to keep us free, so if you just look at it that way, that's gonna help me get through my deployment." I'm a registered Republican. He's a registered Democrat, so we're just opposite ends. But he just didn't want to lose his daughter.

My sister called me up the day before I left and was bawling her eyes out and saying, "What if I never saw you again? How am I going to live without you?" I'm like, "Bonnie, I'm not dead. I'm not going to go over there and intentionally get myself shot, but I know the risks." I knew the risks before I went over there, and I'm still okay to do that. My husband knew the risks and still deployed, because we love the air force and we love our country and we love what we do, so we went. Without hesitation, we went. And we would go again.

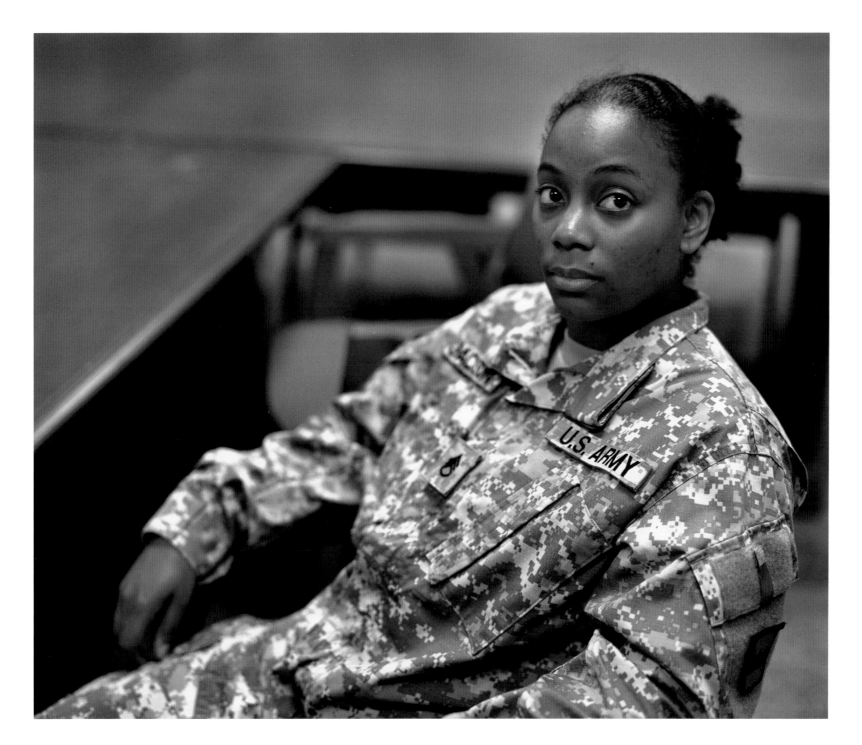

Staff Sergeant Chanda Jackson, U.S. Army

Ensign Colleen Fagan, U.S. Navy

I've never liked things to be too complex on the outside. I think that we're already very complex as human beings; the least we can do is simplify our lives. As a soldier or sailor or airman, you have this great position where you can afford to not be so engrossed in the politics of society because if you try to, it gets in the way of the mission. I think one reason why a lot of service people don't vote, or don't think about voting, is because they don't want to touch politics, because it confuses what we're doing.

This war can bring out the best and the worst in people; it's the kind of experience that only people who were there really understand. And a lot of times, you feel like only those people will understand you. You'll rarely find service people who have been friends through deployments ever break that bond. It's a security blanket, essentially.

In my opinion, the navy did their best to keep the morale high; they couldn't have done a better job. For the most part, I don't blame my service branch or any other service branch for their decisions. But a lot of us were starting to say, "What is going on in the White House?" So we really started to ridicule politicians.

I started to see the mission as failing, to be honest with you. At the beginning, it was like, "Okay, we're doing something." And then, right around the end, it became, "Okay, I'm supporting the troops, but I'm not so sure about the mission anymore."

If I can go back in, I will. I'm very happy with the life I have now, but I have tasted both sides of the fence, and I think I prefer the military life over the carefree. I wouldn't be going back for the politicians who are running the war, or the taxpayers who are funding the war, or the people who control the White House and all of its everyday functions with the war. I would honestly be going back there for the troops. They need the support, and I would be going to help them. The real heroes of this war are not people like Rumsfeld but the people who are over there.

Sergeant Katharine Broome, Virginia Army National Guard

I deployed to Iraq and had some internal struggle with it because I believe in what's happening in Afghanistan. When the president started bringing Saddam Hussein into the picture, I wasn't convinced. The fact that I had to deploy to a country where I didn't necessarily believe we needed to be in the first place was really, really difficult for me.

I was able to justify it because I am a medic. I was not responsible for pulling triggers; I was only responsible for helping those who had been hurt and, to me, that made going over there okay. My National Guard unit is a very tight-knit group of people. I would not have

Ensign Colleen Fagan, U.S. Navy

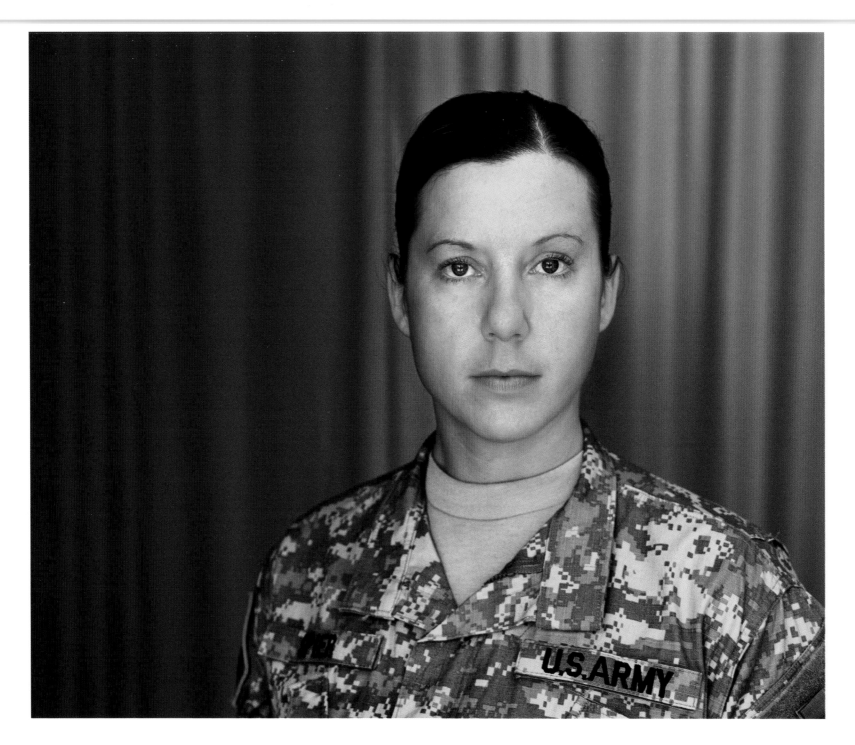

Warrant Officer Chelsea Spier, U.S. Army

been able to sleep at night had I known that my family was over there and, if one of them got hurt, I wasn't able to help.

Warrant Officer Chelsea Spier, U.S. Army

May was when we got into Victory, the compound outside of Baghdad International Airport, and we ended up staying there. It was almost like the wild, wild West—you know, the pioneers trying to get their patch of land. "This is gonna be your building; that's gonna be our building." They had let all the animals loose from the zoo, so all these wild animals—lions, tigers, panthers—were trying to feed themselves. They had to sleep on top of the buildings because they were afraid these animals would come inside and attack the soldiers. We didn't want to kill them, so we tried to capture all of the animals and give them back to the zoo. We had to go into these buildings that were almost immaculate—marble walls, floors, ceilings.

I was told from Day 1, You always take care of the soldiers, no matter what you do. And, if at all possible, you've got to try to stay positive because everybody around you is going through their own sacrifice, being away from their family and their everyday, normal life. I'm not saying I didn't have my own personal issues; I missed my family and friends, and I felt two years were taken away from me. I had to go back and be normal again, which I could not.

To be positive and appreciate the people around you gave me a better outlook and a better way of being. I couldn't just be yelling and screaming all day and hate everybody around me. After two rotations, I wanted to be there for the soldiers and do the best that I could. I do not want to treat anyone the way I was treated when I came in, so you learn from every leader: the good, bad, and indifferent, and you take all the positive things from every leader.

At first, you know, you're mad because you have this time taken away from you. You come back, and everyone's gone on with their life. Everybody still has their cell phone in their car and their cable TV, and you come back, and they say, "Oh yeah, you're back. Nice to see you. I'm going to work." And you're like, "Wait," you know? You're just trying to get back to that peace of being normal again.

Captain Carla Campbell, U.S. Army

For some, it brought us a little bit closer, for 90 percent, it distanced us off in that some of my family doesn't really approve of the military thing, but that's my decision. My mom was run off at first but she's totally in it now. She shows pictures. She has this life-size picture of me that she shows everybody, this big ol' picture on the wall of me in uniform, and you walk in and you're like, "What?" And she shows everybody. It's weird. And my dad is the same way.

But it strengthened some and some it has distanced off. I haven't talked to quite a few people ever since I came back or before I left because they did not approve.

I made my mom stop watching the news because every time I got an email or every time I called her, she was crying hysterical because she'd see someone else has died or see stories, and I'm like, "Stop it. Stop it, stop it, stop it." All you see are the highlights of the bad stuff. You're not seeing all the good stuff that's happening. You're not seeing all the rebuilding of the schools . . . Everything that we're doing and all the hands-on stuff that we're doing. You get snapshots of that. But honestly, that don't sell news. The bad stuff does. People are more interested in the gossip sometimes than the truth. And that's why I was like, "Don't watch it. Just stay away from it because you're not going to get the real picture. If you actually want something, go ahead talk to someone who's been over there. Ask them." I know it's free speech and all that but . . .

Colonel Jenny Holbert, U.S. Marine Corps, Retired

I think probably the most remarkable were the Iraqi people. They suffer so much; they don't deserve the situation they are in. They're just normal people like everybody else, and they have a horrible existence. It's worse than any third-world country I've ever been in because it's so desperate over there. And they just want to survive, and they really just want their children to survive and do well. That's all. But it's these decision makers and politicians and everybody else who get in their way of having a decent life. So many things are out of their control.

I was thrilled because it was important in my career to have experienced, or done what you're supposed to do in the military—go fight. Now I'm a colonel, and I'm female so I'm not going to be on the streets when a squad is patrolling in the city. That's not going to happen. So how close can I get? What can I do? I got to do the second fight in Fallujah as the public affairs director.

I made decisions that would impact perhaps on a global scale. In some ways, that was exciting. In some ways, oh boy, you just wrack your brain. You're trying so hard to make sure that this is the right thing to do when, in fact, you don't know. There's plenty of chaos over there.

Truth is elusive. I've come to learn that there are a lot of facts out there, but there are very few truths. What we perceive to be truth here is not truth in Iraq.

I felt very grateful that I got to be the one in charge of the public affairs effort for this tremendous battle. It was so gratifying. It didn't matter how hard it was; it was just so professionally satisfying to be the public affairs director for the MEF, to call the shots and do it.

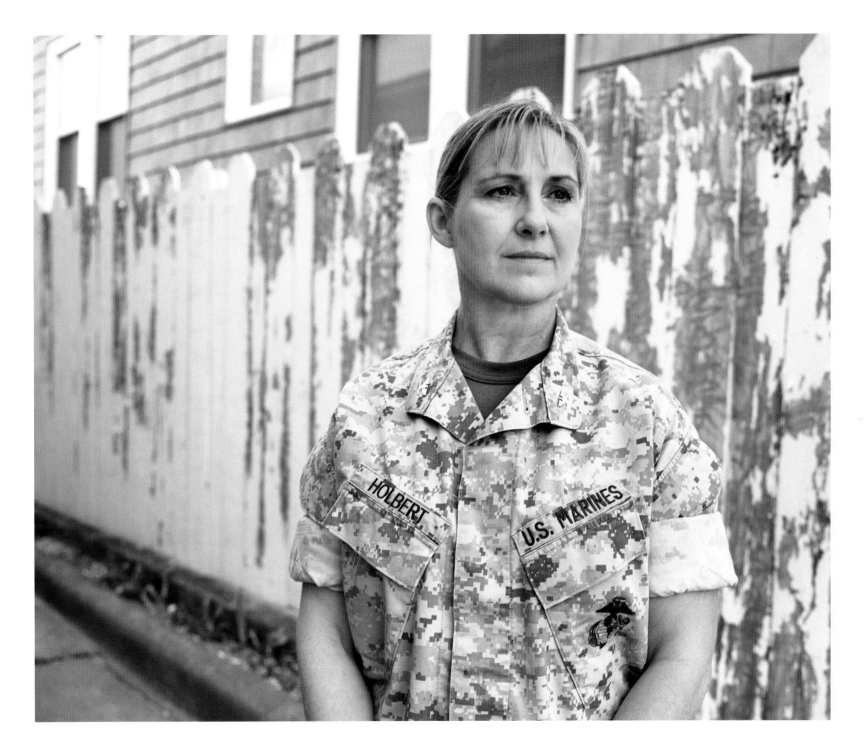

Colonel Jenny Holbert, U.S. Marine Corps, Retired

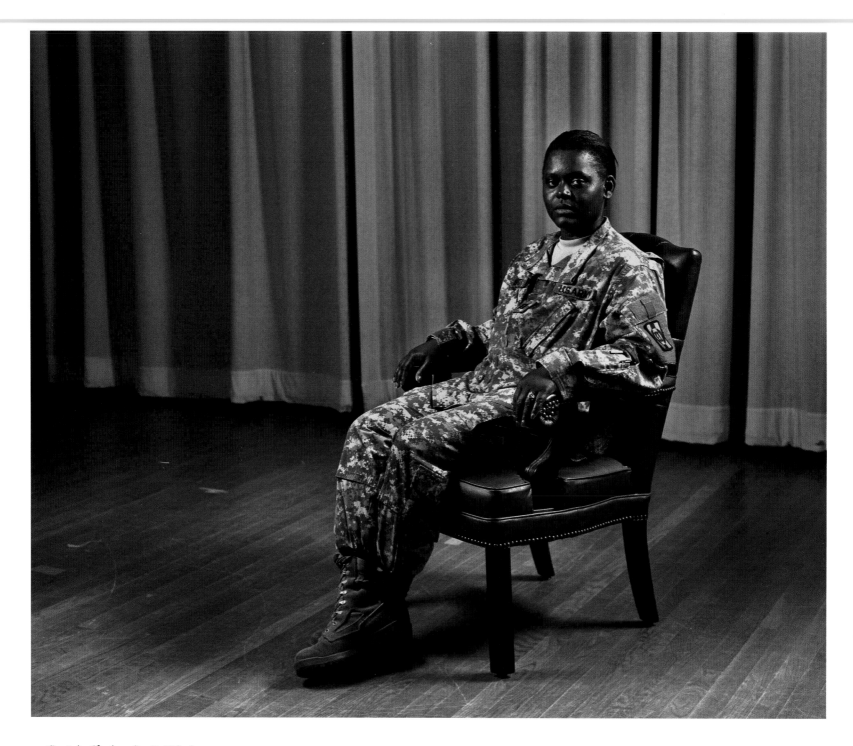

Captain Clarisse Scott, U.S. Army

It was probably one of the biggest events of my life, other than birthing two children. Other than bringing two human beings into the world, that's probably the next most important thing I've ever done.

Master Gunnery Sergeant Constance Heinz, U.S. Marine Corps

I think if I'd have never gotten off of Camp Fallujah and had never had any interaction with the kids, I don't think I would have changed to be a better person. Before I deployed, I explained to my children that I was deploying for the children, so that they had a future, so that they had an opportunity to have a better life. That the kids over there did not have a life like my children understood or knew. They didn't know if their parents were coming home, if they had access to an education. Even though this is how I explained it to my children, whenever I would go for long periods of time without any interaction with children to kind of put me back on track, you start to feel like "Why am I doing this? Why am I making this type of sacrifice?" And then you go out and you see one of these little smiling faces, or you see one that just fell down and has a boo-boo, and you're just like, "This is it. Okay—I got it now—I can keep doing this. I can keep doing this."

Staff Sergeant Shawntel Lotson, U.S. Army

What makes it a lot harder is to know that you're over there fighting for a cause and for a purpose. It's not only to fight for our freedom, but for our patriotic spirit. And when you have our own people back over here in the States . . . it's okay to protest, but it causes a lot of chaos. It hurts for some people to have a family member who's bringing negativity on. Support us no matter what. We're out there trying to do a job. We're fighting for you. We're fighting for everybody. We want to help them establish their own government, so that they can have a nice place to be just like we have—America, you know? We want everyone to feel that experience, whether we're good or bad. We have bad in the States, we have bad across the world, but we still have to help keep the troops' spirits alive. It's hard knowing you're over there fighting, and you've got people fighting over here.

Captain Clarisse Scott, U.S. Army

All the freedoms that we enjoy, people take for granted. You go over there and see people fighting for them and actually losing their lives. I look at people who don't vote—"Why don't you vote? People want to vote and can't vote." Things that people take for granted I take more seriously.

You sometimes see the actions of the younger children and teenagers these days—are they

paying attention to what's going on? All the freedoms that they have just to make bad decisions and go get in trouble? You see on the news somebody's robbing this person, killing that person—what are you thinking about? You have people that are fighting a war, that are losing their lives for you—so you can go do some silly stuff like this?

Staff Sergeant Jamie Rogers, U.S. Army

When you see businessmen, you see professionals. I look at soldiers now: we finally proved that to everybody, that we are professionals. We have skills and trades that other people can't understand. They look at you just like the military's the military. It's not a career. It's not a profession. And I look at it so differently now. I have to do it to the best of my ability. Before, I looked at it as a job. Something that I'm going to do for while and then I'm going to be done.

I just never saw myself as being a career soldier. But we went to war and we were these professionals. People looked to us. We were the experts in certain things. And then you come back and it's not a job to you anymore; you're a professional. And I think that's changed my leadership style 'cause I try to stress that to soldiers: "You're professional. People are going to look to you when things are going wrong, and you're going to have to make it happen. So you should carry yourself with the professionalism as that businessman does. Because that's what you are, you know." I know a lot of people join the military for various reasons, and a lot of them are running from things. Either they have bad relationships with their parents or spouse or they don't have anywhere else to go. They find a family in the military. I consider myself a good professional and I never did before. And I would say that is exactly how it changed my outlook.

I laugh because I watch the news all the time, so I hear all these different opinions: "I support the troops, but I don't support the war." I completely understand what they're saying. They don't want service members to die. And in my job as a retention counselor, I deal with families a lot, and a lot of families say, "I don't want John to reenlist because that's six more years he could possibly go back there." But as a whole, I just don't think that people understand any more the sacrifice that soldiers make. No matter what your feelings are, you should always thank them because they said, "I'm going to die for you," and to me, that's the greatest honor ever. Someone sent me something the other day and it said, "There's two people that have said they'd die for you. That's Jesus Christ, for your salvation, and the American GI, for your freedom." And to me, it's the truth. It's not like we want to die; that's not it at all. But we see this great country we have, and it's something we are willing to sacrifice our time, our family, and our lives for.

Motherhood

Many of the more than 200,000 women who have been deployed to Iraq, Afghanistan, and surrounding countries are mothers, including many single mothers.

Because she occupies what are traditionally two mutually exclusive categories—"woman" and "warrior"—the female soldier has occupied a sexually charged position in American popular culture. Sexualized representations of the woman in battle began in this country with eighteenth-century woman-warrior ballads and cheap early nineteenth-century novels about women who cross-dressed and followed their lovers into battle—and the stereotypes of the sexy female soldier have plagued military women ever since. Yet these pop culture representations—whether they are the lascivious cartoons about WACs and WAVEs of the 1940s or the busty women in camo bikinis in G. Gordon Liddy's "Stacked and Packed" calendars of the 1990s—have invariably focused on single women. If "woman" and "warrior" were categories that seemed incompatible, then "mother" and "warrior" were an even more unthinkable combination. However, the current wars have made such thinking obsolete.

Frequent deployments can attenuate women's bonds with their children. Yet even as military life makes motherhood difficult, motherhood is the reason many women give for joining the armed services. For women whose children have serious health problems, joining the military is a way of getting good health insurance.

With the military stretched to the breaking point, the marines now consider women with six-month-old babies eligible for deployment. In the army, eligibility begins when the babies are four months old.

The fact that many female combat vets are single mothers throws issues of child care into sharper relief. A recent article in *Good Housekeeping* magazine details the crisis in child custody agreements that has arisen as a result of mothers' frequent deployments. Some judges accept the argument of military mothers' ex-husbands that women who deploy should have permanent custody transferred to the child's father on the grounds that a mother's deployability inherently makes for a less stable family environment. Since one-third of deployed troops have kids at home, child custody has become an issue that fills the pages of military blogs and has drawn a lot of attention in such media outlets as the *Washington Post*, NPR, and *USA Today*.[1]

Even mothers who do not face custody issues grapple with adjustment problems that most troops deal with after returning home from a year or more spent in a combat environment. Many women I interviewed referred to their PTSD diagnoses and the symptoms that they developed as a result of combat trauma, ranging from anorexia and compulsive eating disorders to TMJ (temporomandibular joint disorder), rage issues, and nightmares. However, mothers, by and large, did not want to label themselves as truly damaged—perhaps because the taboo against being an impaired mother is so strong. When I discussed this issue with journalist Joshua

Kors, who has written extensively for the *Nation* and other publications about the problems faced by returning veterans, he told me that fathers he interviewed openly acknowledged their struggles with PTSD. Not so with the mothers I spoke to.

Our culture has always seemed able to cope with the idea of fathers as warriors—think of all those photographs on the front page of your local newspaper featuring a returning soldier seeing his baby for the first time or reuniting with his older children. We may be less able to handle the idea of mothers as warriors, which to many people may bring home more starkly the cost to military families of this seemingly endless conflict. Yet it may also force the American public to realize not only that military life and motherhood are compatible for many women, but that in many cases the bonds formed among soldiers or marines may feel even stronger to women than those they have with their children.

The American public has accepted female war casualties—over one hundred to date from the current wars—far more easily than many commentators had expected.[2] Apart from news stories about child custody issues related to deployment, there has been less media attention to mothers in battle than one might have expected. Yet as the wars continue and mothers are deployed for long periods, often returning with physical and emotional injuries, their stories will force us to reshape our cultural ideas about motherhood.

Master Sergeant Odetta Johnson, U.S. Army

I was probably approaching my eighteenth year before the tough question came. And so that was eighteen years of being a reserve soldier and watching other people. Training and preparing and here's the ultimate mission. And it was difficult because I was a divorced mother with two kids and I also had just been promoted to lieutenant on the police department.

Every day was amazing because you didn't know what you were gonna be a part of. You didn't know if you were gonna go to the Ministry of Defense and see them sign some great document that was gonna free someone from something. You didn't know if you were gonna go on a mission to assist with them recruiting new Iraqi soldiers. It was exceptional.

Whenever I got hurt I would tell them, and I thought it was so exciting I was sending pictures home. But I had no idea they were like, "Oh. Oh." And I was like, "Oh, it's not that bad." But they were keeping up with me when I said, "Well, I went to the Ministry of Defense two days ago." And they were like, "Mom, that was near Suicide Cape." And I was like, "How do you know about Suicide Cape?" "It's on the internet."

I'm a police officer, mother, and I'm in the military, and not necessarily do they come in that order, and when my son became ill that was one of the tough decisions—when they said, "Well, we're gonna allow you to go to care of your son because he was gonna be incapacitated." And I felt such an enormous amount of guilt and of course my family is, "What? "What are you talking about?" But for me it was hard because we went in together and we wanted to finish all together.

He had to have an operation on both of his feet. He had an extreme case of flat feet and I knew that once they operated on him that for a couple of months he would be incapacitated.

Of course, my family needed me. Of course, we have family care programs where people are supposed to care for them, but I kept hearing my son say, "But, mom I want you. I want my mom." And so again here comes the commitment issue of saying that I have signed up and this is where I'm supposed to be at this time. And it's not like you go on a mission every year. It was just my time and so many different things was happening at the time that I was supposed to be serving my country.

Staff Sergeant Phyllis Magee-Lindsey, U.S. Army

My oldest son was in the fifth grade, but they understand so well. They was like, "Well, mom, what are you doing?" "Well, I gotta get you because we gotta go back to Mississippi." "But where are you gonna be?" I said, "I'm gonna be in Iraq or somewhere." They were like, "Oh" and they get real quiet and then they start to wonder, "Momma you gonna be safe over there?

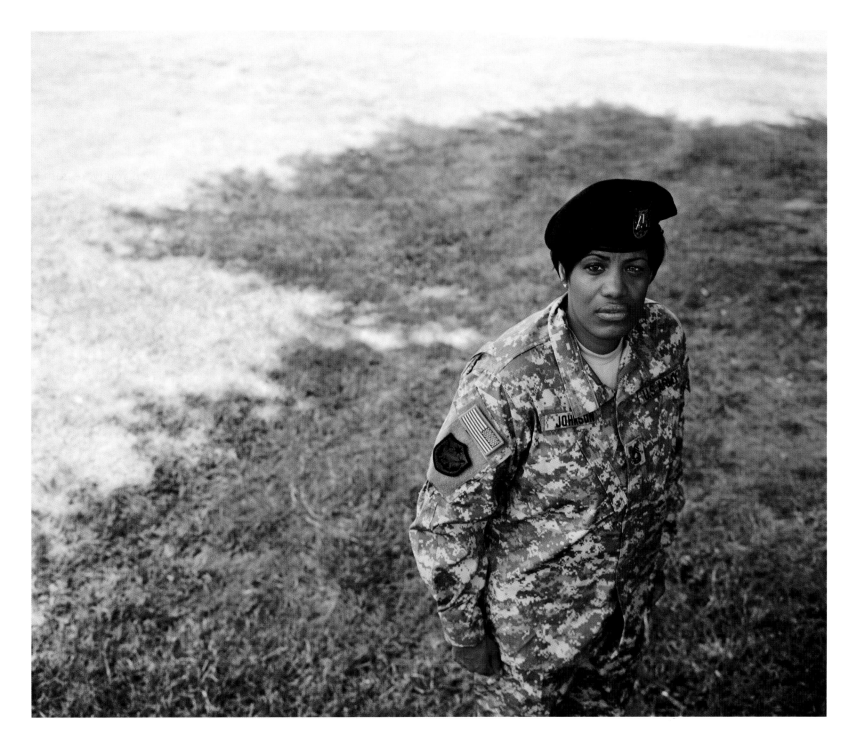

Master Sergeant Odetta Johnson, U.S. Army

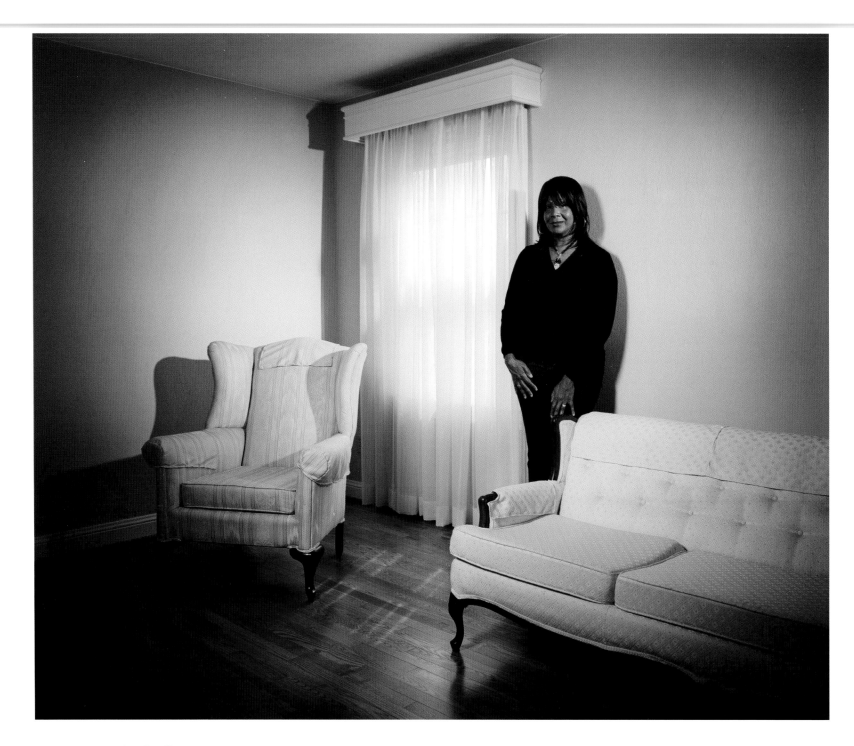

Lieutenant Colonel Willa Townes, U.S. Army Reserve, Retired

Momma, what are you gonna have to do? Momma, you gonna be fighting the bad men?" and all of that and so it just got crazy.

When I got there the first time, the worst thing I could imagine happened to me: I saw a dead body. I was like, I'm trying to leave this place as untouched as possible because, after the army, I have to be able to be a mother to my sons and mother them effectively.

Katrina hit while I was over there the second time. I had been accustomed to calling my kids regularly. When I couldn't get in touch with my boys and talk to them, I remember really feeling useless. Just not knowing had me crazy because you're watching this stuff on TV. My family was there, too. They did allow people from the area to come home and check on their families. When we were going home, we were flying with wounded soldiers. Just seeing those soldiers, and the way the nurses and the doctors took care of them and all of that, was just like . . . "Oh, my God." They were laid out, and some of the soldiers could get up and move a little, but you could tell that it was taking all their willpower to just move from there to the toilet. There were amputees on that plane and people who had mental problems; they were giving them medications so they would be able to fly.

And then we got back to New Orleans. Other soldiers spent all the time that they could before they had to get back, and they still didn't know where their families were. But I found my boys. They were good. They were surprised to see me.

My family thinks I'm crazy. "Not quite right"—I think that's how they say it. But there's nothing wrong with me. Some of the things that I probably wouldn't have said before, I'll tell them now. I'll try to be tactful, but sometimes it doesn't come out tactfully. But they still get the meaning.

Lieutenant Colonel Willa Townes, U.S. Army, Retired

I found some great people that were the directors at my son's daycare, 'cause I was telling them, "You know, folks at work are talking to me about getting in the reserves." And I said, "What do you think about that?" And she said, "Oh go for it." And I said, "Yeah, but I have no one to keep Sam." She said, "Oh yes you do. Us." And it was great. So when I had drill, they would keep Samuel and everything was fine.

Veteran's Day 2003, I get a call from my commander saying we probably need to start getting people on orders to start our planning for this deployment. As a single soldier, you have to have a family care plan. Someone must be available to take care of your child if you are deployed. So, I had that, and I thought, "Oh, this is great." My sister was the one. Well, when it happened, my sister got very sick and so she could not do it. I was devastated. I did not know what I was gonna do, because in the military, if you can not go by that family care plan, you'll

be put out, and I put too much into this, and I can't give that all up. Of course, that's my child and if I don't have anyone who can take care of him, then I don't have a choice. And so there I was. It was December. We had started the MOB process, so I had to get out of my apartment, and somebody had to take my son. Well, yeah, who? The lady who had been keeping him all along while I had drill. This particular day when I found out, my sister said, I probably will need back surgery. There's no way I can do this. So, I called her, just to vent, and I was talking. I was real upset. She says, "You have no problem." She says, "We will take Sam," and she and her family took care of Sam, and I will tell you this: I never worried about him, not one day. I love her dearly to this day. And I trusted her without a doubt. So, that worked out. Nothing was interrupted in his life, except for me not being there.

I felt like I had really accomplished something in my life. I did something to try to change another part of the world and to do something good for somebody, and I was a part of that, so I felt so proud. I could look in the mirror and know that I did the best that I could do, not to let a mission drop or to do anything that was illegal or anything wrong, but to do what I was supposed to do and be a good soldier. I felt good about that, and I knew that my son was just so proud of me, and my new husband. All of that was great. I was floating, coming back.

Corporal Maria Holman Weeg, U.S. Marine Corps

I didn't know for sure what was wrong with me. I just knew that I was really tired all the time and, when you're around all the guys, you always have to act tough, and you can't cry and whine or anything; you have to act like a hardcore marine. So I just had all this locked up inside.

I started getting morning sickness and thought that was just combat stress. A lot of girls who I talked to said they didn't get their period while they were in combat. So of course it was pretty sad that my husband had to tell me that I was pregnant. When I'd talk to him, he'd be like, "Maria, what's wrong with you? Something's wrong. Maria, you're going to go to medical." I was like, "I'm not pregnant. I took a pregnancy test before I left. It was negative; nothing's wrong with me." He was like, "Well, if you don't go, I'm going to contact your chain of command out there." So he actually helped me out. I'm a little stubborn sometimes.

I felt like I was leaving my unit out there. I really felt like I was deserting them, that it was still my job. My buddy, he actually took my place, and he ended up getting hit by a mortar and dying. That just goes to show that everything happens for a reason because that could easily have been me if I wasn't in my situation. And I had a really hard time coping with that—that it possibly could have been me. But little did I know [my baby] Blake saved my life.

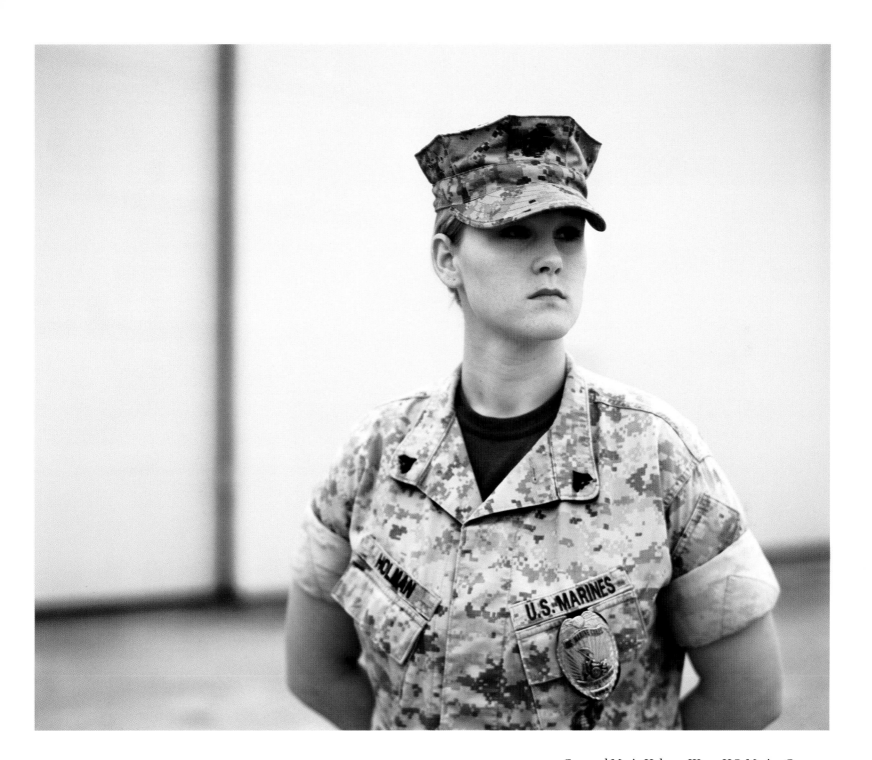

Corporal Maria Holman Weeg, U.S. Marine Corps

Staff Sergeant Connica McFadden, U.S. Army

My daughter was six months old. It was very hard. It still bothers me to talk about it now, because she lost her mom and dad for nine months going over there to fight the war, and—I don't know—she was so innocent . . .

I couldn't understand why we had to go, so it was hard for me to deal with it. I was kind of blaming the president a lot, but I knew that we had a job to do. My husband just kept telling me to stay strong, that it was going to be okay, and he tried to reassure me that we were both gonna make it back home to see our daughter.

We did escort missions, where we had to be the gun trucks; there wasn't any infantry protecting us. You get training in your MOS and that's your specialty. But you're a soldier and what people fail to realize is that means you're going to be out there doing whatever—kicking in doors, pulling guard. Your job extends further than just your MOS. That's basic soldiering, and you have to do it.

The first time we came back, my daughter didn't recognize me or my husband. She wouldn't come to me. She just was looking at us like, "Who are these people?" And that was the hardest part. My son came with open arms, but my daughter . . . it was very hard for her, and she wouldn't even stay with us. We had hotel rooms for my mom and dad, and my aunt and uncle. They kept her because she just cried and cried and cried.

We had come back in August. On the weekends, when we had down time, we went to South Carolina to see my family. When we visited in November, I said, "She's gonna have to just be with us, and we're just gonna have to work through this together." I was tired of being apart from her, so we went and got her for good. And she struggled at first, but then she got used to being with her brother and that made it easier. For a while, she only wanted to be around him, and when she cried, she wanted him instead of me or her dad. And then eventually she started latching on to me again; her dad was the last one she came around to, so it was real hard.

Sergeant Jocelyn Proano, U.S. Marine Corps

I got married and had a baby. I wanted to be a mom and stay home, and then they finally hit me with the deployment. She was a little over one year old. That was the worst ever, to leave my kid and everything.

The mommy mentality left me as soon as we got on that bus. All of a sudden, the marine hit me and I'm like, "All right we've got combat training." I'm thinking we're going to go up there, and we're going to start shooting.

I called my mom every day, "Hey, how's the baby, what is she doing?" She wasn't walking

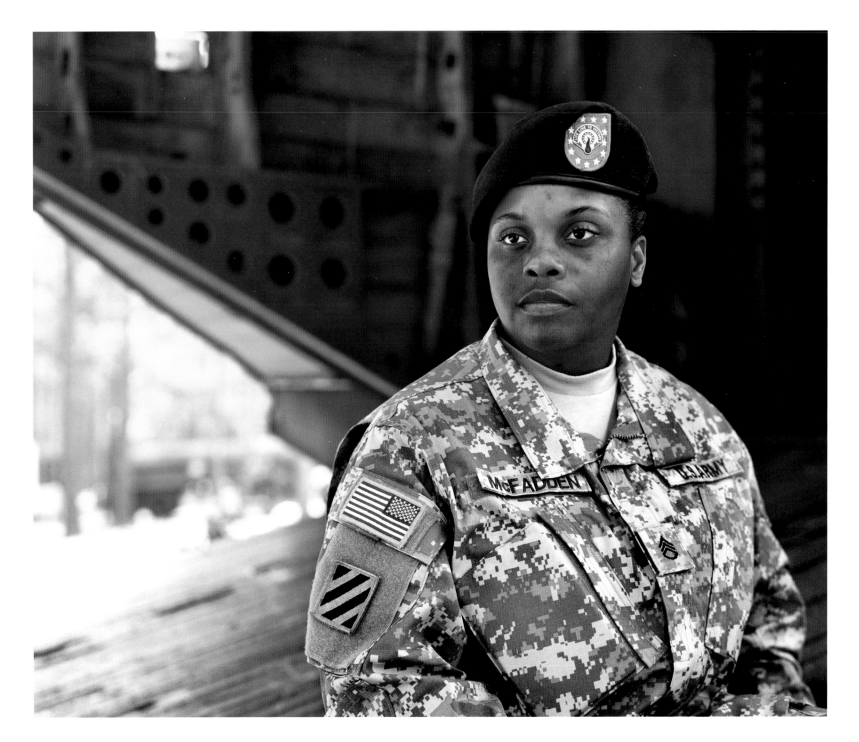

Staff Sergeant Connica McFadden, U.S. Army

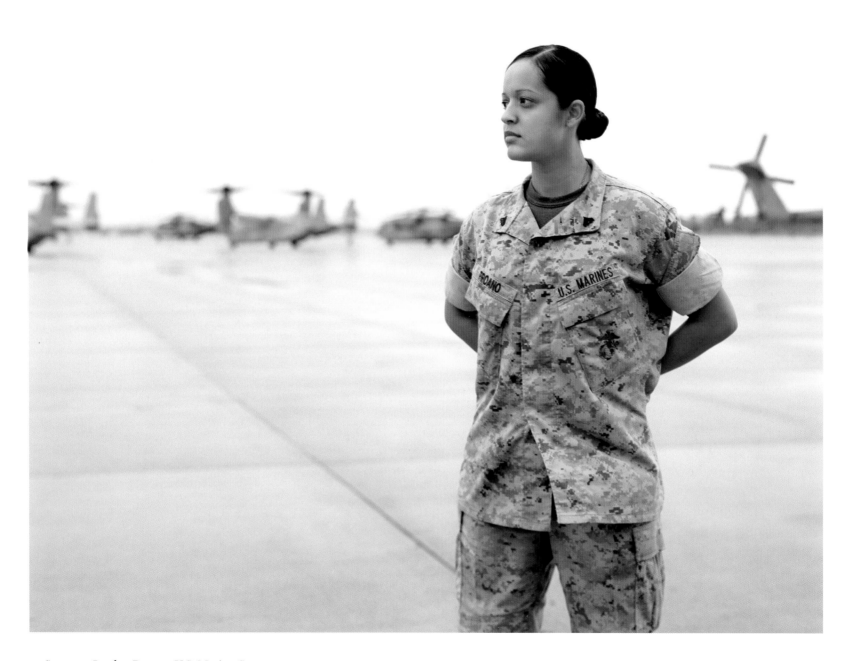

Sergeant Jocelyn Proano, U.S. Marine Corps

and talking when I left and, all of a sudden, she's babbling, "Mama." That was the most emotional part. I cried on the phone when I heard her talk; it was sad, but it was so amazing at the same time.

I liked being out there because, who cares, you're at war. Who cares if you don't have your boots laced up the way you're supposed to, or you don't have a good haircut. You come home, and they're shooting you with all these regulations again.

I need to get out of here because now I'm sitting back in the office doing paperwork. I'm not out there doing all that cool stuff. So I'm actually trying to deploy again, even though my mom's like, you know, you don't want to leave your daughter again. That's kind of hard to juggle. You want to be a marine, and you can't be a mom all the time. I feel bad for wanting to go out again, but I don't want to live my life in the Marine Corps thinking, "Man, I should've deployed again, I should've done that." So, it's kind of hard.

Master Gunnery Sergeant Constance Heinz, U.S. Marine Corps

For my son, it wasn't that hard. He was up at grandma and grandpa's, where he loved to be. He had his uncles and all around; he got to do all the boy things—the hunting, the fishing, you know, he just totally ran amok and he was just so happy with it. For my daughter, it was different because my daughter and I have always been very close. Even up until a couple of months when I was there, when I would talk to her, she'd cry, you know, "Mom—I just want to come over there. Please? I promise to be a good girl." Yeah, she didn't understand that I'm in Iraq, I'm in Fallujah, we're at war. "Sweetie, you can't just come over here. It doesn't work that way. You just can't do that. Just be strong. I'll be home."

The hardest thing about leaving them was just they've always been my biggest supporters. They've always accepted me for who I am, they understand my need and my desire to be a marine, and they've never questioned that they've always made the most sacrifices. My children having to go live with grandma and grandpa was a bigger sacrifice than me going to Iraq because they were the ones that were being uprooted once again, having to change schools, having to change their lifestyle once again because of what I did. And they always take it like a trooper though and seldom complain.

I got back from Iraq in February of '06, and in September, I found out that I was going to redeploy in February of '07. I came home and I told my children that it looked like I was going back to Iraq, and for the first time ever, it wasn't just "okay." The tears came. They were sitting on the sofa. I was sitting on the coffee table, so I could look at them, and they were like, "That's fine, you can go to Iraq, but we're not moving." My daughter's a junior in high

Master Gunnery Sergeant Constance Heinz, U.S. Marine Corps

school, and this is her third high school that she's been to—here's my son, he's going to his third school in three years, and they told me flat out, "We're not going. We're staying here." My daughter was like, "I have a driver's license, we have our ID cards, send us money. That's all we need. Have the neighbors check on us now and then, but we're not leaving." And I'm like, "No, it doesn't work that way." "Oh yes, it does, because we're not going anywhere. We're staying right here. We like our house. We like where we're at. We're not leaving." And I'm just like, "Oh." And I think had it not been for someone else who hadn't deployed yet and who really needed the experience and wanted to deploy, I really think that had I deployed, my kids would have stayed right here. I don't know how, but they weren't going to go. They finally put their foot down and were like, "Nope. This is how it's going to be."

Master Sergeant Lisa Whipple, U.S. Air Force

I was ecstatic about going and I knew that it would be awesome. I'm a single parent, so there were those feelings, too, about having to leave. I have two boys and I deployed twice within a year and a half. The first time, they were six and ten. When I got back the second time, they were eight and twelve. Two back-to-back was a little hard. I missed my youngest son's birthday three years in a row, so that was hard, but I was just happy for the experience. You don't get the appreciation of the big picture of what's going on while you're here working. A lot of us are just doing nine-to-five jobs. It was so fulfilling just being over there.

My ex-husband actually came here and stayed with them. So they were with their dad here, in our house, so that reintegration was actually fairly smooth. And then within three months, I found out that I was having to go again, and I was having the same mixed feelings. I knew I was going to do something different. I was excited to be able to do that. But then I was like, "Wow, that's so soon." This time, my kids had to move to Nebraska to be with my family. And that made it more difficult to be away than the first time, because they had a relationship with Grandma and Grandpa, but they had to start new schools, meet new friends. They had already gone half the year in Virginia to school, so they were not thrilled with me having to leave again so soon and then having to uproot and go. But I'm really thankful for my family, because my boys adjusted well and they did excellent while I was gone, and that's due to my parents and the care that they showed them.

I was ready to come back because I was ready to get back to my kids. That was the most difficult part about being away from here. But at the same time, there's so much that I felt like we were doing there that it was hard to leave, knowing that my kids are being taken care of here and they're doing well, but we're needed over there. Being here in the military and being

deployed in the military is two totally different things. I really wasn't ready to leave there knowing the things that were going on and the things that we actually were doing to help, so it's been a more difficult reintegration for me. I've been back about six months already and it's still difficult. It's been a little bit more difficult for the kids, too, because once again, they had to change schools and come back and then we had to get back into our routine. We're adjusting though.

Staff Sergeant Laweeda Blash, U.S. Army

It was very stressful for the children. When I first went in OIF in 2003, my youngest was going on three years old. And he took it the hardest because mommy wasn't around. Dad was around, but there was no one like mom. It was heart-wrenching knowing that you had to leave your family, not knowing what to expect, praying to God that everything's just gonna stay afloat till you come back. And you pray that you come back. You pray that this hurt is over.

One night a mortar came in, and when it hit and shook the ground, there was so much glass. So much glass went inside my ear, I lost my hearing for about nine months. I wound up going to a surgical hospital located in Balad, and they removed the glass. I just thank God that I didn't lose my hearing.

My children showed strength in front of me, but they were upset. They were worried. One of my sons got affected so bad, he wound up staying back one grade; he just couldn't concentrate. They didn't want me to go. As a matter of fact, my oldest son—the one who got sick, who was retained—said, "Mommy, I'm tired of you going." I said, "I know but, you know, Jesus got a plan. He's allowed me to go for many reasons, and plus that's part of my job." So he took it with a grain of salt and just did his best. They took it real hard.

I learned you can't go back home and expect everything to be the same, 'cause it's not. 'Cause they learn to adjust without you. So, I learned, okay if I'm used to grocery shopping on a Saturday, but now the routine is a Sunday, let me stick with Sunday, because they in that routine now, and everybody is comfortable with that. So, it's not gonna change just because I made it back. Learning to step back and see what the family already have set, that's what helped me out: when they go grocery shopping, when they wash clothes, when they clean the house, things of this nature. I did feel that I have to reestablish my relationship with my kids every time and that every time it comes to my husband and I, we had to go back to dating again. I had to learn how to relate to each child again. That was my biggest challenge, and I'm still learning, 'cause it's kind of difficult to go to a school when teachers are telling you about

Staff Sergeant Laweeda Blash, U.S. Army

the kids, and I felt very odd, 'cause I didn't know what to say to them because I've been gone. I really felt out of place with that.

I've learned to listen more, whereas before I went through all these deployments, I was a 50-50. Now I've learned to be a 90 percent listener, believe it or not, and a 10 percent talker, and that's what really starts getting me in synch with them. I knew I was out of place. They had already established something, and it was time for me to fit in. I learned a lot of other soldiers have a difficult time with that, especially mothers. I'm just blessed because I have a husband. If I was a single parent, I don't know how my situation would have been.

Coming Home

When Sascha and I first talked about this project, we envisioned interviewing and photographing only wounded women veterans. We wanted to emphasize the fact that female troops were facing the same dangers as their male counterparts and were paying the same price in lost limbs and other injuries. My first conversation with a retired military officer changed our plans. "You know," she said, "no one comes home from a war without wounds." The wisdom of this comment was immediately apparent and only seemed more vivid the further we got into the project.

These wounds often manifest themselves through high-risk behavior. A May 6, 2009, *USA Today* story noted that more marines had been killed in motorcycle accidents in the previous twelve months than had suffered combat fatalities in Iraq (other service branches also experienced huge increases in motorcycle fatalities during the same period). As Marine Master Sergeant Brad Warner noted, "The adrenaline that sustains soldiers through combat can get them into trouble when they climb on a motorcycle. Warner returned from a tour in Iraq last year without a single death in his unit. Within the first 90 days home, though, a soldier in his unit died shortly after buying his first motorcycle."[1]

Sergeant Katharine Broome, Virginia Army National Guard

I deployed in October of 2005. I was married and, I thought, happily married. I was living in a house with a husband and two dogs. I was just finishing my freshman year of college. When I went over there, all of that changed.

I came back to a completely different world. My husband left me, cheated on me, so I got a divorce. I had to have my friends and family move all of my stuff into a new house while I was gone. When I came home, I had to Google directions to my own house because I didn't know where I lived.

Airman Victoria Hager, U.S. Coast Guard

We sat one night on the bow, that's the front part of the boat, and we're just laying on this uncomfortable grate, looking up. And we're just talking for a couple of hours. We could have been sleeping, but we were fantasizing about what our life was going to be like when we got home. Food, sleep. See your friends and your family. Live a normal life. Not worry all the time. There's always something to worry about—whether it was operational or not. And you thought about it all the time. If you were on a watch, you were doing your job but you were thinking about going home all the time.

As soon as I set foot in America, I was like, "I'm home." And Bahrain became a dream. It happened. It definitely happened. There's no doubt in that, but it's not anything I need to worry about. I'm where I want to be and that's all I focused on.

Petty Officer First Class Kelly Falor, U.S. Coast Guard

The Coast Guard said that they'll fly you to anywhere in the world you want to go for your R&R. We got over there, everybody was like, "So where'd you go on your R&R?" I was going to go to some exotic place that I would never be able to pay for ever in my life. I had my mind set. I was asking everybody, you know, "Where'd you go." And they were like, "I just went home." They already had the look of defeat that we had six months later. And I was like, "Why?" and they were like, "Just something about home." When it came time, I was like, "North Carolina, please." Just sit, eat, with my daddy and my grandma and let them take care of me, and let me sleep and eat for a little while. A hot dog from 7-Eleven—that's all I craved for months.

I went home for the fourth of July, and it was on the news some Iranians were launching missiles. I was watching the fireworks, and I was just crying the entire time. I left the fireworks, 'cause I was just terrified that something was gonna happen to them and I wasn't gonna be there. Now that they're all home, I do feel better.

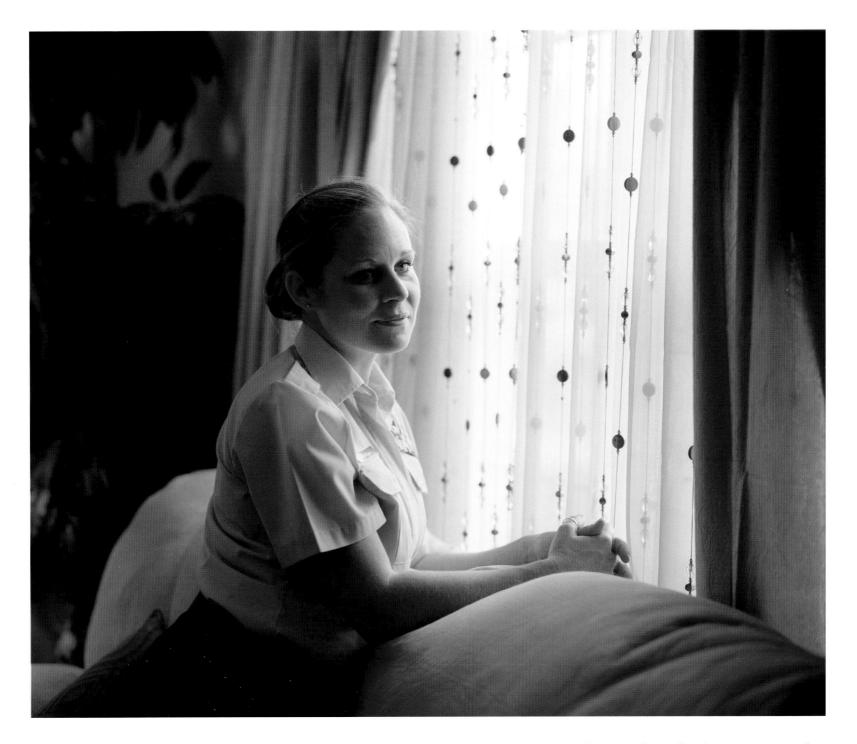

Petty Officer First Class Kelly Falor, U.S. Coast Guard

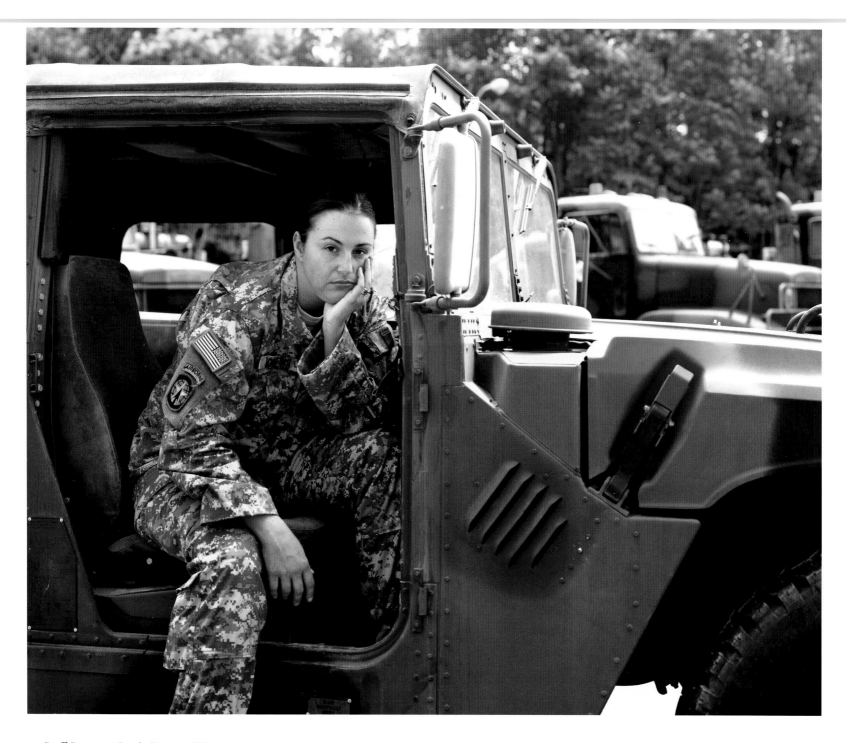

Staff Sergeant Jamie Rogers, U.S. Army

I went through a phase where I was drinking a lot, and I felt like I was owed more respect than the cashier at 7-Eleven was giving me. I just did this for you—show me some respect. Don't treat me like that. I'm over that now. It took me a while to adjust to being home. I came back before those guys, so I was without them. I was with them for a little over a year, they were part of my daily life and then I came home by myself. I don't like to talk to other people about it, because you have to explain so much.

Staff Sergeant Jamie Rogers, U.S. Army

As a soldier, it's something that you always want to do. For myself, I felt it was my obligation and that's what I had been training for all those years, to do my job in combat. And I was very honored. I got to lead soldiers in combat, and I proved to myself that all this training was worthwhile, that it wasn't something they were telling us to do, we were doing it for a purpose, and it all came to fruition when we deployed.

I remember the camaraderie. The platoon was very, very, very close. We knew that when we were out there we were big targets because we rolled with three Humvees and we had a six kilometer radius. Our mission changed throughout the year but at one point there was a lot of patrols getting hit with platter charges, also known as shape charge or EFPs. We just knew that no matter what, if one of us got hit, one of us was going to be there. And that was very, very assuring and that's what made us go out there every day. 'Cause we knew that we had each other. We weren't fighting for ourselves, we were fighting for this person here. It was very tough, because I was a squad leader, I had a lot of young soldiers.

Our mission was MSR patrol and convoy security. We used to joke that we were outside the wire more than inside the wire. At first, we ran missions mostly at night because it's a lot safer and they can't see you as well. But then it changed, and we started twenty-four-hour shifts. So sometimes you would work a twelve-hour patrol in the day, or a twelve-hour patrol at night. And twelve hours in a combat zone is very intense—not only physically demanding because of all the equipment you wear, but also mentally draining because you never know what's gonna happen. Never.

In our patrol, I always made sure that we had extra water, extra MREs, no matter what. Not just for the kids; if we saw older people, they always got something. It helped us develop a relationship. Maybe those people went out and told stories to other people. And maybe, hopefully, one day, they'll see that we're there for the good of things.

As a soldier, you feel like you cheated death. There were two soldiers I knew very, very well who didn't come home to their families. Worked with them day in and day out. Sometimes you feel yourself slipping up and going back to your old ways. And you're like, "Why am I

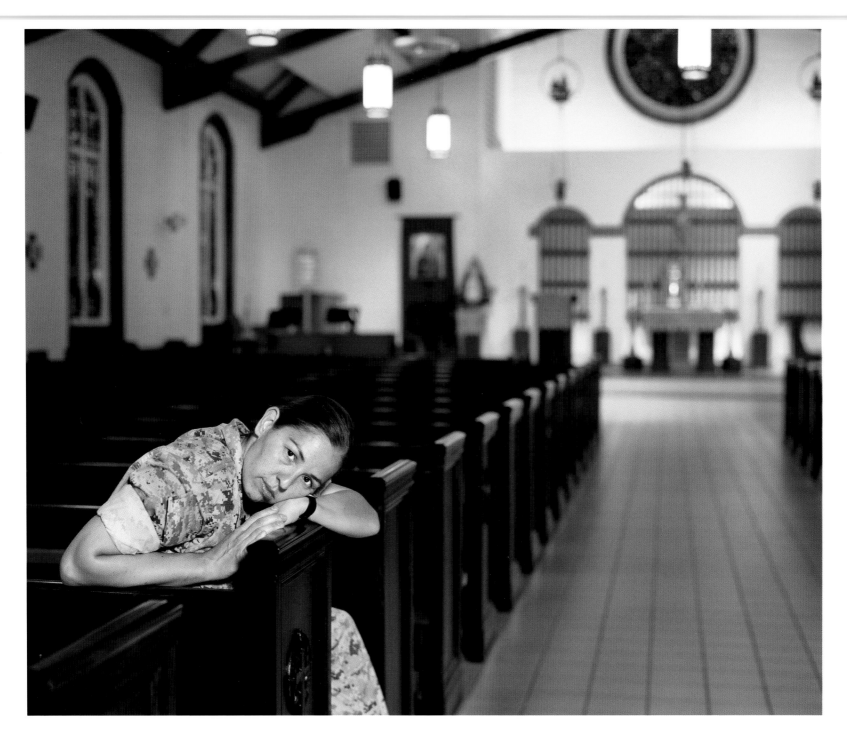

Religious Program Specialist Second Class Rachel Doran, U.S. Navy Reserve

here?" You gotta reflect and say, "This person died so I can do what I need to." It's very life-changing.

People worry about their jobs, but at night, they go home to their wives and sons and daughters. We don't. If Uncle Sam says go, we go. We really don't ask questions. We might complain about it, but we don't ask questions. And they're just not grateful at all.

Some people do come up and say, "Thank you," or "I appreciate your service." But many of them, if they come up to you, ask immediately about the war, if you support it, and then they give their opinion. A servicemember doesn't need to hear that. A servicemember can say, "Thank you. No problem," and go on. But not everybody wants to hear your opinion. Sometimes, just keep your mouth shut.

Religious Program Specialist Second Class Rachel Doran, U.S. Navy Reserve

I was in Iraq, back for two weeks, went to Africa for three-and-a-half months, came back for twenty-five days, and returned to Iraq. So I never had a chance to decompress between any of those deployments. The last two were strictly volunteering.

Everybody thought, "Did you hit your head?" When I told my sister I was going back, she started crying, and she's like, "You're killing me. You have to stop doing this." I'm just like, "Sorry." But I went back again, and I actually didn't think twice about it.

I had developed TMJ really bad. I noticed my stress levels were going through the roof. When I came off of the last deployment in February, I had an enormous amount of stress built up, but I didn't realize it because I never felt very hostile over there.

I actually realized I had some serious anger issues when I was in Wal-Mart in Los Lunas with my mom. She has a handicapped sticker on her car, and this car was backing out and didn't see her. So my mom tooted the horn and just kind of waved, and the guy flipped my mom off. I flew out of her vehicle, screaming at him, "What the hell's your problem?" My mom's like, "Rachel, get back in." I said, "Shut up." They were just very rude and disrespectful. I wasn't using any bad words, and then his wife called me a bitch. I flipped out. I was yelling, yelling, yelling, and I realized all of a sudden, "Oh, crap. I'm not in Iraq. I'm in a parking lot in Los Lunas, and my mom thinks I'm losing my mind."

So the vehicle drove away and my mom gets out. She has this paranoid, worried look on her face, "Um, well, I think we need to . . ." I was like, "Shut up." You know, every time she started talking, I was like, "Shut up." Finally we got home, and she just had this look on her face, and I was like, "What?" She was like, "You have some anger issues," and I said, "No, I don't." And then I realized I did. I definitely had a lot of processing that I did not do from all my deployments.

The wounded-warriors barracks is right across the street. You go over there and see some guy who's probably half the person he was before. And you're just wondering, you know, what is it all for? Why is this nineteen-year-old kid gonna be in pain for the rest of his life? I hope it was worth it.

Captain Clarisse Scott, U.S. Army

I've got friends that are on their fourth rotation. It's opening up to the community now. It's affecting people's churches; even though they may not have a relative there, they may have a church member that has a son or daughter over there, so they're taking it more. If you don't understand, if it doesn't hit close to home, then you tend not to care.

Master Sergeant Odetta Johnson, U.S. Army

I left America to go to a country where I felt like a stranger because things were different. When I came back I felt like a stranger in my own home and in my job.

I had to realize that my kids knew how to cook. They knew how to iron their own clothes. Those were things that I enjoyed doing. I enjoyed cooking and I enjoyed having their clothes ready. And they had choices now. They were more opinionated. I saw more attitude. I saw more personality. And they weren't the bookworms they were when I left. They had iPods and video games. They were into a different kind of music. I had to realize that the world just didn't stop while I was gone for fourteen months. That they changed just as I had changed. People said I changed a lot and I couldn't see it.

I assumed 'cause I had been in forensics that it wouldn't be a big deal because I've seen bodies before. I've smelled flesh. I said it's not gonna be a problem when I go back. I'm gonna be fine. But there was so many other things that I saw, so many other things: talking with my interpreters, building friendships because you can't let them get but so close, but it's difficult when you work with someone every day and they taught you about their family and one day they come back and tell you that their whole village is gone or everyone's dead, but they're coming to work every day.

Specialist Elizabeth Sartain, U.S. Army, Retired

I have very little patience for civilians. You know, if they're not moving fast enough, doing something for me, "Don't you understand? There's a war going on. Hurry up!" I have a very short fuse since I've come back, and I just don't understand why civilians don't move like us and act like us, and it was really hard when I came back.

I take massive doses of medication to get me to sleep at night. Usually I only get about five

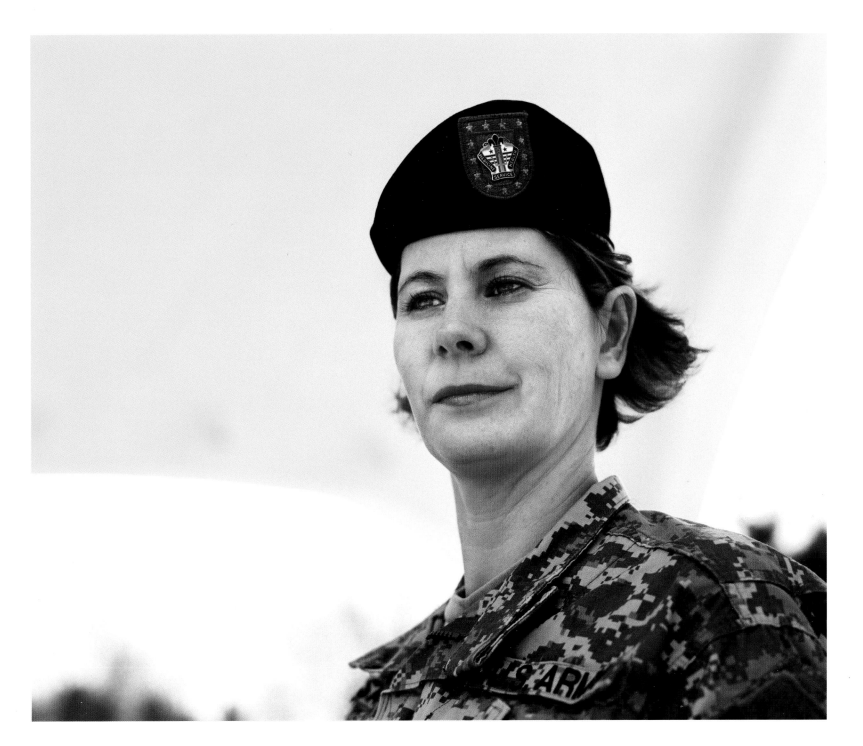

Specialist Elizabeth Sartain, U.S. Army, Retired

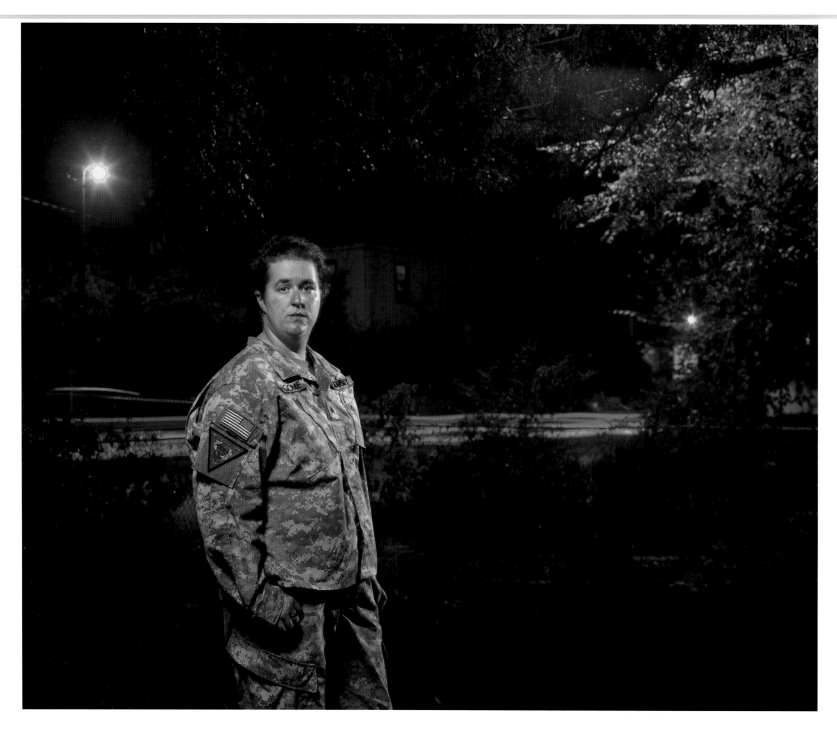

Sergeant Katharine Broome, Virginia Army National Guard

hours of sleep a night, and I have to get the doctor to write a note, so I can have a day off and just catch up on sleep, because even with the sleeping medication, it doesn't always work. With the nightmares, it's just really hard.

When I was over there, I became anorexic. I wouldn't eat any meat, and then I would be so depressed and tired that when it was my day off, I just couldn't even make it to the chow hall, so I lost over thirty pounds in six months. Then I started having restless leg syndrome, panic attacks, anxiety attacks. Since I've been back, I still have insomnia and nightmares, and now I overeat. I have gained forty pounds—just from the depression, from constantly feeling like the food is going to make me feel better.

I'm angry. I didn't have this PTSD before deployment, and it's a career-ender for me. I know PTSD is so prevalent. There are a lot of people who have it, but they're two years away from retirement, so they don't want to get help. Or they're up for a promotion, so they just end up living with it.

I mean they try to be a more caring army, but it's not going to change. They're still going to be going around in the same circles. So many people are trying to get out of the military because of it.

Master Sergeant Bonnie McKusick, U.S. Air Force

I ended up getting divorced after I got back. And some things had happened while I was over there that made it really hard. I came home to an empty house. So that was the adjustment part. We were married for seven-and-a-half years, he was in the Marine Corps, always deployed, and then I was deploying. Military to military is hard in itself, but then when you have two members deploying all the time, when you're apart more than you're together, that's the adjustment that I'm talking about. Separation is hard for people, and I'm not throwing any blame. You just have to move on and the next day is going to be a better day. And hope for that, and so that's what I had to do.

I would go back and do it again in a heartbeat. They think I'm crazy. My own leadership says, "You want to do that again? What's wrong with you?" And I just loved it. I loved the experience.

Sergeant Katharine Broome, Virginia Army National Guard

I'm still uncomfortable talking about things to people who have no idea. People ask inappropriate questions. People think that just because they've seen a movie or read a book that they know how to talk to me. The only time I can discuss it and be completely at ease is if I'm talking to somebody who was right there with me. When I first came back, I would end

up leaving parties or walking out of situations because you would meet someone for the very first time and the first question out of their mouth would be, "How many dead people did you see?"

My life completely forked off of the original trail that it was going down and it completely flipped my world upside down. I'm grateful for it. I think I'm in a much better place now.

I'm definitely changed. I have a shorter fuse. I tolerate less. I see things more in black and white. There's less gray area for me.

The whole experience is with me everywhere I go. I can't leave it behind. It's in every new relationship I build. It's affected every old relationship I had. Everything I read, everything I see, I can relate to some aspect of my deployment. I've been back for eight months and for some reason I just thought that by now it wouldn't be as big as it is inside of me, but if anything I feel like it just gets bigger. Sometimes it just overpowers things.

Sergeant First Class Kim Dionne, U.S. Army Reserve

One professor said, "Kim, do you have to wear your uniform to class? You look like a killer going off to battle." I just freaked the hell out. I was mute for the rest of the semester in all my classes. I couldn't even speak because I was so hurt and affected by that.

My first time driving, I'd see a sign and a railing and I'd be freaking out. Oh, there's an IED on the back of that sign or I'd see a dog running through and I'd think that there could be a bomb inside of him or something. Like a huge video game: that's how it felt to me. I couldn't drive for a week. And then I learned to just look forward and then slowly incorporate things into my field of vision so I could drive myself to work.

Captain Kelly Nocks, U.S. Army

We were just north of Baghdad International Airport. My platoon had an important job. We got all the supplies—food, bottled water, ammunition. My platoon sergeant and I switched: every other day she went out and on the opposite day, I went out.

I'm sitting in my Humvee. It was 2003, so you don't have armored vehicles. I'm checking on my side of the road, and an IED goes off; they buried it underneath the ground. I don't know if I felt the impact, but there's that huge black smoke. I grabbed the radio, called the vehicle in front of me, and told them we got hit. I was trying to get out because the next thing they do is hit you with small arms. I couldn't move my legs. With the impact, I was most likely in shock, but I think I felt an enormous pain in my leg. I never looked at my leg, and they put me in the back seat.

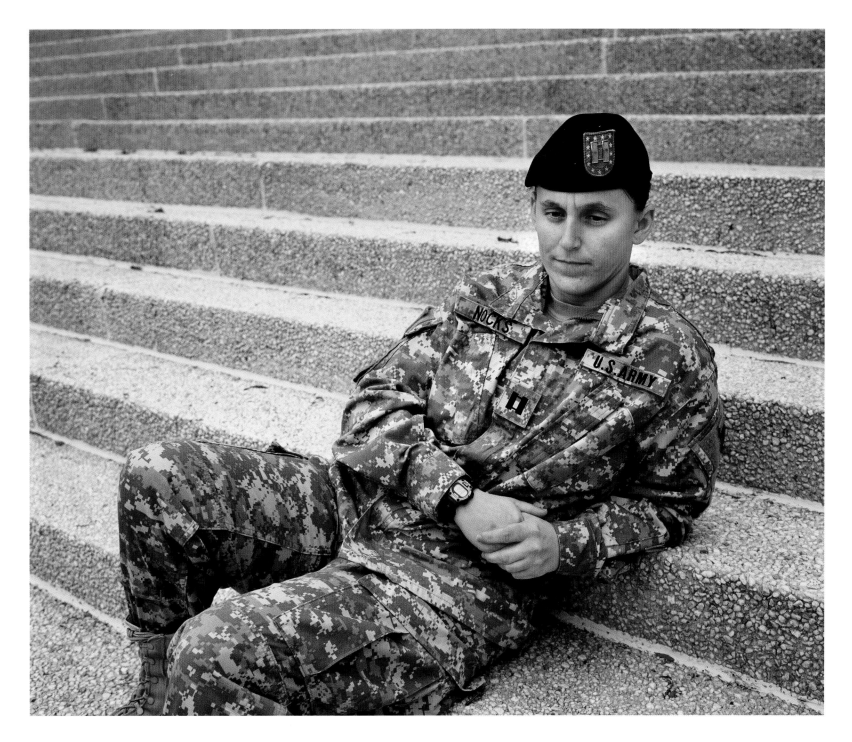

Captain Kelly Nocks, U.S. Army

Shrapnel shattered my tibia and fibula; if I had gotten out of the vehicle, I would have amputated my whole leg. I was medevaced to the combat surgical hospital in Baghdad. They did surgery and put in an in-line fixator, which is four pins.

My eighteenth surgery took the rods out of my leg, and then I didn't walk. I had no weight bearing on my right leg for fifteen months. If I really wanted to, I probably could have had it amputated. But for some reason, I didn't. Some days, I wonder why I didn't; but I didn't, and I'm happy about that.

I passed my PT test and went through the medical board. My profile read, "No tactical vehicles, no running or jumping or crawling." It was really restrictive, and it still is today. But it doesn't say that I can't deploy; and when that time comes, it will be fine. It's just a matter of how much gear I can wear. I can't run whatsoever and shouldn't even try, but no one really notices. And I accept that I could lose my leg any time.

I know I'm going back. I will deploy. I still think that I'm doing great things, that I can continue in my job and stay in the army.

Captain Carla Campbell, U.S. Army

It's actually pretty noisy in the U.S. We lived in the middle of the desert. I mean you have stuff going on with choppers but other than that the people are a little bit more soft-spoken. Just readjusting to being around civilians was my biggest thing. 'Cause I'll be talking and throwing around jargon, with my family sometimes, I'll be talking with acronyms and just talking about stuff, and they'll be like, "What are you talking about? Can you slow down and start over?"

Probably my biggest thing to readjust to was taking care of myself. Because over there I get up, somebody makes my breakfast, somebody makes my lunch, somebody makes my dinner. All I do is show up in the line and say, "I want that, that, and that." It's like having a great mom over there, and you come back and you're like, "Oh. I left mom home." And having a driver! That too. I had somebody driving me, and now all of a sudden I have to drive myself again. It's like, "Oh. How do you work this again?"

Changing Relationships

Women in the military usually suffer much higher rates of failed marriages than men, and that trend held true again in 2008. Army women divorced at a rate of 8.5 percent compared to 2.9 percent for army men. Female marines divorced at a rate of 9.2 percent, compared to 3.3 percent of male marines.[1]

Many women find their marriages ending shortly after they return from their deployments, and others struggle to repair their relationships. The experience of deployment can create a vast gulf between partners, which is one reason Staff Sergeant Sol Michelle Nolte of the U.S. Marine Corps volunteered to deploy; given her husband's frequent deployments, she saw this as the only way to truly understand what he had been going through. Yet for couples in which both parties have been deployed and suffer PTSD, coping with the symptoms together may be more difficult.

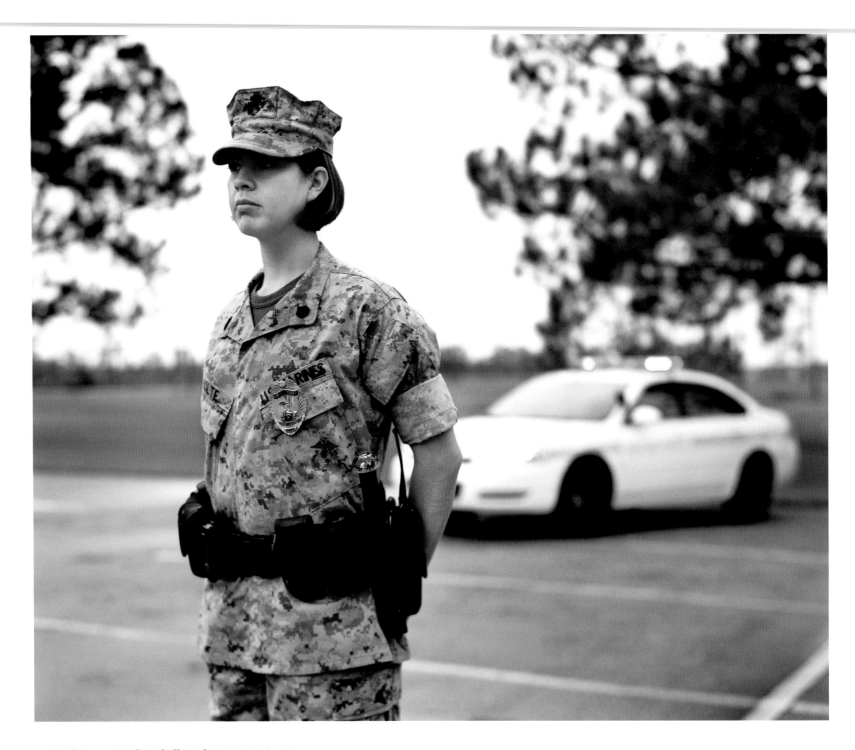

Staff Sergeant Sol Michelle Nolte, U.S. Marine Corps

Staff Sergeant Sol Michelle Nolte, U.S. Marine Corps

My job was corrections specialist at first. I requested to go to work at MCT as a troop handler because I didn't know too much about patrolling, convoys, or weapons, other than what they teach in boot camp, and it was a blur to me anyway. I got to meet a lot of grunts, and they used to tell me they were getting ready to deploy, and some of them already had one deployment. So I got pretty interested and wanted to deploy.

My husband was out there when everything started. And I was a little frustrated that I wasn't putting in my share just yet. When he came back, he didn't tell me too much, but I knew that it was important to me to be there too, to understand him, where he was coming from and to put my share into it, too.

I volunteered for a deployment. I had twenty days to prepare. I was excited because I was going to deploy, and my husband was like, "You're crazy. You don't know what you're getting yourself into." But I thought that I was right. I thought it was my time to do it. When I got there, that's when the chills started. And I was like, oh my god, what did I get myself into? But, yeah, I was pretty excited before I left.

Me and my husband, we did a double deployment. I went there first; then he got there. Then I came home, and he was there. He was working in the flight line, and I was working at the detention facility. I was working twenty-four hours on, twenty-four hours on REACT, and then really twelve hours off.

When I got home, my parents were here. They came over and welcomed me and all my friends. I had maybe twenty people waiting for me when I got back and it was exciting, but I just wanted to be alone, since my husband was out there. We had a meal, and I asked my friends to leave, and I just sat in my house. Stared at the walls. Just sat there. For probably about two weeks, I didn't go out. I didn't call anybody.

He's had four deployments to Iraq and one to Africa. Before Iraq started, he had one to Norway and six months to Puerto Rico; he just partied that time. In the seven years we've been married, we've probably spent maybe three years together, if that. We had to try to get to know each other every time he came home.

Sergeant First Class Gwendolyn-Lorene Lawrence, U.S. Army

I was one of those broken families. I came home and my husband said he wanted a divorce. He was a soldier. He said, "I'm tired of two ships passing. I want you home," and I'm like, "Home rather than what? In uniform?" "Home as in no uniform." I'm like, "You telling me to choose what I want? Fine, you can have it." Deployment—you would think that when you're married to someone, they understand you, especially if they're in the same organization, per

se, as you. If you marry somebody else in corporate, you think they understand and feel the whole thing. That would be the least thing you would think that when you finish fighting, they tell you I don't want no parts of you.

Specialist Elizabeth Sartain, U.S. Army, Retired

I had just gotten married five days before I deployed, and my husband deployed three weeks later. I didn't know how I was going to take care of myself. I had let my husband take care of me the whole time we were dating, so I never had to do much to take care of myself. So now when I deployed, I had to take care of myself, and it was very hard.

I met my husband here on post. I was qualifying at an M-16 range, and I was having trouble. So, they sent me to remedial training, and that was my husband. I wouldn't return his phone calls. I was hiding from him. I thought, "You don't want to date anyone in the army," because you hear all these terrible stories. But then he just kept pestering me so much, I just gave in.

He was supposed to be deployed for fifteen months, but he only deployed for six. He came home early for post-traumatic stress disorder. He got back the day before I did. He has PTSD, so we have two people in my house who go through a range of emotions from depression to having anxiety attacks, nightmares, insomnia.

Right now, we're able to communicate really good about it. At first, we really couldn't. We didn't know what was wrong with each other, but now we understand it. We went through a lot of marriage counseling to get where we are today.

This past December, my mom finally started to realize what I went through in my deployment. It took her almost six months. I didn't want to be touched, I didn't want people looking at me. It was hard for them. I felt bad that I had put them through so much, not even realizing what I was doing. But now our relationships are really strong.

Staff Sergeant Debra Fulk, U.S. Army

When I first came home I just felt so out of place because I was so used to working on the go for twelve hours and just thinking about the troops. Doing this. Doing that. And now it was like, okay you can kick back and look at TV, but I couldn't relax. I always had to be on the go, so I drove my poor husband crazy by moving furniture every other day. And everything had to be just right. Everything had to have its place. I felt like I wasn't supposed to be idle. I felt like it was always a mission, something I had to accomplish. So it changed me in that way, trying to cope with all the extra time and with him.

A lot of times unless he had something really to say about something we needed to accomplish in the house I didn't just want to talk on and on and on like I did before. So he noticed the change in me. I wasn't as talkative or as sociable with him as I was before and then it's always the intimate thing. I had to come to grips with that and come back around to get comfortable in that way. I didn't want to go out in the community where it was a lot of people because all I knew was getting up in the morning, going to work, on my job, going to the dining facility. Everything was in a perimeter. So, to go out and shopping, to be at the movies, I didn't want to be around all these people and I just felt claustrophobic. I didn't want to get on the phone. So he noticed that those changes had been made in me along with the anger.

First Sergeant Shirley Wright, U.S. Army

My husband could not deal with the fact that I chose to continue my military career. At first, he said, "Whatever decision you make, I'll support it," but when it came down to it, he just couldn't. He just couldn't handle the fact that I could be deployed again. When I got back, my ex-husband, he couldn't understand why I just needed to be alone for a while, and he was anxious to see me, and I could understand that, but I just couldn't handle it. I had no "me" time, just to be alone and just to breathe. And it was nothing against my husband. I just needed to be alone. And that was real hard.

Women in the Military

I always asked women how they felt their deployment experience had been affected by their gender. They talked about their service in Lioness or other all-female units, they reflected on how they felt they were more compassionate than their male counterparts, they talked about soldier-on-soldier rape or the need for better gynecological services on their bases. A few women were offended by the question and said that their gender had nothing to do with their military service. The first time a marine told me this, I wasn't sure how to take it, especially when I heard it from someone like Corporal Chalina Seligson, a machinist who was the sole woman among fifty-five men in her unit. When I asked Master Gunnery Sergeant Constance Heinz, the public affairs officer who had arranged for the interview, about servicewomen who downplay the importance of their gender, she said it made sense to her. In Sergeant Heinz's view, young female marines do not face the same challenges today that she had in the 1980s. Yet the brother of a male marine told me that WMs (women marines) are still referred to as "walking mattresses," and Constance herself, an ardent biker, was still not able to get full membership in the Leathernecks, the marine motorcycle club she rode with.

Two studies of women in the military, both released in 2008, are noteworthy here. The first, by the Pentagon, used data from 2006 to report that one-third of women in the military report have been sexually harassed.[1] Yet a recent study of 30,000 active duty personnel by sociologist Jennifer Hickes Lundquist finds that minorities and women—and black women most of all—have the highest job satisfaction in the military, much higher than white males, due to the rank-based hierarchy of the military, which generally overrides the gender and racial biases of civil society. As Lundquist says, "It's not that the military environment treats white males less fairly; it's simply that, compared to their peers in civilian society, white males lose many of the advantages that they had."[2]

These two studies, which would seem contradictory, perhaps best express the complex realities of being a woman in the military today. And the ways that women in the military negotiate this terrain—coping with sexual harassment while finding greater job satisfaction than their male peers—are never simple.

Captain Clarisse Scott, U.S. Army

I was a battle captain in the S3, so I had a major responsibility. My boss was there to coach, teach and mentor, so I was never really alone, and it was a learning experience. Sometimes I felt overwhelmed, but I learned a lot that year.

Day to day, initially I got there and we were working twelve-hour shifts, no days off. Eventually we got into a battle rhythm, where we were able to cut back some, so then it went to having one day off, so you could get some down time to yourself. I would go to church. I got involved in recreational basketball. I had a lot of free time, so I got into exercising a lot—going to the gym—stuff that I wouldn't be able to do if I was at home with a family.

The housing area I lived in had a lot of times where there were rounds that landed. Shrapnel would make holes in the walls of the trailers. We had a lot of eye-opening experiences, because even though I was inside of the wire, you never knew where a round would land. So there were times we would be in full battle rattle for thirty days at a time—everything, when you walked outside, your this, your that, your Kevlar. Everything is a changing experience over there, 'cause you never know what to expect—inside or outside of the wire.

You learn what to tell your family and you learn what not to tell your family, because you don't want them worrying because they already worry enough that you're there. A lot of things happened that I didn't say anything about. Will I ever say anything? No.

I had no intentions of taking R&R. It was too hard to go home and to have to separate and leave again. Then that changed because my daughter started asking, "When is Mommy coming home?" And my husband had to deal with her constantly, saying, "Hey, Mommy's at work." So I changed my mind. I went home for R&R. And that was a great time. My daughter had changed so much in six months.

She's definitely a daddy's girl, because he's been her constant her whole life. We have our moments together—the mommy/daughter thing—but she's all about daddy. Since I redeployed, I've had another baby. So I have a little boy now. He's more of a mommy's boy; he's clingy. I haven't left him yet . . .

I guess I'm kind of an independent woman. I owe that to my grandmothers. I took that concept to another level when I joined the army. I didn't have that luxury of my mom being able to pay my tuition. And I think I took that on over into my relationship with my husband. Some things I'll ask, some things I won't. I'd rather work for it. And being in the military is kind of the same way. It just boosts your confidence and independence. You feel more driven and more in charge.

I push females a little bit harder and say, "Hey, you don't want to be riding behind because you give them a reason not to want to give you anything. You gotta prove yourself constantly

as a female. You could be just as good as the next male lieutenant but because you're a female, you may run a bit slower or something like that. You just have to work harder and find the areas that you're stronger at and work around that."

Staff Sergeant Shawntel Lotson, U.S. Army

When I first joined in, my MOS was a 62 Bravo, which is construction equipment repair, so I had always been the only female and the only black female in that particular section. There were times when I was treated differently, but it just made me more determined to show that, hey, just because I'm a female and black, doesn't mean I can't do my job.

I was Sergeant Lotson and Mamma Lotson: the soldiers really respected me. I treated them as soldiers, but at the same time, I am your friend. You should not be afraid to come to me if you have issues and talk to me. But when it's time to be a soldier, it's time to be a soldier. I was respected a lot more than the male NCOs because of the type of leadership that I provided to the soldiers. The soldiers wanted to feel that they were safe. They wanted to feel that they had a family away from their family. When you're deployed, you need that support. So, the soldiers felt that they could come to me for that. They know I would take care of them in that aspect. You have others, "Oh, suck it up and drive on. Who cares if you've got issues." When you have an issue, you're taking time away, so you can't treat these soldiers like that or else they won't respect you. They won't do for you. And I've seen that a lot out there—where soldiers get treated badly, they have no respect for their leadership.

There was another female soldier, on a different ship. Her ship had about three or four female soldiers, just E-4 and below. This one particular NCO was harassing her—touching her in the wrong way, doing it on the sly, and she had told him to stop abusing his authority over her, and she came to me about it. I approached this individual and told him, "Look, this was brought to my attention, if you are doing this, just stop." I said, "Don't go question any of the females as to what's going on or who came to me. It's conduct unbecoming of an NCO and a soldier, so don't do it." What does he do? He goes out there, and he says something to the soldier again. The company commander and the battalion commander sided with the NCO, even though the soldier had statements from the other soldiers. They kicked her out of the detention facility, told her she's not allowed to come back, and she had to apologize to this NCO. Oh, I was outraged. I asked the company commander and battalion commander, "You know, this soldier does a great job, from what I hear, on your ship. You have this NCO, you've got statements, you've even got letters that he was sending to other female soldiers—yes." He was a huge problem. But they still sided with him.

I was being harassed at one point by an officer. He was making rude comments, saying

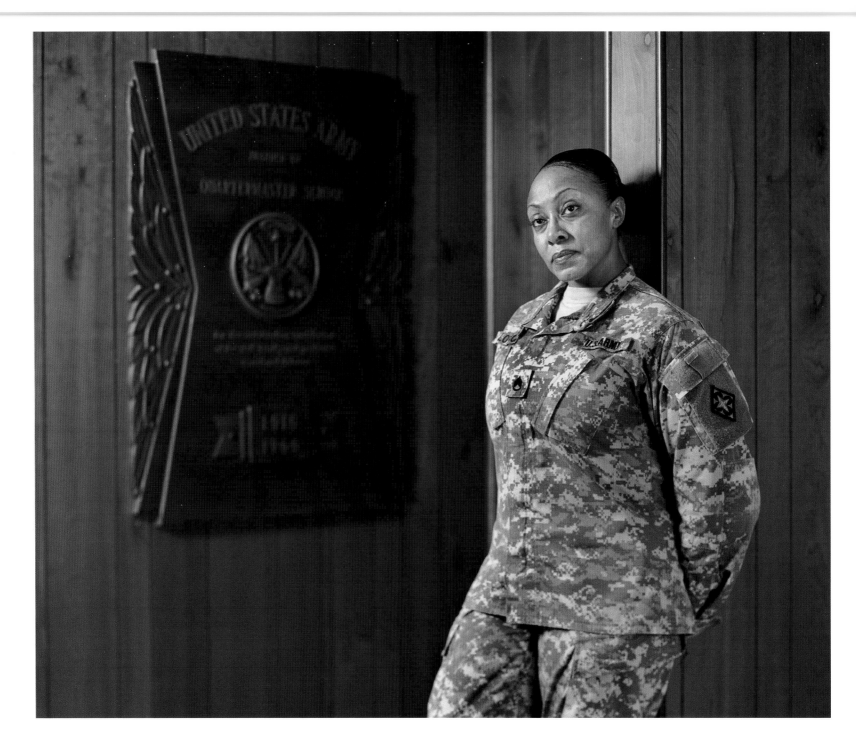

Staff Sergeant Shawntel Lotson, U.S. Army

what he would do to me to other people, and I confronted him about it, and I was like, "You know what? I don't appreciate this—what you're saying. I think it needs to stop." And by me approaching him, being that he's a higher rank, of course, who are they going to listen to? But I did have witnesses who saw and heard things, and took me to Master Sergeant Milsap, and he actually made things happen, and got that officer up out of the area, and that was it.

He was no longer in charge of the particular area that he was supposed to be in charge of. And once we got back, they made sure he was on orders to go somewhere else. Master Sergeant Milsap was a wonderful man.

He got hit with an IED, and the vehicle had overturned, and they couldn't get him out, so he burned alive in the vehicle. And they had brought the vehicle in for me to do the ECOD on it, but being that I did have that day off, I didn't have to be there to see that, and they made sure that I did not see that vehicle, because they knew how much I respected him. One thing that I can try to say that I would hope and be grateful for was that when they pulled him out, his body was split in half. So, I was hoping that maybe that he died from that instead of burning alive in the vehicle.

Sergeant Jocelyn Proano, U.S. Marine Corps

Camp Cupcake was somewhere where the grunts would make a pit stop. They'd see you and you were the most beautiful thing in the world. Back home you may not be much, but out there they've got deployment goggles—you look good, so you're in chow hall and it's kind of uncomfortable because you feel like a piece of meat or something on display. And they watch you eat—they just stare at you and they won't leave you alone. That sucked.

If you were a female, you can not have one guy friend out there. He's automatically—"Oh, you're sleeping with him, 'cause you're a skank, 'cause you're a female." Yeah, that really did suck.

Being a female in the military—being at home or being deployed—it's rough. It's always going to be rough, wherever you are—you always have to try harder to be looked at the same way as some regular old dude. He could be the worst marine ever—he could be fat and nasty, and I could be running a perfect PFT. I could be the best marine. They're still not gonna look at me the same and that sucks. You know that—there's always competition, and that's just something you have to deal with. I don't think that's ever gonna change. Now they get more males that are more gentlemen. They're always trying to help you—they see you lifting something heavy and they're like, "Oh, I'll get it." And it's like, "Hey come on—you keep treating me like this and I'm going to be still looked at as a bimbo, so just let me try. I know you'd be struggling to pick this up, too." It's rough. It's a lot different. You're always at a competition—

always. Even when you're with other females. It sucks—you'd think we'd stick together. We're still always catty. Always. Because there are some little females that put a bad name for you so you have to be better than that other female. Wherever we go—it's competition.

Staff Sergeant Chanda Jackson, U.S. Army

They gave us classes about not being out at certain times. Did we have a curfew? Not really. But did they want you to use some common sense and not be out there wandering around? Yes. So there were issues when it came to things like that. They gave us classes on women being raped over there, not just by someone that was a national local, but by men in the military themselves.

You wouldn't think that you would have to deal with something like that, but it's a reality you had to come to terms with. Wow, I was naive not to even think that could happen. Did I know anybody that it happened to? No. We had a few soldiers where we had to really enforce curfew because they still didn't feel like they were in any type of danger. They felt like, "Oh, it's okay. I'll be fine. I have so-and-so to walk me back." And I'm like, you can't trust anybody. And it wasn't just the military. We had civilians, contractors who were trying to be friendly, and you just had to keep your guard up across the board.

Staff Sergeant Debra Fulk, U.S. Army

I was asked to work for this first sergeant. I got the impression that he had not had a lot of experience working with females. He seemed to be very domineering. When I would speak up for myself and stand up to him, he did not like it. I went to bat for the soldiers. That's when I would often get myself in trouble.

I ended up getting a reduction in my rank. I have it back now, but it got to the point where he escalated this negative relationship with his documentation. And there were other male soldiers who appeared to have the same leadership style.

The more I would fight, the harder things would get for me. I was put on extra duty in the hot heat to stack sand bags—long hours during the mid-part of the day. But I never did fight it because my goal was to get my rank back. So there were things that happened to me that I'm not necessarily proud of, but not ashamed of either, because it boils down to me standing up for my rights.

There were other females, but they sat back and did nothing. At first I was very angry. When I step back now and look at things in the healing process, I realize that it was survival for them. I have this new duty as an equal-opportunity person in the unit I'm assigned to now, and I'm glad to be a part of it because I am a fighter. I am an advocate not only for rights

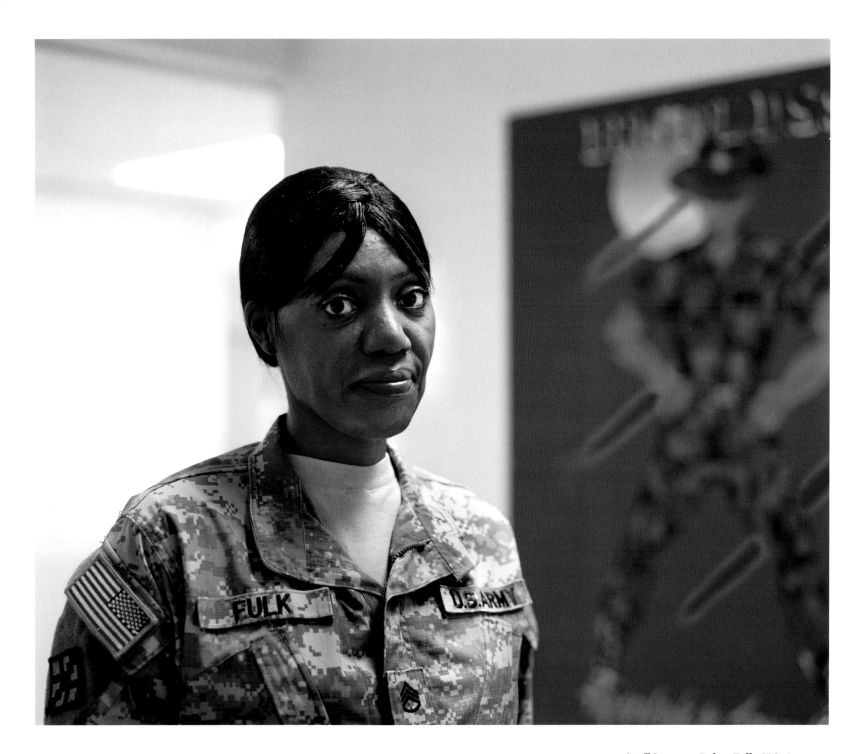

Staff Sergeant Debra Fulk, U.S. Army

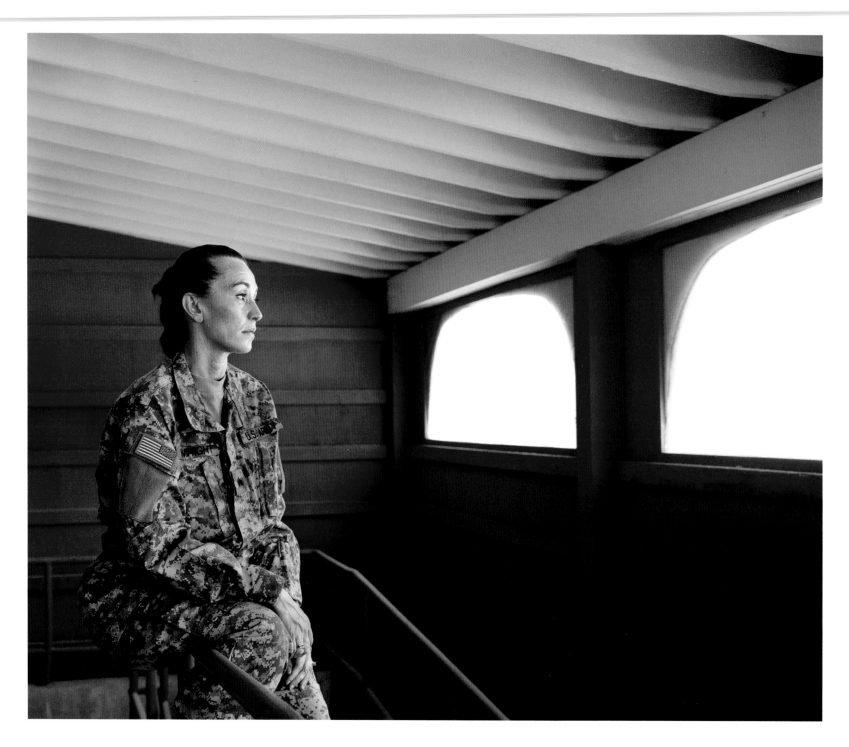

First Sergeant Shirley Wright, U.S. Army

for women, but also for rights for people in general. I think about those women who stood back and did nothing. I would have done it differently. I can truly say from my heart that I would have risked a lot more in order to stand up for justice.

So I was considered to be a troublemaker. I took EEO training the other week and, you know, it was just really interesting to see how those advocates are often looked upon as being troublemakers when we stand up for what is right.

Yes, you have to have a voice. You have to stand up for what you believe in. You have to pursue. You have to persist. If I give up, what about the people who come behind me—the other females, my grandchildren?

Sergeant Katharine Broome, Virginia Army National Guard

Our whole medical section was female. I think that says a lot, that we have a natural maternal instinct to take care of these people. The fact that I'm a female probably made it a little bit harder to see all of these young boys getting hurt. Men can look at it and say that's a soldier, women can look at it and say that's somebody's son. No physical aspects were any harder. The jobs that we were tasked to perform were still done to standard, but the humanity and psychological toll of some of the things we saw made it harder on us, because we turned these casualties into humans with girlfriends and wives. I think that we brought more humanity to the actions that we were performing.

There were three female pilots in my unit, and female door gunners and female crew chiefs and medics and we're not standing in Kuwait in a safe place. We're not completely hidden from what's actually going on and we're not immune to the things that people envision only the infantry men seeing. I think that people forget that this war does not have a front line. This war is fought all over the place every hour of the day and there is no marching up and facing each other and pulling out your muskets. This is people with rocket launchers in the back of pickup trucks pulling up, pointing it toward where they might hit something good and where they hit is not full of men, it's full of everyone.

First Sergeant Shirley Wright, U.S. Army

When I was in Desert Storm, I was in a big warehouse full of infantry men. There were only three females, and we were attached to this infantry unit as their support. Well, they weren't used to females being with them in the military. We're sleeping cot to cot to cot; we're not separated. That didn't bother me because, you know, the guys in my unit learned from me personally, that just because I'm a woman doesn't mean you disrespect me. You treat me as

a soldier when I'm in this uniform. You have no right to force me into anything that I don't want to do, and I was very, very strong, adamant. I stood my ground.

That's one thing with a lot of females who come in. I always try to let them know: look, the guys are gonna say stuff because they're gonna try you, but you have to stand your ground. You have to be the one to say yea or nay. If you let them manage you, they're gonna keep doing it. And for a woman to be in the military, you have to stand your ground: "No, I'm not a piece of meat for you to have whenever you please. I'm a soldier. I deserve that respect. And I still deserve respect as a woman." If you don't do that and give in, of course you get labeled some not-very-nice titles.

There were actually times when I tried to handle it on my own, and some people just didn't have a clue. And that's how I learned. I used to be very quiet and just tolerate it, but you can't do that and focus on your work. You really can't. I had a squad leader who actually propositioned me in my room when he was supposed to be inspecting my room. And it was kind of scary because he shut my door, and he locked it, and he turned off my light, and he's like, "I've been waiting for this." And I was like, "Look, Sergeant, you need to leave right now." And he's like, "Well, nobody has to know." I was like, "I have a conscience, and I'm not that kind of person. You need to leave right now." I opened the door and said, "You need to leave. If you don't leave, I will scream." And he just stood there. I actually started counting and, each time I counted, I went up higher, and my voice got louder. He left me alone after that, but he could never look me in the face.

Sergeant First Class Kim Dionne, U.S. Army Reserve

On the base we had a great woman general, General Halstead. She was just this little petite woman. And she had the base on lockdown. Her chief of staff was a colonel, another female—she had two females, like bookends. It was just really great to experience women running the show.

There were notices up in the bathrooms everywhere, "If you're a victim of sexual assault or abuse, please report." So, there was an EEO there. There was an IG. There was all kinds of programs in place that were taken very seriously and yet there were still rapes occurring and that saddened me. The general had issued out whistles to all the women. And then one of the sergeant majors said, hey that's discriminating against the men, so the men all got whistles, too.

Religious Program Specialist Second Class Rachel Doran, U.S. Navy Reserve

We were like the happy little family. There was seven of us living in there, in this little hut. I got known as the crazy white girl. They were all Puerto Rican or African American and they kept saying, "You're the crazy white girl." I said, "It's crazy Native American. Thank you very much." We all had our little sections and it was so clean. We celebrated Christmas together. We decorated Christmas lights until we blew them up because of the power exchanges. We had a Christmas tree. We exchanged Christmas presents and the only rule was is it couldn't be a care package re-gift. It was a good time. We organized this girls' party in our SWA hut where we all put our jeans on and our civilian clothes, all trying to act normal eating junk food, it was great. I love those girls.

Sergeant Kimberly Baptist, U.S. Army Reserve, Active Guard Reserve

It's just really bad for the women who have to go to the bathroom at night. You don't want to walk two to five minutes in the dark because there were rapes that went on around there. I mean soldiers raping soldiers—it's horrible. We're in a war. Can't you be nice to each other? But, people are people. So we used a lot of porta potties. When there were rapes they put out wanted signs and they put our rewards. They did get prosecuted. We had JAG out there and they actually had a court where people went to hearings and we had witnesses and everything. I never knew the people—if I did know them I didn't know that they were the victims because it's very under wraps. I wasn't out wandering around in the dark. I mean they tell you to bring flashlights, but what's a flashlight going to do?

Sergeant Major Andrea Farmer, U.S. Army

I've gotten respect. I've had opportunities. I'm one of the blessed ones. The army has allowed me to break a lot of glass ceilings, and they've given me a lot of opportunities and allowed me to excel, which hopefully paved the way for other soldiers. I haven't seen a lot of changes because I guess I came in after the WAC Corps. So since I came in, leaders have approached me and they've asked me, "Do you want to try to do this? Do you want to do that? This is the first time we've had a female do this, would you like to do it?" And they've given me great opportunities.

Sergeant First Class Keisha Williams, U.S. Army

My mom was a single parent. I got caught up with the wrong crowd in high school and ended up getting pregnant at fifteen, so I had my son. My mom was determined that I was going to graduate from high school. So I graduated on time in 1995, and she gave me a year to decide what I was going to do with myself. I finally decided that I would give the army a try and joined in 1996.

I left September 21, 2005, which was my mom's birthday. I remember being on the bus and calling to wish her a happy birthday, telling her that I would call her again as soon as I could. That's when it hit me that I was really going to be deployed, that it was really happening.

In the maintenance company and on the base itself, we had a lot of females—you know, plenty of moms, even grandmothers, in the National Guard and reserve. So you were able to have, as I like to say, "Women talk." You know, "Hey, is that normal, what I'm feeling right now?" So that was a good thing.

When I went to Iraq, we met a few Iraqis. And it made me realize that we all have the same common ground, no matter what we believe. We all want to take care of our families; we all want a better life, to be healthy, to live each day to the fullest. So that's what I took from it.

When it was time to come home, I felt like, "Hey, we made it through the year. I'm gonna see my son soon." Once we got to Kuwait, you didn't know exactly what day you're gonna fly. So when you finally got the call that you're gonna fly out, you're just real excited. When we actually got to Hawaii, it was the best thing in the world. We flew into Hickham Air Force Base, and it was just the best place in the world. For me, Iraq was this dream I had, and now I'm back in reality. That's how it felt to me; it was great.

I reenlisted while I was in Iraq. I would rather be in Iraq than worrying about my son or my mom or my sisters ever going.

Staff Sergeant Jamie Rogers, U.S. Army

The last seven weeks I was in Iraq, our mission changed and we went to internal resettlement, which is detention facilities. We guarded Iranians. My soldiers just hated that part. The Iranians had females, and they had to have female guards. And my soldiers hated that. It was so boring.

The people that were in the detention facility, they were being repatriated to different countries. They're called the People's Mujahedin of Iran, and they ran missions into Iran for Saddam. The Iraqis didn't like them, and the Iranians, of course, didn't like them. But they were funded by very rich people in Iran. They worked for Saddam. They ran missions for him. Like if he wanted someone taken out, he would send them in. Because they were

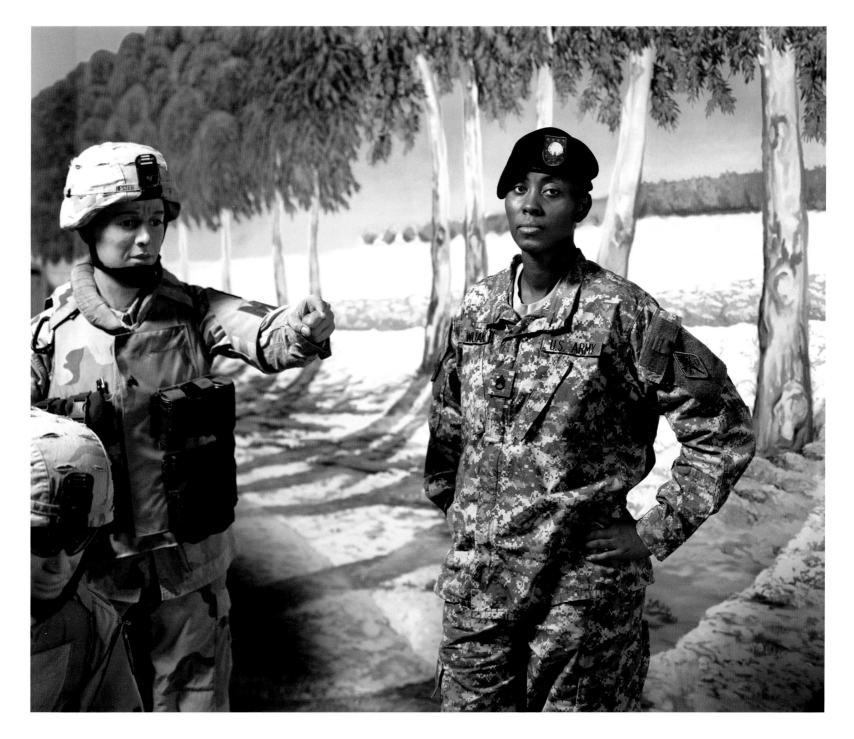

Sergeant First Class Keisha Williams, U.S. Army

Iranians. They knew the culture, they knew the land, they knew the people, and they spoke Farsi. They could blend in very easily. But they had battalions of women. It was really strange. It was a little camp called Ashraf. They were very segregated. They couldn't get married or nothing like that. But they were kind of in limbo with the Geneva Convention. So of course we had to protect them because we're Americans and that's a part of our job. We can't just let them go. And I'm sure that they have a lot of intel.

When they wanted to get repatriated, they would go through a liaison, and lawyers would work with different countries, like Canada, Germany—some of them went back to Iran—and they would go into our facility until they got repatriated because once they left that little camp, they were outcasts. They had awesome woodwork. They built all kinds of stuff in the camp. They were always woodworking, or they had a little gym they could work out in. They'd take English classes. It was nothing like Abu Ghraib.

Airman Victoria Hager, U.S. Coast Guard

I think on the boat you had to prove yourself a little. Reporting in, they know they're getting females—not they're getting Kelly and Vickey, they're getting females. And so they watch you a little bit more than they would a male. They see how far they can push you to what limits. What they can say, and how you're gonna react to it. How hard you're actually going to work—or are you gonna pull what they call the female card. I think it takes a little while to get in with the crew than it would a guy. And there's boundaries that they can't cross, so that makes it hard, too. With guys, they can say whatever they want, joke around whatever. They have to watch when there's females around. Our captain, Mr. O'Mara, he was very big on that. You know, your manners—you don't say this. Wrong words to call the people in the area. You don't say that. If he heard anything, he would address it right away.

Petty Officer First Class Kelly Falor, U.S. Coast Guard

We had DVDs—we'd get 'em in care packages or just people's personal movies. And Mr. O'Mara was big into the fact that we were all a family and we wouldn't watch a movie with nudity sitting beside our brother or sister, so it needed to be turned off or fast-forwarded so that nobody felt uncomfortable, which was good in a sense. At first we were like, "We're all adults." But at the same time, there were times when I would be the only one sitting in there, and it would be a bunch of guys and something would come on and the guys would start saying stuff. And it wasn't anything that I would have ever said anything about. It wasn't anything that made me like, vilely uncomfortable, but . . .

Prior to going over there, I never had any issues whatsoever with being a female. I'm a cool chick that gets along with everybody, you can say whatever you want around me. I'm not going to be offended. My dad raised me by himself, so it's not anything uncomfortable for me at all. I'm used to being at work and me being the only female. You know the girls who are getting in trouble or there are rumors—I'm like, "Psssh. That's what you get for acting that way." Going over there opened my eyes to being a female in the military big time. Not on the boat, 'cause we were the only boat out there that had females on it, so all of us together were like brother and sister. We hugged and whatever—not a big deal. But when we would pull in and go to the exchange—I hated it. I learned to walk with a purpose. I would not have any makeup on, just walking and not even trying to look cute, not even being cute, you could just watch the heads turn as you walked through. It was awful. One of my friends used to stand like a bodyguard and wait for me and stare at people that stared at me, because it pissed him off so bad, because he was like my brother and he's very gentleman-like. I would turn around to do something and some guy is taking off his sunglasses and checking me out a foot away from me, just gross. Absolutely gross. Definitely have a different opinion about being a female in the Coast Guard. I come back here and I'm comfortable again. But I wouldn't want to go back over there in that environment at all.

Ensign Colleen Fagan, U.S. Navy

I've always been a feminist, but I didn't realize until I got out and looked back on my experiences that you can be a feminist and make things easier for women coming after you, but still work cohesively and peacefully with men. Let's face it—women are a minority in the military, but I think you can keep your female identity and still beat it with the best of them.

Master Gunnery Sergeant Constance Heinz, U.S. Marine Corps

Well, when I was fifteen, we came to the States from Germany. And I left home and I was gone for two years, and I lived on the street for part of that time, I drove a truck part of that time. I can remember, children were seen, they were not heard. I can remember, as a woman, you need to be domestic, you need to do this, you need to do that. My mother had family in Germany, my father had family in Austria. And the women were all homemakers, and the men all worked, you know, it's like, "I'm not going to do that. That's not happening. I want something bigger. Something better." I never thought it would be the Marine Corps, but I knew that that's not what I wanted—what they all had.

Sergeant First Class Gwendolyn-Lorene Lawrence, U.S. Army

The military was an opportunity. The army, air force, navy, marines—all the branches would say, "Okay, women, prove your point. Prove you're citizens." We shot that. We went over and beyond to say, "Here—we are here. We are citizens. We deserve the right to defend our country in whatever capacity we can," and you don't have to be at war, but I'm saying I felt that I could contribute. We still had the racism, the sexism, the discrimination. You still had all of that, but now you had women that was making way, and we were like, "If we can make way, it'd be safer for generations to come." We read about in other countries how they draft women and whatnot. Here, this county—we didn't even have to have the draft. So it was your own free will, your own free choice, but it was an opportunity—go to school, have a job. At least it gave you something so if you did come out of the uniform, you'd have some stability, education, something to further whether for you or for your family.

Terminology

AIT: Advanced Individual Training. The training a soldier receives directly after boot camp.

Camp Bucca: A prison camp maintained by the U.S. military in the vicinity of Umm Qasr, Iraq.

Camp Virginia: Located near the Udaira Range in northern Kuwait.

CO: Commanding officer.

D-Fac: Dining facility.

E-4: Corporal.

E-5: Sergeant.

ECOD: Estimated cost of damage.

EEO: Equal employment officer, the person in charge of making sure that no one in the unit suffers racial or gender discrimination.

EFP: Explosively formed penetrator, also known as a platter charge or a shape charge; a type of shaped charge designed to pierce armor.

FOB: Forward operating base. FOBs serve as staging areas for technical operations in Iraq and Afghanistan. Although some are fairly primitive, many of them house thousands of troops and feature amenities like swimming pools, fast food restaurants, and internet cafés.

Hajji: A sometimes derogatory name for Iraqis used by U.S. troops.

IED: Improvised explosive device. These roadside bombs, often hidden inside dead animals or under pieces of trash, have resulted in a great number of casualties.

IG: Inspector general.

JAG: Judge advocate general.

JDAM: Joint direct attack munition. A guidance system to improve the accuracy of unguided gravity bombs in adverse weather conditions.

KBR: Formerly known as Kellogg, Brown & Root, Inc. Private contractors operating in Iraq and Afghanistan, responsible (among other things) for providing most of the housing for American troops.

Life Support Area Anaconda: One of the largest bases in Iraq, located near Balad, sixty-eight

miles north of Baghdad. Many troops refer to this FOB as "Mortarville" because it received so much mortar fire in 2004.

Lioness Program: Developed by the marines in 2004, this program assigns females to combat units for the purpose of conducting searches of Iraqi and Afghan women.

M16: Standard-issue combat rifle used by infantry.

MCT: Marine Combat Training.

MEF: Marine Expeditionary Force.

Medevac: Medical evacuation.

MOB process: Mobilization process.

MOS: Military occupational specialty.

MP: Military police.

MRE: Meals ready to eat.

MSR: Main supply route.

MWR: Morale, welfare, and recreation.

NCO: Noncommissioned officer.

NCOIC: Noncommissioned officer in charge.

OEF: Operation Enduring Freedom. The military name for the war in Afghanistan.

OIF: Operation Iraqi Freedom. The military name for the current war in Iraq.

PAO: Public affairs officer. Person in charge of communications with the media.

Platoon: A military unit typically made up of thirty to fifty soldiers.

PT: Physical training.

PTSD: Post-traumatic stress disorder.

PX: Post exchange; i.e., an army base retail store.

REACT: Reaction force—troops on call to provide rapid response to developing situations.

RPG: Rocket-propelled grenade.

TBI: Traumatic brain injury.

TMJ: Temporomandibular joint disorder, a painful condition of the jaw.

VBED: Vehicle-borne explosive device. Also known as a VBIED, or vehicle-borne improvised explosive device.

WAC: Women's Army Corps. Established during World War II, the WAC was disbanded in 1978.

WAVES: Women Accepted for Voluntary Emergency Service. In August 1942, the WAVES comprised the first group of women to join the navy. Although the group officially ceased to exist with the passage of the Armed Services Integration Act of 1948, the name was used for navy women well into the 1970s.

Introduction

1. According to figures from the U.S. Department of Defense's Defense Manpower Data Center cited by Army public affairs officer Wayne Hall, August 10, 2009.

2. Women's Research and Education Institute, "Chronology of Significant Legal and Policy Changes Affecting Women in the Military: 1947–2003," http://www.wrei.org/Women%20in%20the%20Military/Women%20in%20the%20Military%20Chronology%20of%20Legal%20Policy.pdf (accessed May 27, 2009).

3. Figures as of September 30, 2007. U.S. Bureau of the Census, http://www.census.gov/Press-Release/www/releases/pdf/cb09ff-03.pdf (accessed August 15, 2009).

4. United States Department of Veterans Affairs, "Women Veterans Population: October 2008," http://www1.va.gov/womenvet/page.cfm?pg=53 (accessed May 29, 2009).

5. Number of active duty members as of September 30, 2008. U.S. Department of Defense, http://siadapp.dmdc.osd.mil/personnel/MILITARY/rg0809f.pdf. Statistics on reservists and guardsmen are from http://www.womensmemorial.org/PDFs/StatsonWIM.pdf (accessed August 15, 2009).

6. Air Force Personnel Center, http://www.afpc.randolph.af.mil/library/airforcepersonnelstatistics.asp (current to March 31, 2009). Navy Personnel Command, http://www.npc.navy.mil/AboutUs/BUPERS/WomensPolicy/FactsStats.htm (current to July 2009; accessed August 15, 2009). See also http://www.womensmemorial.org/Press/stats.html (accessed August 15, 2009).

7. U.S. Department of Defense http://siadapp.dmdc.osd.mil/personnel/CASUALTY/oif-deaths-total.pdf, and http://siadapp.dmdc.osd.mil/personnel/CASUALTY/oefdeaths.pdf. (current to August 1, 2009).

8. The question of pregnancy is a very touchy one, in that conservative commentators have long offered the possibility of pregnancy and the larger issue of women's sexuality as reasons why women should not serve alongside men in a combat zone. See Kingsley Browne, *Co-Ed Combat: The New Evidence that Women Shouldn't Fight the Nation's Wars* (New York: Sentinel, 2007); Brian Mitchell, *Women in the Military: Flirting with Disaster*, (Washington, D.C.: Regnery Publishing, 1998).

9. Linda K. Kerber, *No Constitutional Right to Be*

Ladies: Women and the Obligations of Citizenship (New York: Hill and Wang, 1998), 240.

10. See, for instance, Lisa Merrill, *When Romeo Was a Woman: Charlotte Cushman and Her Circle of Female Spectators* (Ann Arbor: University of Michigan Press, 1999).

11. Belle Boyd, *Belle Boyd in Camp and Prison*, with a new introduction by Sharon Kennedy-Nolle (Baton Rouge: Louisiana State University Press, 1998), 82.

12. Kennedy-Nolle, "Introduction," *Belle Boyd in Camp and Prison*, 40–48.

13. Sarah Emma Edmonds, *Memoirs of a Soldier, Nurse and Spy: A Woman's Adventures in the Civil War*, introduced and annotated by Elizabeth D. Leonard (DeKalb: Northern Illinois University Press, 1999).

14. Loreta Velazquez, *The Woman in Battle*, introduction by Jesse Alemán (Madison: University of Wisconsin Press, 2003), 99.

15. U.S. General Accounting Office, *Report to the Ranking Minority Member, Subcommittee on Readiness, Committee on Armed Services, U.S. Senate*, "Gender Issues: Information on DOD's Assignment Policy and Direct Ground Combat Definition," October 1998, http://www.gao.gov/archive/1999/ns99007.pdf, 3 (accessed August 1, 2009).

16. Kayla Williams, *Love My Rifle More Than You: Young and Female in the U.S. Army* (New York: Norton, 2005), 15.

17. Robert Scheer, "Saving Private Lynch Take 2," *AlterNet*, May 20, 2003 (accessed June 3, 2009).

18. Rick Bragg, *I Am a Soldier, Too: The Jessica Lynch Story* (New York: Alfred A. Knopf, 2003), 10.

19. Jackie Spinner, with Jenny Spinner, *Tell Them I Didn't Cry: A Young Journalist's Story of Joy, Loss, and Survival in Iraq* (New York: Scribner, 2006), 65.

20. Kathleen Parker, "Guys and Dolls: the Facts of Life about Co-Ed Combat," *Weekly Standard* 11, no. 7 (October 31, 2005): 38–39.

Why I Joined

1. Julian Borger, "U.S. Military Stretched to Breaking Point," *The Guardian*, January 26, 2006, 17.

2. Douglas Quengua, "Sending in the Marines (to Recruit Women)," *New York Times*, April 21, 2008. For a fascinating paper on the ways the military now recruits women, see Melissa T. Brown, "Gender, Recruiting, and the Iraq War," delivered at the Annual Meeting of the American Political Science Association, August 28–31, 2008.

Earlier Wars

1. For a history of women in the military, see Jeanne Holm, *Women in the Military: An Unfinished Revolution*, rev. ed. (Novato, Calif.: Presidio Press, 1992).

Relationships with Iraqis and Afghans

1. Figures drawn from the website "Iraq Body Count" (http://www.iraqbodycount.org/), May 21, 2009. This number includes only violent civilian deaths, rather than those caused by increased infant mortality rates, health problems related to lack of proper sewage and electricity, etc. As Jonathan Steele and Suzanne Goldenberg recently noted in an article summing up the controversy surrounding civilian body counts, the Iraq body count is generally accepted as the most conservative source as it uses "'passive surveillance,' a statistically conservative method that only

deals with facts on the ground. The IBC lists all cases where at least two media sources report an incident causing one or several deaths, keeping a careful tab of the victims' age, gender, occupation, manner and place of death, where information is available." Needless to say, the number is hotly disputed, with a January 2008 World Health Organization study estimating that 151,000 civilians died in the first three years of the war, and a 2006 Johns Hopkins study putting the number to that date at over 600,000. See Jonathan Steele and Suzanne Goldenberg, "What Is the Real Death Toll in Iraq?" *The Guardian*, March 19, 2008, 6.

Contractors

1. Pamela Hess and Anne Gearan, "Officials: Most Troops out of Iraq in 18 Months," Associated Press, February 24, 2009.

2. Michelle Tan, "CID Races to Catch Up with Greedy Contractors," *Army Times*, February 22, 2009.

3. James Risen, "Use of Iraq Contractors Costs Billions, Report Says," *New York Times*, August 11, 2008.

4. And, as Army Captain Timothy Hsia recently noted in a *New York Times* op-ed piece, the lack of legal oversight for contractors, who operate free from regulation by either U.S. or Iraqi laws, has also meant that contractors have engaged in unsafe practices without fear of legal consequences: "Soldiers at a base in Balad have accused one contractor, KBR, of making them ill from burning toxic materials like aircraft fuel and arsenic, and medical waste, including amputated limbs. But in my experience incident and waste mismanagement occurs on many bases." Timothy Hsia, "A Clean Fight," *New York Times*, February 28, 2009, A19.

Motherhood

1. Amy Engeler, "Deployed Military Parents: Choosing Custody or Duty." *Good Housekeeping*, March 2008, 107–12; Pauline Arrillaga, "Deployed Troops Battle for Custody of Children," *USA Today*, May 5, 2007, which also appeared on the same date in the *Washington Post*; Brian Mann, "Soldier Loses Custody of Child After Iraq Tour," National Public Radio, February 14, 2008.

2. Lizette Alvarez, "Jane, We Hardly Knew Ye Died." *New York Times*, September 24, 2006 (Week in Review, pp. 1, 4).

Coming Home

1. William Welch, "As Deaths Spike, Motorcycle Training Pushed for Troops." *USA Today*, May 6, 2009, http://www.usatoday.com/news/military/2009-05-06-soldierriders_N.htm (accessed August 6, 2009).

Changing Relationships

1. Pauline Jelinek, "Divorce rate Increases in Marine Corps, Army," http://www.thefreelibrary.com/Divorce+rate+increases+in+Marine+Corps%2c+Army-a01611732198 (accessed August 6, 2009).

Women in the Military

1. U.S. Department of Defense, " Fiscal 2007 Sexual Assault in the Military and 2006 Gender Relations Survey Results Released" (news release), March 14, 2008, http://www.defenselink.mil/releases/release.aspx?releaseid=11757 (accessed May 28, 2009).

2. Quoted in Sarah Kliff, "No Glass Ceiling Here," *Newsweek*, June 23, 2008, 17.

Suggestions for Further Reading

Appy, Christian G. *Patriots: The Vietnam War Remembered from All Sides*. New York: Penguin, 2004.

Benedict, Helen. *The Lonely Soldier: The Private War of Women Serving in Iraq*. Boston: Beacon Press, 2009.

Bowden, Lisa, and Shannon Cain, eds. *Powder: Writing by Women in the Ranks, from Vietnam to Iraq*. Tucson, Ariz.: Kore Press, 2008.

Estes, Steve. *Ask & Tell: Gay and Lesbian Veterans Speak Out*. Chapel Hill: University of North Carolina Press, 2007.

Herbert, Melissa. *Camouflage Isn't Only for Combat: Gender, Sexuality, and Women in the Military*. New York: New York University Press, 2000.

Holm, Jeanne. *Women in the Military: An Unfinished Revolution*. Rev. ed. Novato, Calif.: Presidio Press, 1993.

Holmstedt, Kirsten A., *Band of Sisters: American Women at War in Iraq*. Mechanicsburg, Pa.: Stackpole Books, 2007.

———. *The Girls Come Marching Home: The Saga of Women Returning from the War in Iraq*. Mechanicsburg, Pa.: Stackpole Books, 2009.

Meyer, Leisa, *Creating G.I. Jane*. New York: Columbia University Press, 1998.

Skaine, Rosemary. *Women at War: Gender Issues of Americans in Combat*. Jefferson, N.C.: McFarland & Co., 1999.

Solaro, Erin. *Women in the Line of Fire: What You Should Know about Women in the Military*. Berkeley, Calif.: Seal Press, 2006.

Walker, Keith. *A Piece of My Heart: The Stories of 26 American Women Who Served in Vietnam*. New York: Presidio Press, 1997.

Williams, Kayla, with Michael Staub. *Love My Rifle More Than You: Young and Female in the U.S. Army*. New York: W. W. Norton, 2005.

Wise, James E., Jr., and Scott Baron. *Women at War: Iraq, Afghanistan, and Other Conflicts*. Annapolis, Md.: Naval Institute Press, 2006.

Wood, Trish. *What Was Asked of Us: An Oral History of the Iraq War by the Soldiers Who Fought It*. Boston: Little, Brown, 2006.

About the Photographs

This began as a personal project of mine and Laura's, and in order to keep the atmosphere between the subjects and the camera as intimate and low-key as possible, all of the shoots were done without assistants.

We worked in many different and unfamiliar locations, often under time constraints.

For these reasons, as well as the fact that I had no prior knowledge of the subjects I would be shooting, I found that I had to rely on gut instinct and my immediate response to each veteran and location for each portrait.

I therefore developed a reactive, flexible, and intuitive approach out of necessity, but given the broad range of subjects we met—their varied experiences, responses, personalities, reactions to the camera—it ended up being the ideal approach for the project. The goal for me from the beginning was to visually document these women as they were at a specific moment in their lives. Some of the portraits were taken pre-interview, some afterward; this certainly had its own effect on the atmosphere and on the look of each portrait. A specific note regarding dress: some of the soldiers we portrayed had already left active duty and thus are seen in civilian clothing.

SASCHA PFLAEGING

Acknowledgments

Our greatest thanks go to the women we interviewed and photographed, who gave so generously of their time, their insights, and their memories. Ashley Kistler first saw the potential of this project, and her vision has shaped this work in many ways. We were extremely fortunate to have worked with her on the exhibit. Thanks go to the administrative staff of the Visual Arts Center of Richmond for all of their help in making the exhibit a success.

We want to give special thanks to David Bearinger from the Virginia Foundation for the Humanities, who encouraged us from the earliest beginnings of this project. A summer fellowship from the VFH offered me time to complete the manuscript and a great environment in which to do so.

Many other people offered crucial help and support: James Chambliss, Steven Danish, Tom Gresham, Robert Holsworth, Fred Hawkridge, and Terry Oggel from Virginia Commonwealth University; Ted Genoways and Waldo Jaquith from the *Virginia Quarterly Review*; project participants Constance Heinz, Jenny Holbert, Kim Dionne, and Debra Fulk; public affairs officers Sarah McCleary and Jamie Rogers from Fort Lee, Amy Robinson from Langley Air Force Base, and Kevin Saunders from the Fifth District, U.S. Coast Guard.

Thanks to Vincent Burgess and Anne Atkins from the Virginia Department of Veterans Services for their advice and encouragement. And thanks, as always, to my writing group: Carol Summers, Gretchen Soderlund, and especially Abigail Cheever. Crucial work was done by transcribers Leigh Gutches and Patty Green; thanks especially to Leigh for her amazingly fast work on those last interviews. Thanks to Julie Pochron and Pochron Studios in Brooklyn, New York, for their excellent work on the photographs in this book. Thanks to Douglas Newman for his help with many aspects of this project, especially the website and his whirlwind sixteen-hour trip to Richmond from Houston to shoot the show's opening (and thanks to John Carrithers for that, as well). Thanks also to Michael

Lease, Sarah Kim, Carolyn Burleigh, Jeremy Brecher, and Betsy Brinson, as well as to Eve Raimon for her hospitality in Maine while we were conducting interviews there.

It's a real pleasure to be working with University of North Carolina Press again. Thanks to Sian Hunter for all of her insights and help in turning a show into a book, and to Paul Betz for expertly ushering this into print despite a very tight production schedule. I also wish to thank Steve Estes and Franny Nudelman for their careful readings of the manuscript and their extremely helpful suggestions for revision.

For all of his support, both emotional and technical, for his love and for keeping life at home fun even during the craziest times, thanks to Allan Rosenbaum. Melissa, Mathilda, Nina, and Leo: this book's for you.